Navajo Saddle Blankets

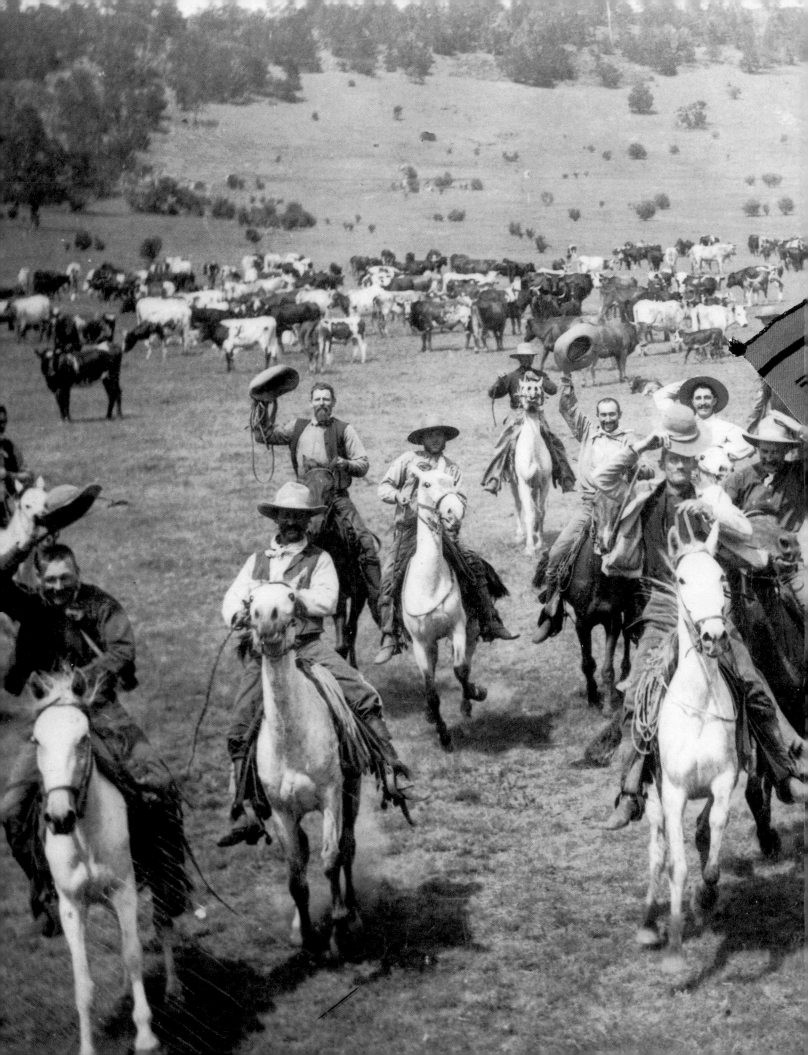

Navajo Saddle Blankets

*Textiles to Ride in the
American West*

EDITED BY LANE COULTER

FEATURING THE COLLECTION OF THE
MUSEUM OF INDIAN ARTS AND CULTURE

Museum of New Mexico Press Santa Fe

Frontis: "Cowboys Going to Dinner," a staged
photograph showing hands working a herd in
Mora Valley, New Mexico, ca. 1897. MNM 5324.

The writing of this book was made possible through
generous contributions by Blair Darnell, James H.
Duncan, Sr., Ginger Hyland, George and Fran
Ramsey, and Jay Haskin and Ruth Richardson.

Major support for this book was provided by
ADVENTURES IN ANTHROPOLOGY, a Museum of
New Mexico Foundation support group for the
Museum of Indian Arts and Culture.

Project editor: Mary Wachs
Manuscript editor: Sarah Whalen
Design and Production: David Skolkin
Composition: Set in Caslon and Gill Sans.
Printed in Hong Kong
10 9 8 7 6 5 4 3 2 1

Library of Congress Cataloging-in-Publication
Data
Navajo saddle blankets : textiles to ride in the
American Southwest / edited by Lane Coulter ; fea-
turing the collection of the Museum of Indian Arts
and Culture/Laboratory of Anthropology.
 p. cm.
 Includes bibliographical references and index.
 ISBN 0-89013-406-5 (cloth : alk. paper) −
ISBN 0-89013-407-3 (pbk. : alk. paper)
1. Navajo textile fabrics—Catalogs. 2. Horse blan-
kets—Southwest, New—Catalogs. 3. Museum of
Indian Arts and Culture/Laboratory of
Anthropology (Museum of New Mexio)—Catalogs.
I. Coulter, Lane, 1944- II. Museum of Indian Arts
and Culture/Laboratory of Anthropology (Museum
of New Mexico).
 E99.N3 N357 2002
 746.1'4'089972—dc21 2002069637

MUSEUM OF NEW MEXICO PRESS
Post Office Box 2087
Santa Fe, New Mexico 87504

Contents

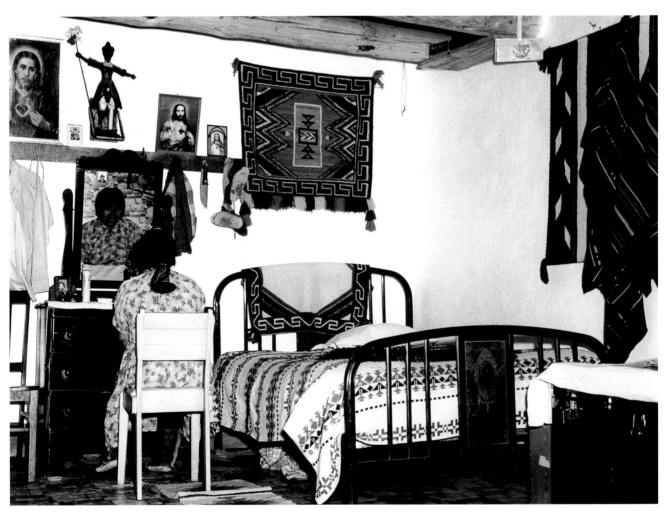

Figure 1. Santiago Moquino bedroom, 1941. Santa Domingo Pueblo interior showing Navajo saddle blankets. Photograph by John S. Candelario, courtesy Museum of Fine Arts, Museum of New Mexico.

OBJECTS PRODUCED by Native artists in the American Southwest tend to fall along a continuum from the most spectacular and most celebrated art forms to the more mundane utilitarian or household items that are often overlooked or taken for granted.

In pottery, for example, elegant polychrome bowls and jars and polished red and black wares win prizes and receive the most attention from collectors, art historians, and museum personnel. Historically, this has meant the near total exclusion of utility wares; indeed, cooking pots have been all but neglected by researchers for many years. Western observers and scholars have failed to recognize that utility wares have their own aesthetic, which must be understood and factored into an overall appreciation of a group's ceramic industry.

The same is true of Navajo weaving. There are over two dozen books currently in print dealing with such topics as Classic-period wearing blankets, the transition from blankets to rugs, and the various styles of rugs that emanated from different trading posts across Navajoland. There are also books about particular weavers and weaving styles, and the Navajo worldview as reflected in their textiles.

Saddle blankets are mentioned in the literature but usually in passing. Often, dealers and collectors refer to the better-woven early blankets as children's wearing blankets. This makes them sound more important and consequently makes them more valuable. In the past, the use of the term *saddle blanket* almost always meant that a given textile was less expensive and not so well made as a counterpart woven as a wearing blanket or, in later times, a rug.

Saddle blankets have generally been seen by both maker and user as utilitarian objects to be worn out and discarded. As a result, we do not adequately appreciate them as an art form in the overall context of the Navajo weaving tradition. By the same token, we tend to ignore designs and weaving techniques that are particular to saddle blankets. This is where the double weaves, the two-faced, the twills, and the tufted angoras come into their own.

Saddle blanket origins pertain to Spanish history and the use of sheepskin saddle pads on donkeys. Navajo weaving has its origin in Pueblo textiles, and

its transition to saddle blankets occurred with the availability of Spanish-introduced horses. Soon, saddle blankets spread across the Southwest and into surrounding regions, where they were used by Natives, cavalry, and settlers alike.

While the great majority were woven by Navajo weavers, it is important to point out that weavers from the Pueblos, particularly from Hopi and Zuni, also wove saddle blankets. It is difficult to identify Pueblo-woven saddle blankets in historic collections even when the collection history is known. Some of the blankets that we identify as Navajo may be Pueblo examples.

Markets changed with the advent of new technologies such as the railroad and then the automobile. While the market for saddle blankets among the Native population began to shrink, demands from the cowboy and rodeo culture began to expand it. Today, the arts are still being practiced, and beautiful Sunday saddles, herringbone twills, and other fine examples are being produced, but the number of skilled weavers is dwindling, and markets are depressed because Navajos cannot compete with the high volume and low price of Zapotec textiles from Oaxaca, Mexico. One group of Navajos from the Keams Canyon area of Arizona is plowing new ground by making saddle blankets with felting techniques that are much faster than traditional weaving methods.

The inspiration for this book was a request from the Museum of New Mexico Traveling Exhibits Department to create a traveling exhibition on Navajo saddle blankets, with Lane Coulter serving as curator. It provided a perfect opportunity to organize a group of experts under the research associates program at the Museum of Indian Arts and Culture/Laboratory of Anthropology to prepare a book on the many facets of saddle blankets. Our intention was to create a book that would serve not only as a catalog of blankets in the museum's collection to accompany the exhibition but also as a general, freestanding volume—the first and only one specifically dedicated to saddle blankets.

It is my intention that the book will be broadly circulated and widely read and that it will prompt readers to look anew at one of the most underappreciated art forms in the American Southwest. I hope it will inspire Navajo weavers to keep the old traditions alive even as they explore new designs, materials, and techniques. I also hope it will inspire collectors to reflect on their holdings and acquire worthy examples from various time periods and will encourage researchers to explore other nooks and crannies in the Native arts that need to be further explicated and explained.

DUANE ANDERSON, *Director*
Museum of Indian Arts and Culture /
Laboratory of Anthropology

EVER SINCE I CAN REMEMBER, I have been surrounded by the interlacing and intertwining of fibers. My mother tells me I was only six months old when I began watching her weave from my cradleboard. She tightly bound me in the cradleboard and stood me against an inside wall or outside under the piñon tree, where she always wove during the summer season, so I could be near her as she worked. When she realized my deep spiritual interests, she began to reminiscence that during the time she carried me in her womb, she frequently wove. My mother and grandmother also said that their mother clan To'aheedlini (streams flowing together) had created skillful weavers in the past. When I was able to grasp with my tiny hand the small weaving tools my father created, I began to experiment with mother's looms.

My parents and siblings were usually out watering livestock when I would sneak around and explore mother's enormous looms. Whatever I attempted by myself, I would unweave before Shima and Shi'zhe'e (mother and daughter) returned home. When I was eight years old, I realized the beautiful process of weaving fibers. I was thrilled and overwhelmed when I realized I could turn plain weaving into mother's beautiful, intricate, and sometimes twill designs. These were too difficult to unweave before my parents came back, so my brothers helped me cover the enormous looms and hide my work, but not for long. After my mother discovered I had been weaving or playing on her loom, to my surprise I overheard my parents say that I should have a loom of my own. My father happily created a small loom and tools especially for me, and he said, "Now you can imitate your mother, and *nizhonigo anileeh, shiyaazhi* (make it beautiful, my little one)." As I explored and experimented with my weaving, my parents and grandparents told stories of how in the beginning of the Diné world, a mystical, spiritual being named Grandmother Spider Woman instructed our first mother, Changing Woman, in the processes of weaving and that it was Changing Woman's responsibility to instruct her female descendants as they journeyed through life.

My mother always said that to be born into a family of weavers was a true wealthy inheritance. A

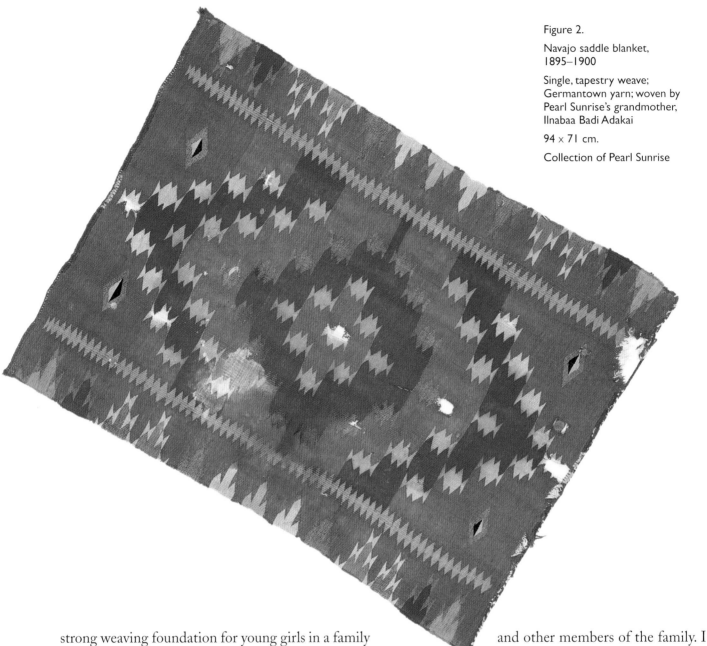

Figure 2.

Navajo saddle blanket, 1895–1900

Single, tapestry weave; Germantown yarn; woven by Pearl Sunrise's grandmother, Ilnabaa Badi Adakai

94 × 71 cm.

Collection of Pearl Sunrise

strong weaving foundation for young girls in a family was so valuable because it taught them not only Diné traditional values but also creativity, ingenuity, and life skills. And the absorption of these life skills was up to the young girl as my parents and grandparents uttered, "*T'aa whe ajit'eo e'eehya*," during the trials of learning about weaving.

My mother delighted in creating designs and patterns from the middle and latter part of the eighteenth century, the so-called eye-dazzler and zigzag designs, using her own colors. For some of these, she incorporated my grandmother Ilnabaa's eye-dazzler designs into saddle blankets. She had learned her weaving skills and designs by watching her mother

and other members of the family. I recall in my early childhood how my mother created saddle blankets, rugs, and wearing apparel, not only for the family and extended family members but also for neighboring tribes such as the Zunis, Apaches, and Utes; she traded these pieces for food, jewelry, agricultural products, and/or animal hides. My mother's paternal relatives, the Adakais, were excellent horsemen and trainers, so the first priority was to keep them supplied with the necessary blankets.

My mother, grandmother, older sister, and I all created many saddle blankets with simple twills and complex patterns over a period of more than one

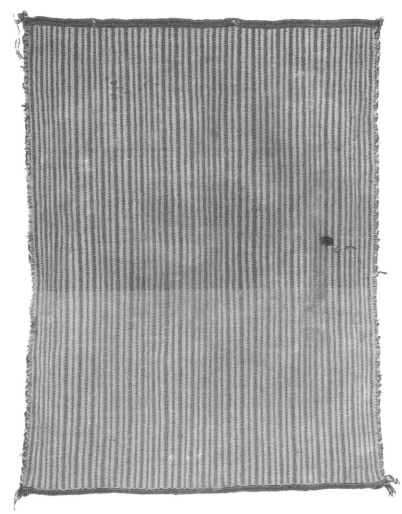

Figure 3.

Navajo saddle blanket, ca. 1910

Single, twill weave; hand-spun wool yarn; weaver: Ilnabaa Badi Adakai

72.5 × 56 cm.

Collection of Pearl Sunrise

hundred years. At times we helped each other in counting the warps, which created various patterns.

Today, I weave various regional-style patterns in plain weaves, diamond-twill, and two-faced weaves; for example, the saddle blankets are sometimes in plain weave but most often in diamond-twill weaves. Recently, I was approached to weave three hundred saddle blankets within a limited time frame for a company that requested they all be the same design and size—in other words, mass production. I refused the project first of all because it spelled too much monotony. There was no room for creativity. The spiritual connection would be absent in mass production, and I would be like a machine. The ultimate reason I refused to do it, however, was the monetary compensation offered, which was insulting, to say the least. My clients appreciate my creative endeavors, so I produce textile projects on that basis.

I'm proud to be a link in the great tradition I'm passing on to my daughters and all those to whom I teach weaving skills today. When my mother passed on a few years ago, I was fortunate to be given all the weaving tools and equipment that came from her grandmothers. I'm happy all three of my daughters are learning to weave from me, as my mother constantly reminded me that I was the sole transmitter of the spirit of weaving. When the time comes, I may have to divide my weaving tools for transmission, but I will definitely pass them on.

Acknowledgments

A NUMBER OF INDIVIDUALS have contributed significantly to the development of this volume. The authors are grateful to Bill B. Price, Willow Roberts Powers, Kathy Foutz, Ray Drolet, Bonnie Benally Yazzie, Clarina Begay, Wesley Thomas, Ron Garnanez, Sarah Natani, Jaymes Henio, Roy Kady, Lena Benally, Paul Zolbrod, J. J. Brody, Ray Dewey, Nancy Looney, Jo Ann Bol, Mike Stevenson, Joshua Baer, Ginger Hyland, Kathy Whitaker, and Carole Warren.

Mimi Roberts, director of Museum of New Mexico Traveling Exhibits Program, consulted on the project in conjunction with a planned exhibition on saddle blankets. Clair Munzenreider and Deb Juchem, Museum of New Mexico Conservation Department, evaluated and conserved the saddle blanket collection. Several individuals on the staff of the Museum of Indian Arts and Culture provided much needed assistance in researching the collection, compiling information, and obtaining permissions. Included are Valerie Verzuh, Anita McNeece, Doug Patinka, Antonio Chavarria, and David McNeece. Duane Anderson served as project manager and fund raiser for the Museum. Blair Clark, Museum of New Mexico Exhibitions Department, photographed the collection.

The authors are grateful to the staff at the Museum of New Mexico Press for an outstanding effort. We are particularly grateful to editorial director Mary Wachs for her management of the project; David Skolkin, who served as art director; Anna Gallegos, director of Museum of New Mexico Press; and Elizabeth McCann for managing the marketing efforts.

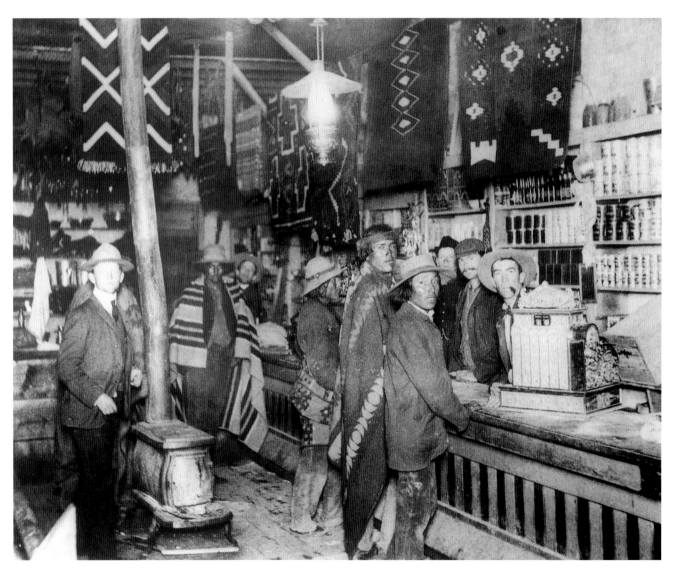

Figure. 4. Trading post at Thoreau, New Mexico, ca. 1890, with a
fringed saddle blanket hanging from the rafters. MNM 9123.

Introduction

By Lane Coulter

NAVAJO WOMEN and sometimes men have been weaving saddle blankets since before 1860 and are still weaving them today. Saddle blankets are the one form of Navajo weaving that has been produced continuously both for Navajo use and for trade. Over those 140 years the market for them has waxed and waned, and the weavers have responded with wonderful textiles. As Kate Peck Kent states in the introduction to her *Navajo Weaving: Three Centuries of Change*, "There has never been a time in the long history of Navajo weaving when the artists were not aware of the needs of the marketplace nor failed to modify their work to some extent to suit the taste of potential buyers" (Kent 1985:3). In order for Navajo weavers to make saddle blankets, they first tended their flocks of sheep, then sheared the fleeces and washed and cleaned them; carded or combed the wool and spun it into yarn; helped build the loom, then strung the yarn on it; wove their textiles; and finally took them to market. A tremendous, time-consuming task accomplished in the arid desert Southwest.

All of the work required to make a saddle blanket was primarily for the comfort and protection of the horse and only secondarily so for the rider. The saddle blanket is the protective padding between the wood and leather structure of the saddle and the back of the horse. Over the years, saddle blankets have been used for many other purposes: as rugs, tablecloths, rolled up and used by cowboys for pillows on the trail, as curtains for doorways, or simply hung on the wall as art. But mostly they have been used as saddle blankets. They have been worn out, patched, stacked one on top of another to provide even more padding, treasured, and collected (see Figs. 5, 6). Relatively few of the countless saddle blankets made over the last century and a half have been added to museum collections. Maybe they were too worn to save, too plain, too small, damaged, had an ugly dye run, or were just too common.

The Navajo became a horse culture and, as such, were themselves the first clientele for saddle blankets. But other markets soon developed (see Price, this volume). The horse was the primary means of transportation in the sparsely populated country west of the Mississippi until the early part of the

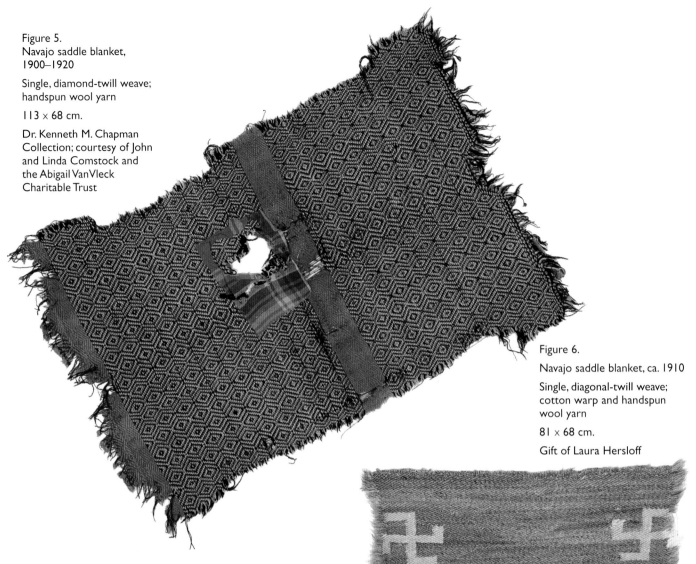

Figure 5.
Navajo saddle blanket,
1900–1920

Single, diamond-twill weave;
handspun wool yarn

113 × 68 cm.

Dr. Kenneth M. Chapman
Collection; courtesy of John
and Linda Comstock and
the Abigail VanVleck
Charitable Trust

Figure 6.

Navajo saddle blanket, ca. 1910

Single, diagonal-twill weave;
cotton warp and handspun
wool yarn

81 × 68 cm.

Gift of Laura Hersloff

twentieth century, and throughout the western United States Navajo saddle blankets were preferred over any other. The rise of the cattle industry and the trail drives of the 1870s and 1880s created demand for drovers, all on horseback. Riding continuously day after day, the cowboys wore out thousands of Navajo saddle blankets at the rate of at least one a year. This created a continual demand for more and more saddle blankets, which continued unabated through the middle of the twentieth century.

Saddle blankets early on became popular as rugs (Matthews 1884). They were perceived as a visual representation of Native American culture and a symbol of the western frontier. Their size, thickness, and ability to withstand wear made them particularly suited for use as rugs on the floors of bunkhouses, dude ranches, southwestern homes, and even in the sunrooms of New Jersey bungalows. Beginning about 1880, Navajo weaving was heavily marketed through mail-order catalogs of Indian traders and curio dealers throughout the West who had developed extensive mailing lists of tourists from across the United States. During the Arts and Crafts period (ca. 1900–1915), Navajo rugs became popular with folks furnishing their homes with Stickley or Limbert oak furniture, and examples of the style were published in Gustav Stickley's *The Craftsman*

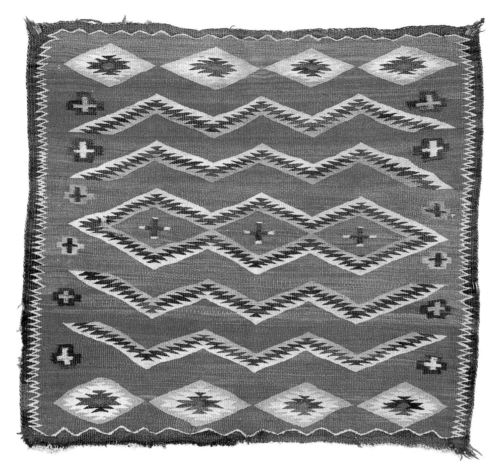

Figure 7.

Navajo saddle blanket, ca. 1900

Single, tapestry weave; cotton warp and handspun wool yarn

86.5 × 78.5 cm.

Bequest of Margaret Moses

Figure 8.

Navajo saddle blanket, 1880–1900

Tapestry weave; handspun wool yarn

79.5 × 71.5 cm.

Gift of Florence E. Dorman

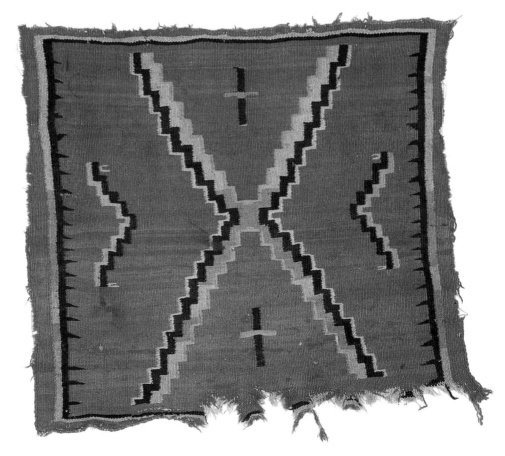

magazine. Navajo weavings were marketed as part of a growing aesthetic that encouraged a simpler life and that championed the "work of the hand." This of course created yet another market and an additional demand for Navajo saddle blankets beyond the cattle industry.

Dude ranches were extremely popular in the first half of the twentieth century, particularly in the 1920s and 1930s. They were the western equivalent of the "camps" in the Adirondacks or the Great Smokies of the eastern United States. These camps had developed in reaction to the urbanization of American life in the Midwest and along the eastern seaboard as city dwellers sought a healthy experience in a "natural environment." Dudes were offered a healthy climate with pure air, wonderful scenery, and a dramatic change from life in the city. They were also exposed to the intriguing culture of the West, including horseback riding, cookouts, square dancing, and Indian lore. Navajo weavings and Pueblo pottery played a major part in creating an authentic atmosphere at the ranches.

An early dude ranch photograph (below) shows tourists and (likely) host-family members gathered outside the Harvey Ranch near Las Vegas, New Mexico, in 1904. The woman on horseback on the right seems to be using a striped Navajo utility blanket folded as a saddle blanket. In another dude ranch photo, the "tenderfeet" at the San Gabriel Ranch at Alcalde, New Mexico, in 1923 are learning to ride, to the amazement and amusement of tribal members

Figure 9. Harvey Guest Ranch near Las Vegas, New Mexico, summer 1904. Striped utility blankets were folded and used as saddle blankets. MNM 87948.

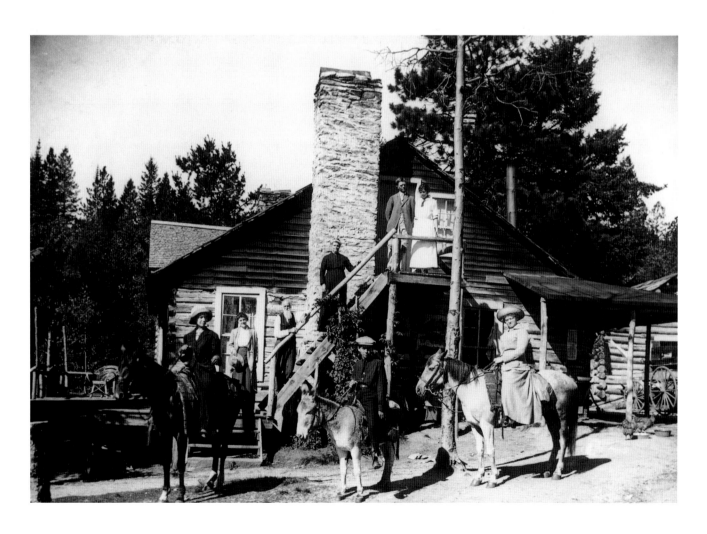

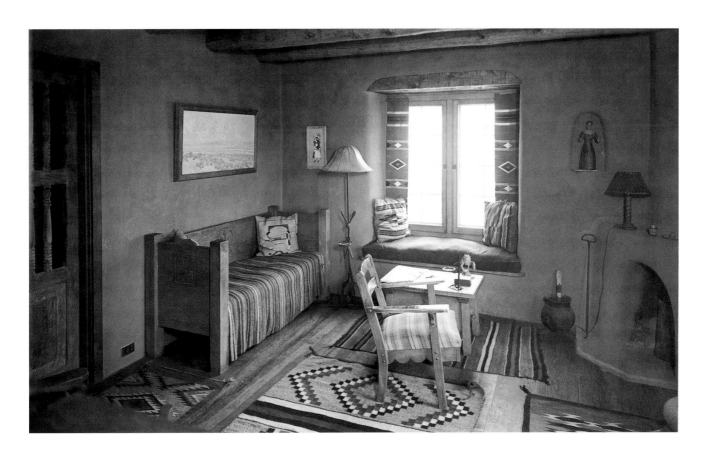

Figure 10. Cabin interior, Ghost Ranch, near Abiquiu, New Mexico, ca. 1935, showing the various uses for older Navajo and Spanish weavings in dude ranch interiors. Photo by T. Harmon Parkhurst. MNM 89670.

from nearby San Juan Pueblo (Fig. 11). The photograph in Figure 58 shows a Germantown saddle blanket being displayed on a cabin wall at the Ghost Ranch dude ranch in northern New Mexico about 1935; an additional saddle blanket, a rug, and a Rio Grande weaving are also part of the decor of the room. Another cabin at Ghost Ranch (above) displays a simple, banded saddle blanket used as a rug, with Navajo weavings on the floor and others made into pillows. An old, striped Rio Grande blanket covers the "Taos" bed, and the curtains were woven in the old Hispanic village of Chimayo. A small Hopi painting and a New Mexican landscape painting complete the milieu. Another photograph (Fig. 12) taken about the same time, from the Tent Rocks dude ranch near Pecos, New Mexico, shows an

unbordered, single saddle blanket with a prominent swastika or "whirling-logs" image in the center of the floor of a log cabin, along with rustic "Old Hickory"–style furniture and a modest Pueblo pottery lamp. Another view showing one of the main public rooms at the same ranch illustrates how the ranch owners prominently displayed western artifacts (Fig. 13). Pueblo pottery is on the mantle and the windowsill, and the blackware lamp on the side table was made at Santa Clara Pueblo. A large Pueblo Indian drum and a Mexican *batea* (painted tray) are featured above the fireplace. Two Navajo rugs complete the scene.

A wonderful view of the social hall at the Canjilon Camp in northern New Mexico, taken in 1925 (Fig. 14), shows the enormous rock fireplace, benches, and window seats, and three large Navajo rugs. In the foreground is an excellent example of a two-pattern, double saddle blanket used as a rug. These interiors clearly illustrate the extent of the

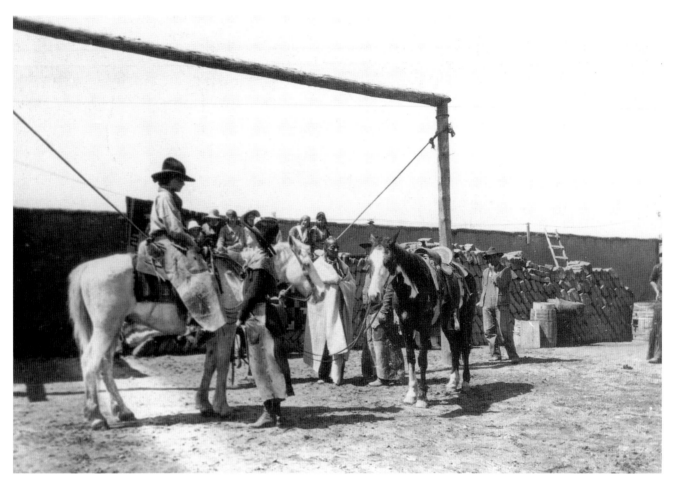

Figure 11. San Gabriel Dude Ranch, Alcalde, New Mexico, September 1923. Dudes receiving their first riding lessons. Photograph by Edward Kemp. MNM 112300.

public fascination with a regional aesthetic that represented a simpler life and one that could be transported anywhere in America.

With the urbanization of the country and the widespread availability of the automobile in the early twentieth century, the concept of riding and breeding horses for pleasure became popular with the upper middle classes. The myth of the cowboy transformed itself into the reality of the rodeo and the real myth of the western movie. These changes led to new markets for Navajo saddle blankets.

Rodeos began as cowboys competed with one another in typical ranch chores, roping, and breaking horses, which then were modified for competition.

Popularized in the early part of the twentieth century by the traveling Wild West shows of Buffalo Bill Cody, Pawnee Bill, and the Miller Brothers' 101 Ranch, rodeos glorified the skills of the real cowboy and expressed the rugged individualism of the American West. The Navajo people have enjoyed rodeos for many years and still support the sport enthusiastically. Figure 15 shows a Navajo rodeo at Chaco Canyon about 1925. Rodeos have always promoted sports that involve riding and thus the continued use of Navajo saddle blankets (see Fig. 16). All of these views of rodeo events, from bulldogging to calf roping, show Navajo saddle blankets in use about 1950. We can clearly see a striped blanket and a patterned border one in Figure 18. The proud cowgirl from Las Vegas, New Mexico, in Figure 17 has her contestant number pinned to the back corner of her Navajo saddle blanket (note tassel). Governor John

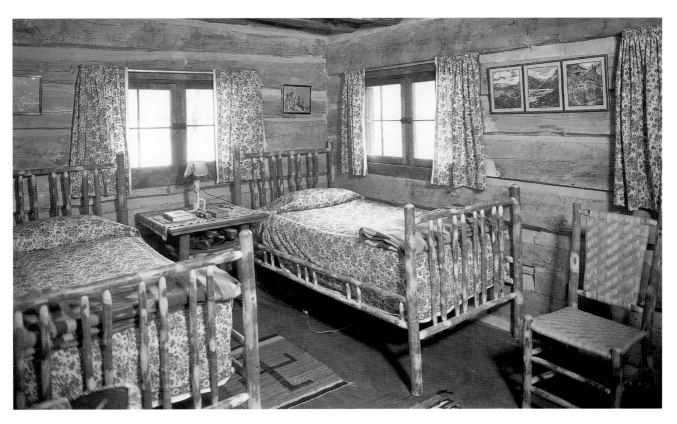

Figure 12. Interior of cabin at Tent Rocks Ranch, New Mexico, ca. 1935. A small saddle blanket is used as a bedside rug; note the rustic furniture and the Pueblo pottery lamp. Photo by T. Harmon Parkhurst. MNM 50992.

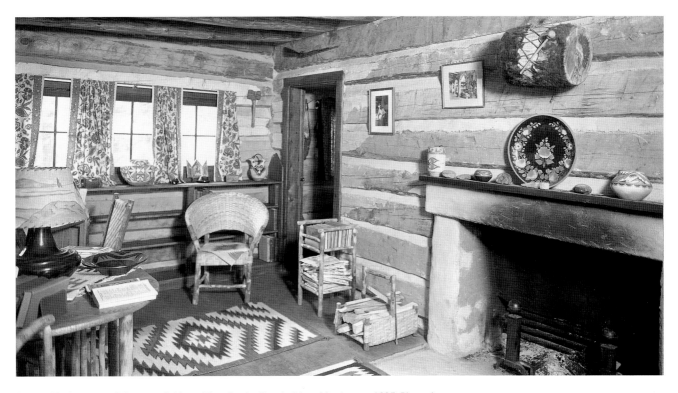

Figure 13. Interior of the main lobby at Tent Rocks Ranch, New Mexico, ca. 1935. Photo by T. Harmon Parkhurst. MNM 50994.

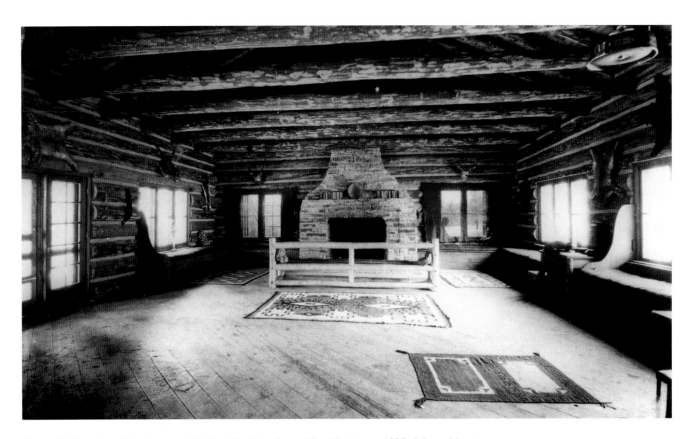

Figure 14. Interior of the large social hall at Canjilon Camp, New Mexico, ca. 1925. A large Navajo rug and a two-pattern saddle blanket are on the wide-board pine floor. Photo by Edward Kemp. MNM 151382.

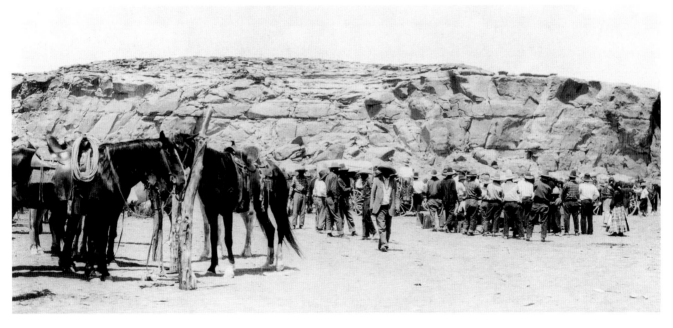

Figure 15. Navajo Rodeo in Chaco Canyon, New Mexico, ca. 1925. Photo by Sam Huddelson. MNM 46487.

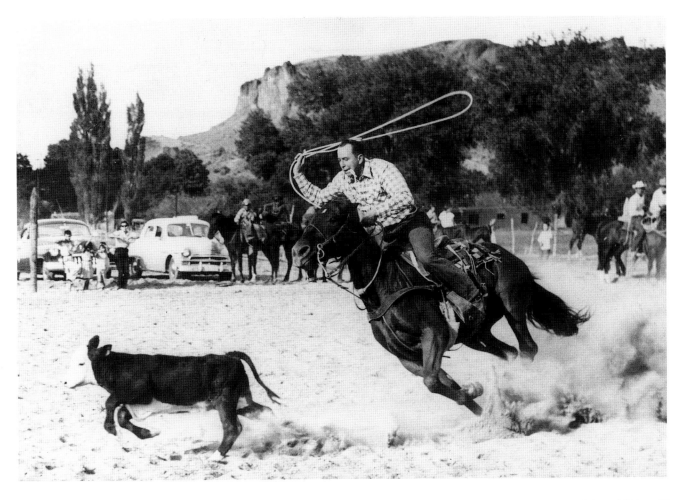

Figure 16. "Roper" at an informal rodeo, New Mexico, ca. 1956. Photo by Tyler Dingee. MNM 20379.

Miles (on the right) is using a twill, double saddle blanket on his palomino horse in the photo taken in the late 1930s at the cowboy reunion rodeo, also in Las Vegas (Fig. 19).

All of these illustrations demonstrate that the saddle blanket has played a key role in Navajo life both as a utilitarian object and as a force in the economic sustainability of modern Navajo life. It represents a material link between Navajo weavers and traders on and off the reservation that helped create a connection with the dominant culture. Saddle blankets fulfilled the aesthetic interests and ideals of the Arts and Crafts period and have served as an emblem for non-Indians of our romance with the American cowboy. Through marketing, this small, modest textile has found a context in the cattle

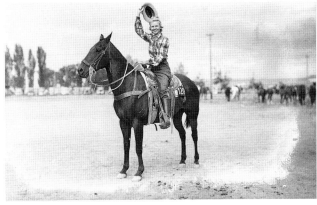

Figure 17. Cowgirl at the Cowboy's Reunion Rodeo, Las Vegas, New Mexico, ca. late 1930s. Her entry number has been pinned to the corner of her saddle blanket. MNM 71904.

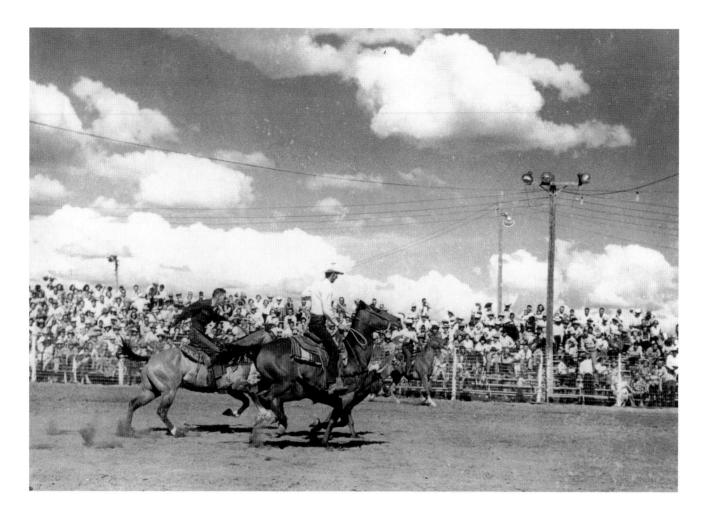

Figure 18. Santa Fe rodeo, mid-1950s. MNM 143153.

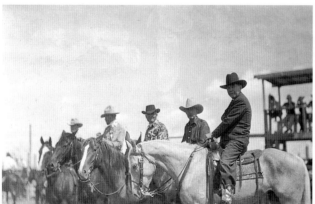

Figure 19. Cowboy's Reunion Rodeo, Las Vegas, New Mexico, late 1930s. Former New Mexico Governor John Miles on the right. Photo by T. Harmon Parkhurst. MNM 71886.

industry, inside rural cabins, on the floors of eastern bungalows, on the walls of art galleries and museums, and even on horseback. It has well served the countless cultural and utilitarian demands placed on it over the last century and a half.

References

Kent, Kate Peck. 1985. *Navajo Weaving: Three Centuries of Change*. Santa Fe, NM: School of American Research Press.

Matthews, Washington. 1884. "Navajo Weavers." *Third Annual Report of the Bureau of American Ethnology*. Washington, D.C.: Smithsonian Institution.

First Contact

By Bruce Shackleford

IN 1540, THE FIRST HORSES traveled through what is now the southwestern United States, with a Spanish expedition led by twenty-eight-year-old Francisco Vásquez de Coronado. Seeking gold, the expedition traveled throughout what is now New Mexico, Arizona, northern Texas, and Kansas. The Spanish horsemen on the early expeditions practiced two basic forms of riding, *a la brida* and *a la jineta*.

A la brida was the medieval riding style of western Europe. The horseman rode with long stirrups, his feet projecting to the front of the horse. The bit used in la brida riding was a broken "snaffle"-type bit. A la jineta, or jineta, was the riding style brought to Spain from the Middle East through North Africa. The rider used a light saddle with a high arch in the front and the rear and short stirrup leathers with wide, flat-bottomed stirrups. The "platform" stirrups enabled the rider to stand in the stirrups for a greater range of movement while riding. The saddles had no horns for roping, as throwing ropes had not yet been developed by stockraisers. The bit for the jineta style was the *morisco*, or ring bit; it had a solid mouth bar with a ring encircling the lower jaw. A la jineta was the preferred style of the horsemen of the conquest, and it had the greatest influence on Navajo horsemen and the tribes that would later control the plains of North America (Graham 1949:17–20). The preferred horse of the jineta horseman was ridden in a style that would be recognized as "western" today. The horses could "turn on a dime" and perform war maneuvers rapidly on the rider's command at a lope or a gallop. The few escaped horses of Coronado did not survive, but the riding styles did (Bennett 1998:327–328).

The skills and tools of horsemanship the Navajo utilized were little changed from those brought by the Spanish. The earliest form of saddle used by the Navajo was made from two cylinder-shaped hide pads with stirrups (Kluckhohn and Hill 1971:83–84). The Spanish colonists used similar pads without stirrups as a packsaddle. Called an *aparejo*, the hide pads were backed with roughly woven cloth and stuffed with animal hair or a plant fiber–like straw (Fig. 20).

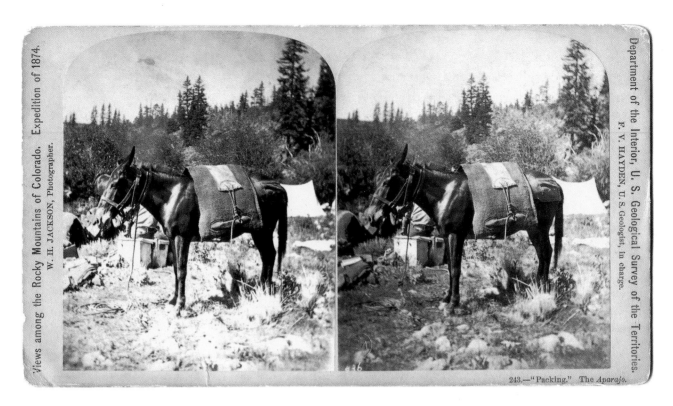

Figure 20. "'Packing' the *Aparejo*," an example of a Spanish-style pack saddle used on a mule. From "Views among the Rocky Mountains of Colorado. Expedition of 1874." W. H. Jackson, photographer, Department of the Interior. Private collection.

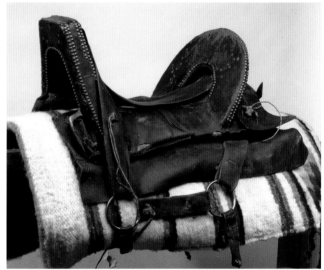

Figure 21. Navajo man's saddle (top), ca. 1880. Navajo woman's saddle (bottom), ca. 1880.

Richardson Trading Company in Gallup, New Mexico, continues to accept saddles in pawn. Amazingly, among the hundreds of western saddles hanging on the racks to be redeemed is one old, brass-tacked, Spanish-style saddle that a Navajo family still pawns each year. Top: Gift of James K. Riley; bottom: Gift of Barbara Cotton Seymour.

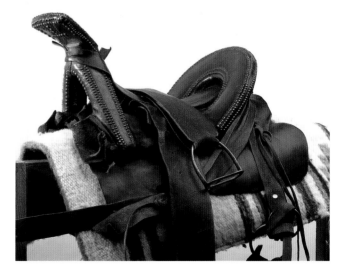

The Navajo copied other Spanish tack including riding saddles and bridles, ropes and halters, hobbles, and anything else used with horses. Ring bits were usually made by Spanish and, later, Mexican blacksmiths and obtained through trade. The saddles the Navajo copied were the jineta-style saddles brought from Spain during the conquest and ridden throughout the colonial era. Jineta saddles were light and easily constructed from wood and rawhide. Stirrups could be bent from wood or iron or obtained from traders (Kluckhohn and Hill 1971:83–85). The horseman often utilized a blanket between the rider and the saddle and another between the saddle and the horse (Kluckhohn and Hill 1971:83–85).

By the 1700s, weaving was the second most important industry in New Mexico behind farming (Jones 1996:133). The common cloth of the Spanish colony was *jerga*; it was woven in long strips about two feet wide and sometimes well over ten feet in length (Jones 1996:154). Jerga was made of loosely spun wool and woven as loosely as it was spun. The result was like a heavy wool gauze. When folded a number of times to the proper size, the ends could be sewn together to create a very serviceable saddle blanket. In Peru, this colonial method of making saddle blankets has persisted to the present time and was probably the earliest form of saddle blanket used throughout the colonies in New Spain (right).

Several other methods were used by the Spanish and later, the Mexicans, to protect the animal's back. The first was a stuffed pad similar to a pillowcase, made of a roughly woven cloth like burlap that was stuffed with animal hair such as horsehair or buffalo hair, grass, or a shredded plant fiber. This type of pad was sometimes sewn to the underside of the saddletree. A process of stuffing pads, then quilting the cloth was used to make pads that were separate from the saddle. A third type of saddle pad was made by felting; the process of binding together to create a felt pad was another Spanish skill used in New

Figure 22
Hispanic jerga; Northern New Mexico, ca. 1860
Twill weave; handspun wool yarn
195 × 58 cm.
Private collection

Mexico. Animal skins with the hair left on also served as pads for both riding and packhorses. Sheepskins were ideal for the purpose and may have been the first saddle blankets used by the Navajo.

Figure 23.

Navajo saddle blanket showing Saltillo influence, 1875–1885

Double, tapestry weave; handspun wool and commercial yarn

138.5 × 88 cm.

Dr. Edgar L. Hewett Collection; courtesy of John and Linda Comstock and the Abigail VanVleck Charitable Trust

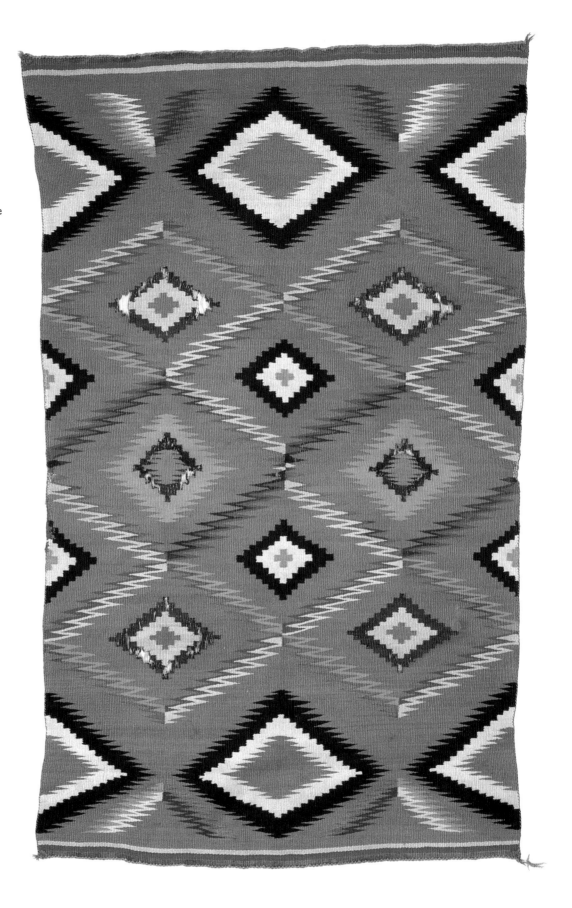

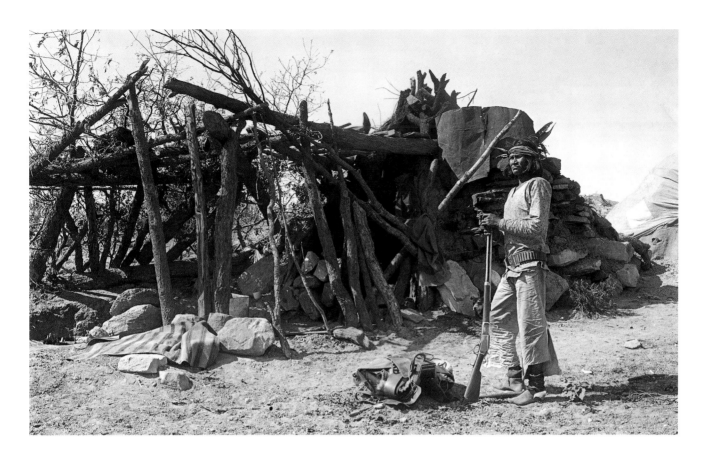

Figure 24. Navajo summer camp, ca. 1890, with a traditional Navajo saddle in the foreground. Photograph by Ben Wittick. MNM 16017.

Saddle blankets were made not only by weaving but also by spinning. Using a wooden tool called a *tarabia*, animal hair or plant fibers like Spanish moss could be spun into a pad. Woven wool blankets were the most desirable then, as they are today; wool blankets keep sweat and moisture away from the horse and pad the animal's back. The appearance of a wool blanket is also important to many horsemen. From the colonial period until the present, textiles woven with traditional designs were produced in Mexico for horsemen. Greek fret patterns, checkerboard designs, and stripes were all popular with riders throughout New Spain.

In Mexico, the old jineta-style saddles had been altered for stock work raising cattle. Sometime in the mid 1600s, a change in handling cattle came to central Mexico: vaqueros began tossing ropes from the saddle. Ropes called lassos had previously been a loop hung from a long pole and dropped over the animal's head from horseback. The vaqueros tied the ropes to the cinch ring of the saddle or to the horse's tail. As the rope-throwing skills of the vaqueros improved, the saddles were changed to accommodate the techniques; horns were added to the front arch of the saddletree, giving the saddle more of the appearance of the present-day western saddle. The saddles were not strong enough to take the shock of jerking down large cattle, and the method of *dar la vuelta* (taking the turn) was developed to lessen the impact to both the horse and the saddle. In dar la velta, the rope was turned around the saddle horn, and the animal was played like a fish on a reel until the rider gained control (Bennett 1998:313–315).

The Navajo interest was not in cattle but sheep, which could be more easily handled because of their size. The Navajo remained so true to the old jineta-

style saddles that they continued to make them into the twentieth century, over one hundred years after the saddles had gone out of style in Mexico due to cattle raising. The choice of the old Spanish-style horse tack stayed popular with the Navajo until the late 1800s (Fig. 24). The cattle industry brought cowboys into New Mexico by the hundreds, all riding western saddles with horns. Although the Navajo rapidly changed to the western saddles that were the descendants of those used in Mexico and Spanish California, they did provide one important tool to the cowboys in the expanding livestock industry: Navajo saddle blankets.

REFERENCES

Bennett, Deb. 1998. *Conquerors: The Roots of New World Horsemanship.* Solvang, CA: Amigo Publications.

Jones, Oakah L. 1996. *Los Paisanos: Spanish Settlers on the Northern Frontier of New Spain.* Norman: University of Oklahoma Press.

Kluckhohn, Clyde, W. W. Hill, and Lucy Wales Kluckhohn. 1971. *Navajo Material Culture.* Cambridge, MA: Harvard University Press.

Graham, R. B. Cunningham. 1949. *The Horses of the Conquest.* Norman: University of Oklahoma Press.

2

*E*arly Navajo Weaving: *1650–1868 and Beyond*

By Lane Coulter

Before beginning a study of the Navajo saddle blanket, it is important to look at the early history of Navajo weaving that informs the evolution of the woven saddle blanket. Navajos developed their weaving skills throughout the eighteenth century, having adopted the techniques and tools from their eastern neighbors, the Pueblo Indian people of New Mexico, in the seventeenth century. They wove articles of clothing, s*erapes* and *mantas,* and/or a variety of shoulder blankets decorated with simple brown and white stripes, using primarily handspun yarns from the fleece of Spanish *churro* sheep.

Beginning in the nineteenth century, Navajo weavers developed a more complex design vocabulary based on terraced or stepped right angles or triangles added to their simple striped patterns. By 1850, they had developed a distinctive palette of indigo blue (produced with dyes traded from the Spanish), scarlet yarns unraveled from imported red cloth, and the natural colors of sheep fleece, dark brown and creamy white. In the years following the Mexican War and the subsequent Treaty of

Guadalupe Hidalgo of 1848, which ceded much of the American Southwest from Mexico to the victorious United States, the Navajos repeatedly came into conflict with their new Anglo-American neighbors. They were constantly raiding villages and ranches for horses and sheep and even attacked some of the newly established army forts. Late in 1863, they were defeated by American forces led by Kit Carson and force-marched into exile on the Bosque Redondo reservation at Fort Sumner, in eastern New Mexico; this is still called the "Long Walk" by the Navajo. Their flocks of sheep were decimated or abandoned, and without the availability of wool, weaving quickly declined, so much so that government agents had to purchase and distribute Rio Grande blankets, woven by Spanish craftsmen in northern New Mexico, to the Navajo people as insulation from the harsh winters.

This period of exile and suffering marks the end of what is now called the Classic period of Navajo weaving. Scholars have debated the dates and even the title for this period for many years. It has been called the Bayeta period, from the Spanish name for the unraveled red cloth used in weaving, and dated

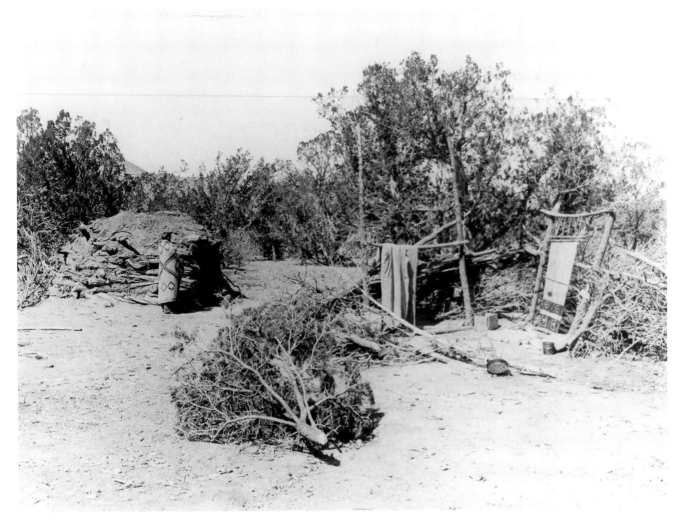

Figure 25. Typical Navajo loom, ca. 1890. Photo by Ben Wittick. MNM 16468.

1800–1863 (Amsden 1934:135); 1650–1865 (Kent 1985:49); or from the early decades of the nineteenth century to about 1860 (Wheat 1984:17). The debate among scholars continues today, but so few Navajo textiles can be truly dated (through collection history) before 1840 that we must recognize the middle part of the nineteenth century as the first *known* flowering of Navajo weaving. During this Classic period, very few saddle blankets were woven by the Navajo, and there are limited examples in the collections of the Museum of New Mexico. One rare example of a Classic-style saddle blanket is seen in Figure 26. It is a small-scale version of a man's wear-

ing blanket, woven in a banded pattern of narrow stripes in various reds, indigo blue, and lavender on a creamy white ground. The saddle blanket was woven from three-ply commercial yarns, raveled flannel, and handspun indigo yarns. The lavender may be an early synthetic dye. Prior to this time, the Navajo themselves were using sheepskins or fleeces under their saddles for protection from chafing.

There is also some evidence that both the Navajos and other tribes who traded for Navajo blankets occasionally used folded serapes or wearing blankets as saddle pad). In the early 1860s, the future clientele for Navajo saddle blankets—soldiers and cowboys—were using commercial saddle blankets manufactured in the East (see Price). About 1865,

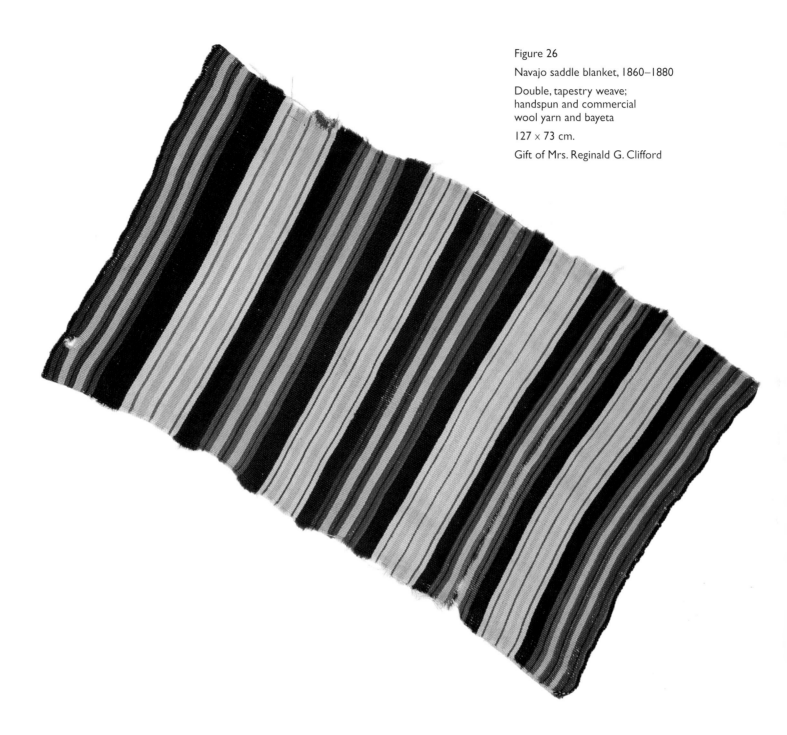

Figure 26

Navajo saddle blanket, 1860–1880

Double, tapestry weave;
handspun and commercial
wool yarn and bayeta

127 × 73 cm.

Gift of Mrs. Reginald G. Clifford

midway through the Navajo confinement at Bosque Redondo, the government began to distribute to the weavers bright-colored commercial yarns from the eastern United States. These were three-ply (made from three threads twisted together), synthetic-dyed yarns generally referred to as Germantowns (named for spinning mills in Germantown, Pennsylvania). Bolts of red cloth to be unraveled for yarn and yarns

dyed with natural (plant and insect) dyes were also distributed. These natural-dyed yarns are referred to as Saxony yarns after their place of origin in Germany (Fig. 30). Identifying these yarns and the dyes used in blankets can give us specific information about the age of the weaving (see Reed).

When the Navajos returned to their homeland in 1868, they immediately began to rebuild their flocks

Early Navajo Weaving: 1650–1868 33

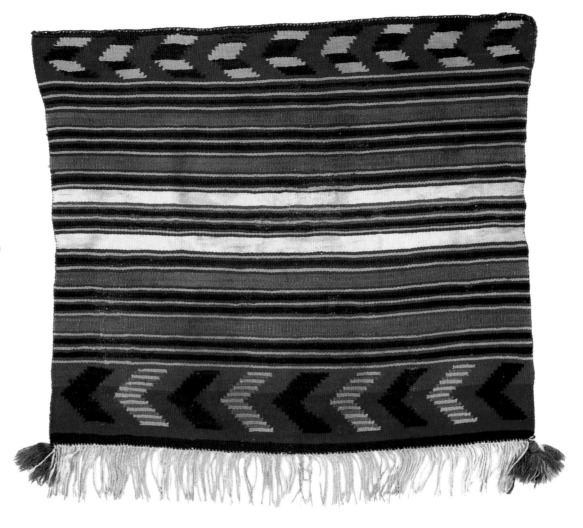

Figure 27

Navajo saddle blanket, 1865–1875

Single, tapestry weave; handspun commercial wool yarn and bayeta

76.2 x 72 cm.

Phillip Stewart Collection

with a new breed of sheep (merino) provided by the federal government. The new sheep interbred with the remnants of the surviving churro sheep and created a wool fleece with distinguishing characteristics that may also be tested and identified. The annuity distributions of the Germantown yarns by the federal government continued until 1878 and even escalated in the years following the Navajo return to the reservation established in their homeland of the Four Corners of Arizona, New Mexico, Colorado and Utah. Navajo weavers learned from contact and trading with the soldiers at Fort Sumner that their textiles were marketable and desirable to outside consumers. Trading posts, both on and off the reservation, were established as early as 1870, by hardy entrepreneurs who traded wool and weavings for staples such as sugar, lard, and coffee (Fig. 28). After the government ceased to supply materials, these traders continued to provide the new Germantown yarns as well as the bayeta and synthetic-dyed flannel cloth for raveling into yarn, in order to increase their trade with the weavers.

The post-Bosque period in Navajo weaving is known as the Late-Classic period, and it lasted from 1868 to about 1880. Late-Classic weavings are characterized by complex serrate designs featuring dia-

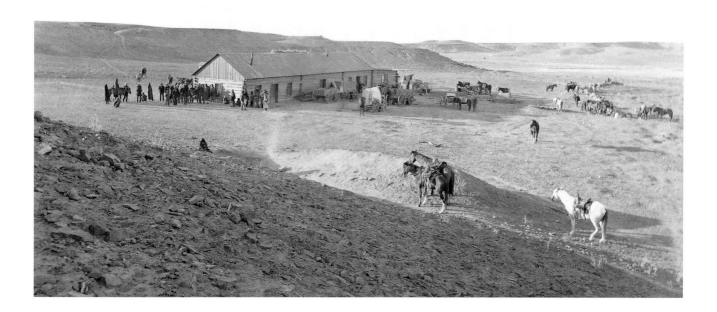

Figure 28. Sam Day's Trading Post, Chinle, Arizona, ca. 1902–1903. Photo by Ben Wittick. MNM 15988.

monds and candy-stripe motifs adopted from the Spanish Rio Grande textiles distributed at Fort Sumner. Other innovations of the Late-Classic period include the introduction of carded, gray handspun yarns (carding is a process of combing the wool to straighten the fibers before it is spun into yarn on hand-held spindles) and the occasional use of a vertical rather than horizontal design layout. The blanket shown in Figure 29 beautifully exemplifies the changes that were occurring in this period. It is woven on a handspun gray field with a vertical layout of stepped diamonds used both as a border and in the central design. The various red yarns are produced from raveled cloth, and the small square details are woven in handspun indigo blue and two colors of three-ply and four-ply commercial yarns (see Reed). The layout and use of a variety of yarns and dyes typifies the weavings of the 1870s. The

innovations of the period are likely due to the difficult but more stable life on the reservation and the demand for weavings by traders because of the cattle industry's growth (see Price). The more predictable supply of yarns and colors stimulated more design possibilities, and the ease of weaving with prespun yarn certainly encouraged the expansion of Navajo weaving designs. The Late Classic period is the first in which designs were developed specifically for saddle blankets, both in the double and single sizes. The double size (at that time about 28 inches by 50 inches) was used by folding it in half to double the thickness and give additional protection for the horse. The single-size blanket of the period is a bit

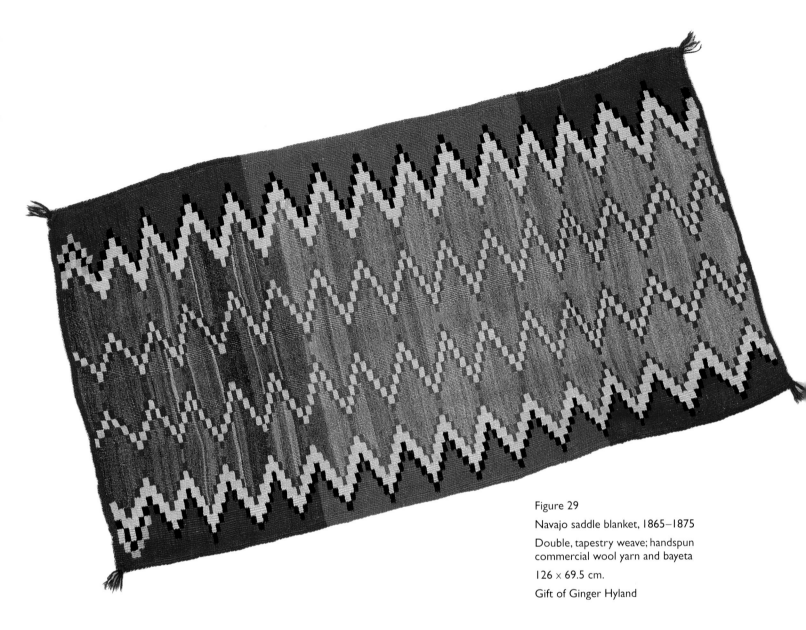

Figure 29
Navajo saddle blanket, 1865–1875
Double, tapestry weave; handspun
commercial wool yarn and bayeta
126 × 69.5 cm.
Gift of Ginger Hyland

larger than half the double size. When double saddle blankets are illustrated in books such as this one or shown on a wall in a gallery or museum, we see them as two-dimensional images. This is quite distinct from their image when folded and used under a saddle. Navajo weavers were very aware of the design when seen in three dimensions (Baer 1998).

It is important to describe and illustrate two other forms of weaving produced during the Late-Classic period that might be confused with saddle blankets. The first and most common are small serapes, often called child's blankets (Fig. 30). These were described firsthand by Washington Matthews,

a military doctor (and collector) on the reservation in the early 1880s. Dr. Matthews described these weavings as "small or half size blankets made for children's wear. Such articles are often used for saddle blankets (although the saddle cloth is usually of coarser material) and are in great demand among the Americans for rugs" (Matthews 1884:387). The "Americans" were most likely soldiers or their families garrisoned on the western forts or Anglo settlers in the burgeoning towns of Santa Fe and Albuquerque, or even in California.

By 1880, the availability of cross-continental passenger trains gave rise to the beginnings of a curio

trade of objects from the American West; this trade catered to elements of late-Victorian decor—a curio corner or cabinet displaying intriguing items from other cultures. The small serapes Matthews describes were of very fine weave and often had much more complicated design elements, including central diamonds derived from the Saltillo, Mexico, designs used in Rio Grande blankets from northern New Mexico. They were far too thin and valuable to be used under saddles. They would have served well as small shoulder blankets for the Navajo, but their beauty and scale also made them desirable to travelers as authentic, easily portable souvenirs. They were often purchased by soldiers temporarily stationed in the West during the Indian Wars period and were taken home at the end of a tour of duty as emblems of contact with Native peoples. This accounts for numerous small serapes that have survived in remarkably good condition (Baer 1998).

The Late-Classic small serape (Fig. 30) from the Museum of New Mexico collection has an almost identical palette to the fringed saddle blanket shown in Figure 27, with very similar banded areas and chevron details in light and dark indigo blues and several rich, raveled reds. It is very finely woven and would offer little protective padding for a horse.

The other Navajo weaving of the period that might occasionally be confused with or even used in a pinch as a saddle blanket is the woman's dress half (Fig. 31). The dress halves are exactly the same size as the saddle blankets of the period and are made from the same materials, but they have very specific designs that are unlike the usual saddle blanket designs. These traditional garments are woven as two identical halves and are sewn together along the sides. Their designs typically feature a broad, dark-brown center band with red fields at each end and are decorated with rows of small diamonds or triangles in indigo blue centered within each red band. These were woven as traditional women's clothing and were

not collected by visitors in the same quantity as the child's blankets, probably due to their simplicity of design and lack of availability as trade items. Examples of the small serapes and dress halves are well represented in the museum's collections.

The limited number of nineteenth-century saddle blankets in the Museum of New Mexico collections are excellent examples of those woven at the time and provide a good representation of the styles of these functional pieces. Obviously, most of the saddle blankets from the nineteenth century were used on horses and may have lasted a year or two in daily use. We are fortunate to have any of these rare survivors to study and relish for their beauty. The period that follows the Late Classic, the Transitional, represents an explosion of color and pattern and the development of a new technique—the twill weave—that would become the basis for Navajo saddle blanket weaving for almost a hundred years.

REFERENCES

Amsden, Charles Avery. 1934. *Navajo Weaving: Its Technic and Its History*. Santa Ana, CA: Fine Arts Press.

Baer, Joshua. 1998. *The Last Blankets*. Santa Fe, NM: Joshua Baer and Company.

Kent, Kate Peck. 1985. *Navajo Weaving: Three Centuries of Change*. Santa Fe, NM: School of American Research Press.

Matthews, Washington. 1884. "Navajo Weavers." *Third Annual Report of the Bureau of American Ethnology*. Washington, D.C.: Smithsonian Institution.

Wheat, Joe Ben. 1984. *The Gift of Spiderwoman*. Philadelphia: The University Museum, University of Pennsylvania.

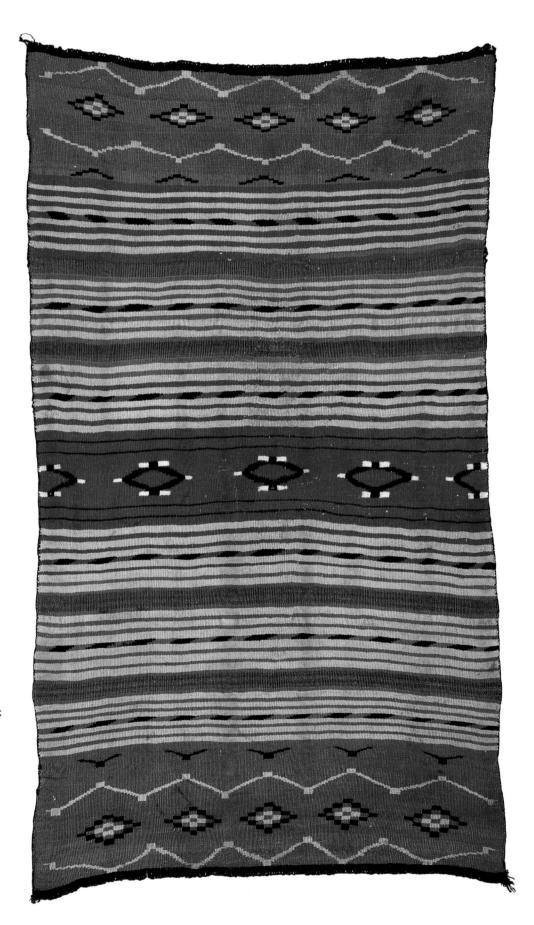

Figure 30

Navajo small serape,
ca. 1870–1880

Double, tapestry weave;
handspun, commercial wool
yarn and bayeta

141 × 81.5 cm.

Mrs. Phillip Stewart Collection;
courtesy of John and Linda
Comstock and the Abigail
VanVleck Charitable Trust

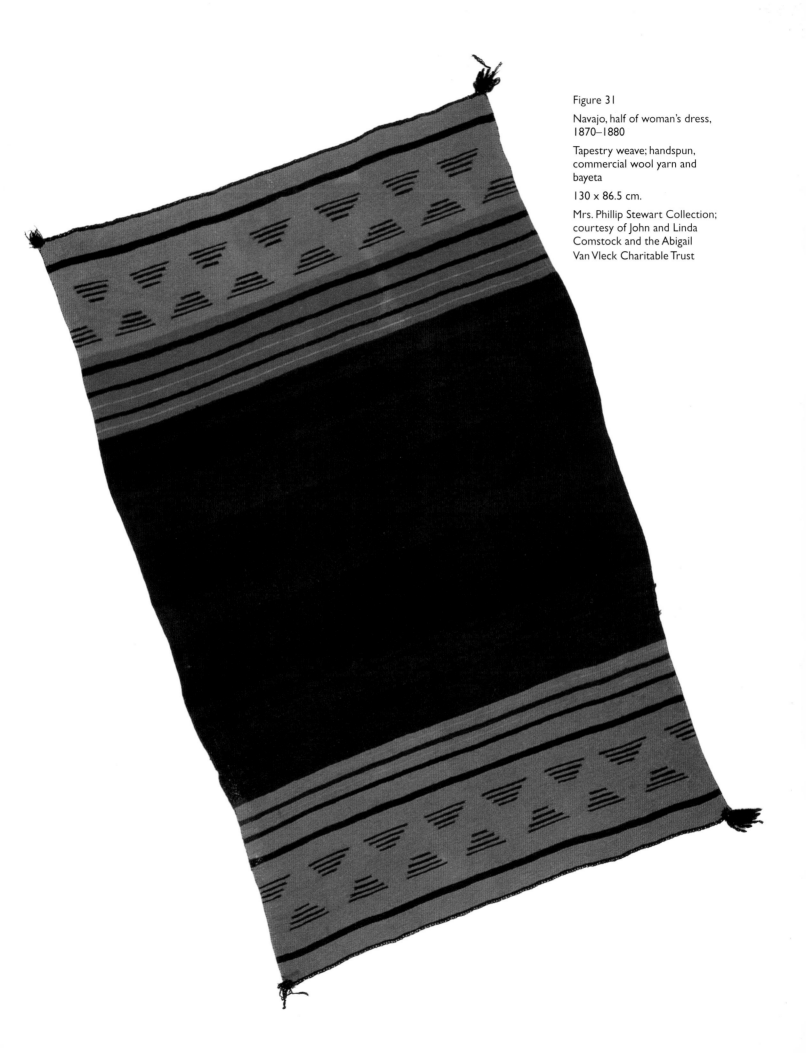

Figure 31

Navajo, half of woman's dress,
1870–1880

Tapestry weave; handspun,
commercial wool yarn and
bayeta

130 x 86.5 cm.

Mrs. Phillip Stewart Collection;
courtesy of John and Linda
Comstock and the Abigail
Van Vleck Charitable Trust

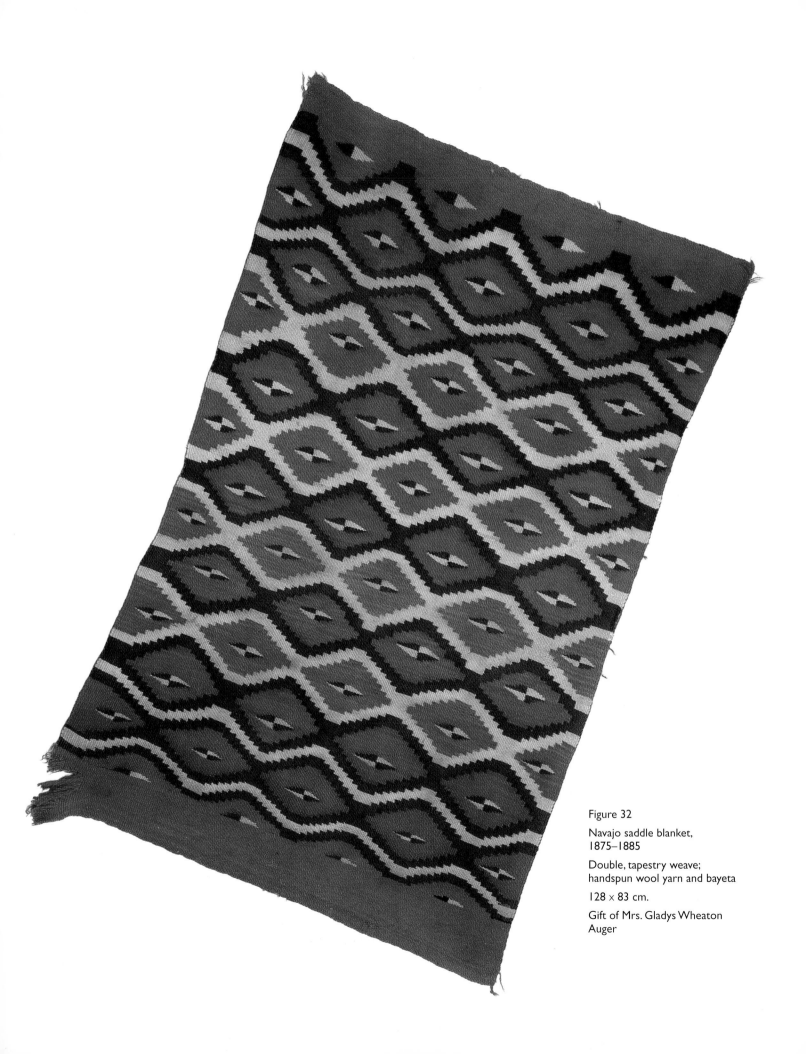

Figure 32

Navajo saddle blanket,
1875–1885

Double, tapestry weave;
handspun wool yarn and bayeta

128 × 83 cm.

Gift of Mrs. Gladys Wheaton
Auger

*L*ooking Backward, Looking Forward: The Transitional Fulcrum, 1868–1910

By Susan Brown McGreevy

THE TERM *Transitional period* refers to Navajo textiles produced during the late nineteenth century that do not conform to the earlier Classic, wearing blanket tradition (see Coulter) but have yet to develop into regional-style floor rugs (see Rodee, this volume). In this chapter, I discuss influences from Bosque Redondo that became integrated into the textile repertoire after the Navajo Reservation was established in 1868 and conclude with the date 1910, the year before publication of the J. B. Moore catalog of Navajo rugs. Saddle blankets play a prominent role in textiles produced during this period. However, transitional textiles were not woven in either a temporal or spatial vacuum. Looking backward, by 1870 Navajo weaving technology had existed for at least two hundred years, and as we shall see, some design elements found in transitional saddle blankets had Mexican and Rio Grande precursors. Looking forward, the production of the ever-useful saddle blanket persists in Navajo households even today.

THE SETTING

Perhaps no other period in Navajo history reveals as clearly the capacity of Navajo culture to adjust to change, to bend and never break, as does the period immediately following the return of the Navajos from the Long Walk (Roessel 1983:518).

Because the history of Navajo weaving so clearly reflects the history of the Navajo Nation, a brief mention of the events surrounding the "Long Walk" introduces this discussion.[1] When the federal government employed Colonel Kit Carson to subdue the Navajos, his mission was accomplished by a destructive, scorched-earth campaign. Lives were lost, crops destroyed, sheep herds decimated. In 1864, Carson led the Navajos on a forced march of three hundred miles to Bosque Redondo or Fort Sumner, where they were held in captivity for four traumatic years. Navajos refer to the place as *Hweeldi*, a word suggesting imprisonment and dread (Powers 2001:26).

This period of profound dislocation brought about a dramatic hiatus in the history of Navajo weaving since it effectively disrupted the Classic period (see Coulter); however, it also witnessed the introduction of new sources of designs and materials. Since the Navajos no longer had sufficient sheep to provide adequate raw material for weaving blankets, the government issued Rio Grande textiles. Many of these blankets featured angular serrate designs that had been influenced by Saltillo serapes woven in Mexico, which in turn had influenced design developments in Rio Grande blankets (see Coulter). These designs subsequently stimulated the development of new serrate configurations in Navajo textiles. In addition, three- and four-ply Germantown yarns superseded handspun wool. According to the late Joe Ben Wheat, an eminent Navajo weaving authority (personal communication, 1980), over seventy-five thousand pounds of Germantown yarns were issued to the Navajos between 1864 and 1878. Necessity became the mother of invention as these new external stimuli gradually became fused into the preexisting Navajo weaving tradition.

THE RESERVATION

In June 1868, a treaty was signed that established a reservation in northwestern New Mexico and northeastern Arizona. The Navajos returned to a land that had been acutely stressed. Former cornfields now yielded crops of weeds, orchards had been reduced to mere tree stumps, and most families had no livestock whatsoever. Although goats were the most important subsistence animals, since they provided milk and cheese as well as meat (Bailey and Bailey 1986:36–37), sheep had greater significance in everyday Navajo life. Prior to Bosque Redondo, churro sheep provided the raw material for producing a variety of household necessities. As one Navajo weaving authority has observed, "An integral part of daily life, weaving served to clothe the family, provide bed-

ding and horse blankets, and produce items for barter" (Hedlund 1996:51). Indeed, Navajo textiles were among the most prized trade items with Spanish and later, Mexican traders, as well as with other Native American groups. As Wheat observed, "By 1800 Navajo weaving was the most valuable product of New Mexico" (1977:13). Furthermore, Navajos believe that sheep were given to them by the Holy People (sacred beings). Even today, sheep are considered to be part of the family. Navajo women say, "Sheep is mother, sheep is life."

Among the terms of the Treaty of 1868 were provisions for the government to help the Navajos settle on the reservation and begin to rebuild their fragmented economy. In 1869, government distributions consisted of 14,000 sheep, 100 billy goats, and 900 nanny goats (Bailey and Bailey 1986:38). In subsequent years the herds increased rapidly. However, the sheep that were issued were the so-called improved merino breed. While merino sheep are a better source of meat, their fleece has a high lanolin content and therefore is more difficult to hand-process than that of the churro. As a result, the quality of Navajo weaving declined temporarily. Other annuity goods included Germantown yarns, indigo and *bayeta* yardage to be unraveled for wool, commercial dyes, and metal carding combs. In spite of the trauma resulting from the Bosque Redondo internment, Navajo women continued to weave.

TRADING POSTS

Almost as soon as they had resumed weaving, however, external events once again influenced the direction of Navajo weaving, and by the late nineteenth century, emphasis on handwoven garments for Indian use began to shift to a more commercial orientation. While this transition was partially the result of the aftermath of Bosque Redondo and the disruption of former trade routes and markets, the principal catalyst for change was the establishment

of Anglo-managed trading posts in various parts of the reservation beginning in the 1870s.[2] The Navajo words for trader and trading post—*naalyehe ya sidahi* (one who sits for merchandise) and *naalyehe ba hooghan* (merchandise, its home)—convey the commercial aspect of these stores; however, these unique places were not only mercantile centers but also important locations for Navajos from far-flung areas to socialize with relatives and friends.

The earliest traders in Navajoland primarily dealt in hides, pelts, and surplus livestock and only very occasionally would trade for a Navajo weaving. By 1875, as a result of a flourishing wool market, a few traders were buying Navajo wool for shipment to the east. With the arrival of the railroad in the 1880s, trading posts proliferated and came to dominate the Navajo economy. Navajo families brought in their wool in the spring, lambs in the fall, and weavings throughout the year, receiving, in turn, credit to buy a wide variety of household necessities: groceries, canned goods, and hardware. Trading posts also supplied factory-made woolen blankets. Fringed shawls for women and nonfringed blankets for men, produced by a mill in Pendleton, Oregon, soon became particularly highly prized by the Navajos.[3] The popularity of these commercial items soon obviated the need for Navajo women to weave wearing blankets.[4]

GERMANTOWN YARNS

At the same time, three- and four-ply, aniline-dyed Germantown yarns (see Reed), first issued by the U.S. government at Bosque Redondo, were later available to Navajo weavers through traders. Chemical or aniline dyes were invented in England in 1856 and shortly thereafter became popular in the United States as well. The yarn manufacturers in Germantown, Pennsylvania, were quick to adopt these new, cheaper dyestuffs. A sampler of Germantown yarns that was published by Marshall Field and Company of Chicago exemplifies the wide variety of available yarns.[5] Since the yarns came ready to use, they saved the weaver many hours of labor-intensive preparation. Most Germantown textiles were woven on commercial cotton-string warps, an additional time-saver. Furthermore, Germantown yarns were more regular in diameter than handspun, thus contributing to the technical perfection of these textiles (Kent 1985:77).

Like textiles woven before *Hweeldi*, the technique for Germantown styles was plain tapestry weave (for an analysis of weaving techniques, see Begay-Foss, this volume). However, these colorful yarns provided a new and vibrant palette for Navajo weavers. Outlined serrate diamonds and emphasis on vertical placement typify the influence of Saltillo/Rio Grande designs (Figs. 33, 34). Some weavers liked to experiment with visual and spatial relationships that created dynamic optical illusions, which became known as "eye dazzlers" (Fig. 35). Still other weavers preferred step-terraced designs that were reminiscent of earlier "chief"-style and serape designs (Fig. 32). These traditional patterns sometimes featured serrate elements as well. Trading posts also supplied a variety of packaged aniline dyes that many weavers used to achieve the same colorful palette found in Germantown yarns. Some saddle blankets woven with aniline-dyed handspun yarns feature designs that are similar to their Germantown counterparts (Fig. 36).

While most eye-dazzler textiles conform to the same general size as earlier wearing blankets, smaller weavings the size of saddle blankets also were produced. It would seem that Navajos in the late nineteenth century valued Germantown saddle blankets. Consider, for example, the following comments from the story of Old Man Hat: "After he [Old Man Hat] travels for several days to another family camp, an uncle gives him a 'double saddle blanket—a fancy blanket woven with Germantown yarn' . . . and an older clan sister presents him with another saddle

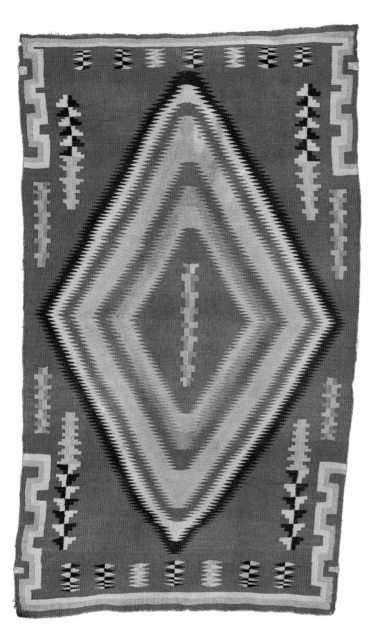

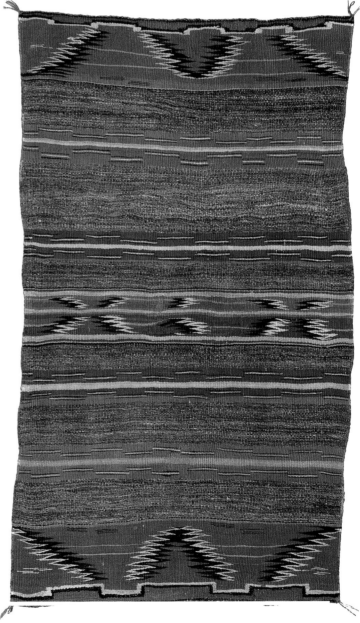

Figure 33

Navajo saddle blanket, 1880–1900

Double, tapestry weave;
Germantown yarn

129 × 77.5 cm.

Gift of Mrs. R. E. Twitchell; courtesy
of John and Linda Comstock and the
Abigail VanVleck Charitable Trust

Figure 34

Navajo saddle blanket, 1870–1880

Double, tapestry weave; handspun and
commercial wool yarn and bayeta

137.5 × 80 cm.

H. C. Yountz Collection; courtesy of
John and Linda Comstock and the
Abigail VanVleck Charitable Trust

Figure 35,

Navajo saddle blanket,
1880–1890

Double, tapestry weave;
Germantown yarn

119.4 × 78.7 cm.

Mrs. Phillip Stewart
Collection; courtesy of
John and Linda Comstock
and the Abigail VanVleck
Charitable Trust

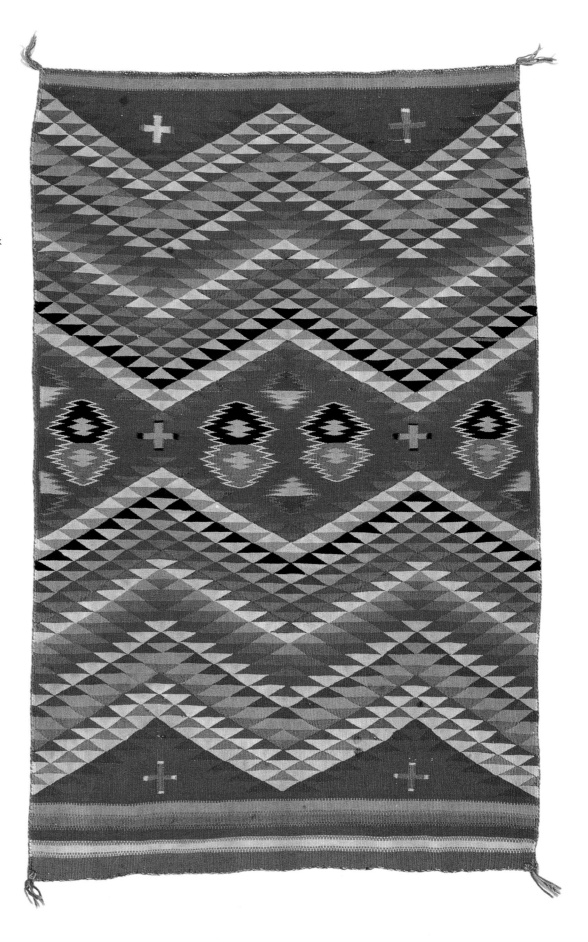

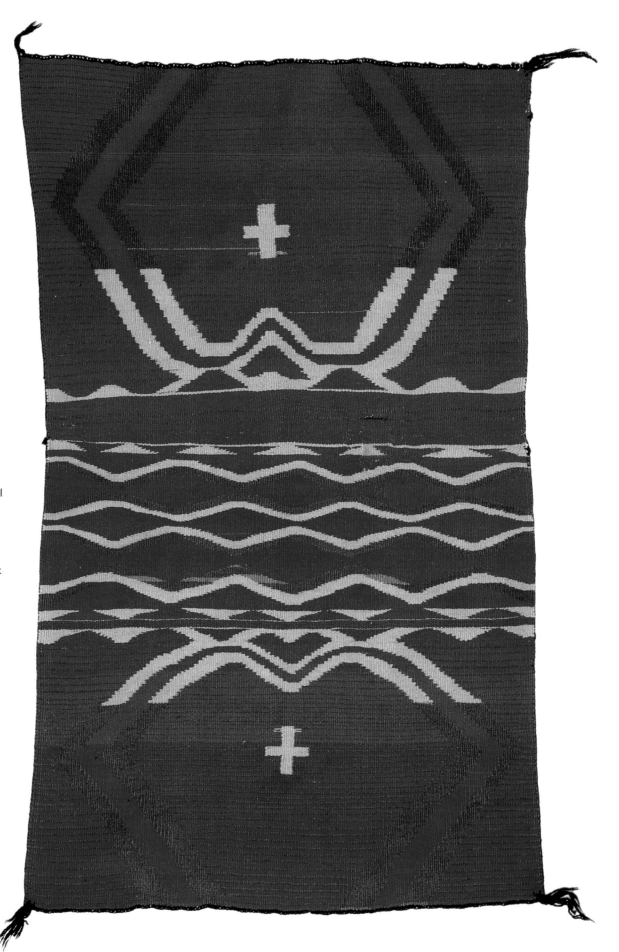

Figure 36

Navajo saddle blanket,
1860–1880

Double, tapestry weave;
handspun and commercial
wool yarn

127 × 81.3 cm.

Mrs. Phillip Stewart
Collection; courtesy of
John and Linda Comstock
and the Abigail VanVleck
Charitable Trust

blanket with 'pretty designs that she had woven herself'" (Dyk 1966:317, 319). These decorative saddle textiles sometimes were embellished with colorful fringes and tassels (Figs. 37, 38). The Franciscan fathers observed that "wooden needles (made of rosebush) were used to sew selvedge [fringe] and tassels on saddle blankets" (Franciscan Fathers 1910:309). The Anglo-American terms *Sunday saddle blanket* and *Sunday saddle throw* reflect our understanding that these colorful textiles were used for special occasions (Figs. 39, 40, 41). Rather than being placed under the saddle, like more utilitarian versions, these unique blankets were thrown over the saddle so that the design and fringe would show to

best advantage. Most of these elaborate throws were smaller than regular saddle blankets, with lengths (warp) and widths (weft) ranging from about twenty-five to thirty-six inches. Because their use was decorative rather than utilitarian, Sunday saddle blankets were never produced in great quantity, and examples are exceedingly rare.

Since saddle blankets obviously are made as horse gear, it is relevant to note that horses have played an important role in Navajo life since they were introduced by the Spanish and continue to be highly valued even today. They are used for transportation, herding sheep, and participating in rodeos. In addition, large horse herds confer prestige

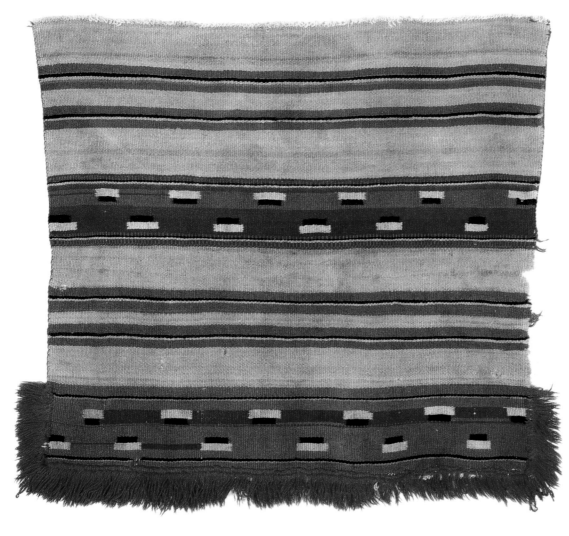

Figure 37

Navajo saddle blanket fragment, 1880–1900

Double, tapestry weave; handspun wool yarn

78 x 68.5 cm.

Gift of Hugh Bryden McGill; courtesy of John and Linda Comstock and the Abigail VanVleck Charitable Trust

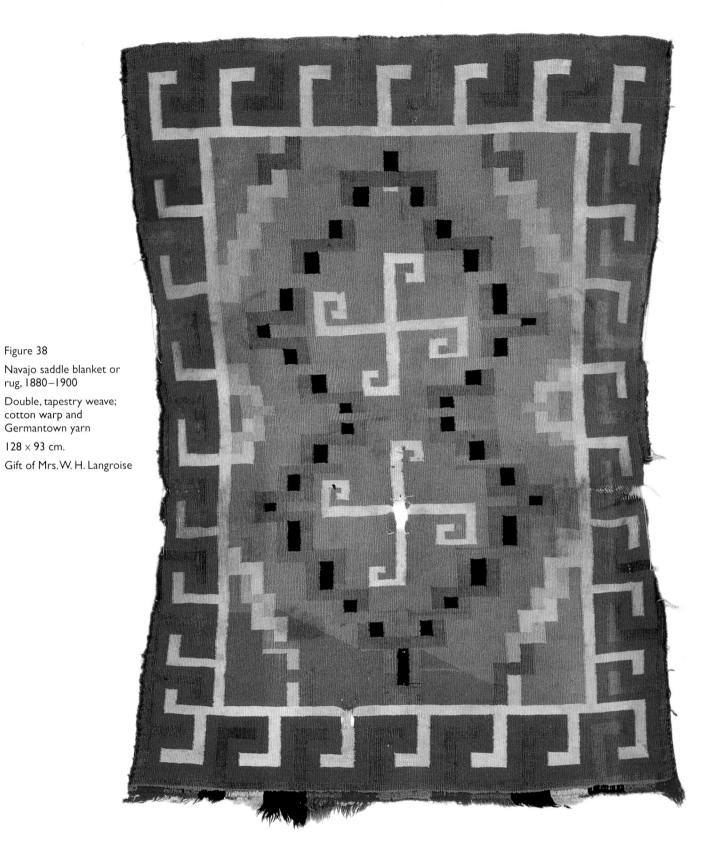

Figure 38

Navajo saddle blanket or
rug, 1880–1900

Double, tapestry weave;
cotton warp and
Germantown yarn

128 × 93 cm.

Gift of Mrs. W. H. Langroise

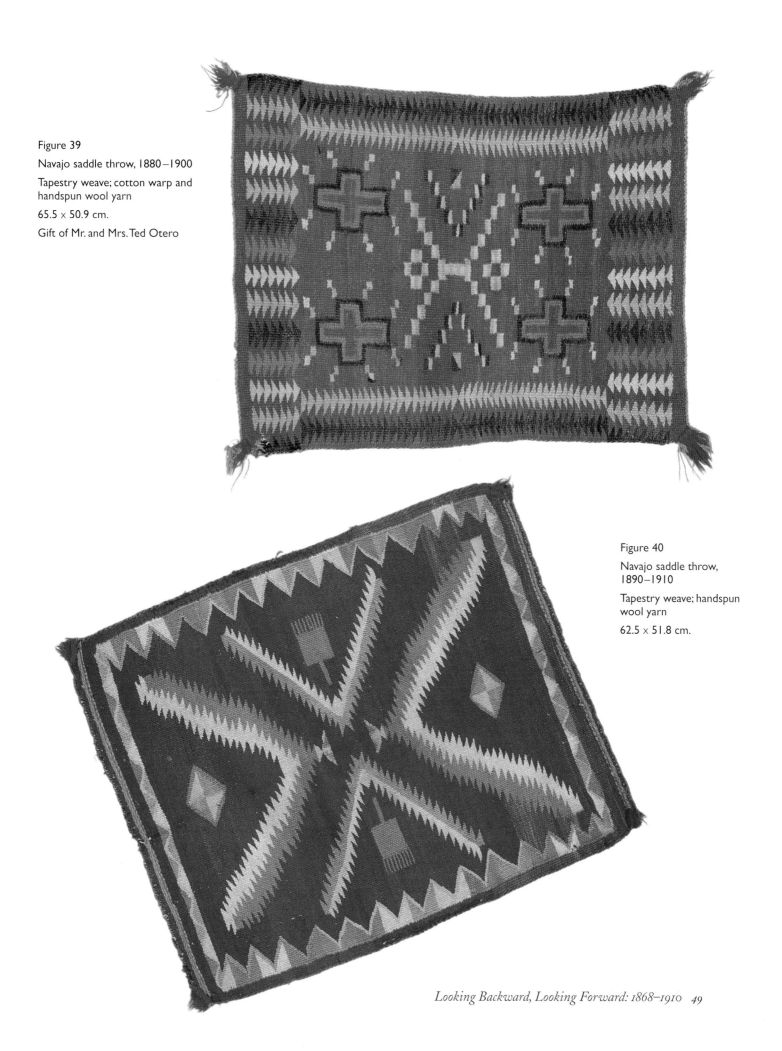

Figure 39
Navajo saddle throw, 1880–1900
Tapestry weave; cotton warp and handspun wool yarn
65.5 × 50.9 cm.
Gift of Mr. and Mrs. Ted Otero

Figure 40
Navajo saddle throw, 1890–1910
Tapestry weave; handspun wool yarn
62.5 × 51.8 cm.

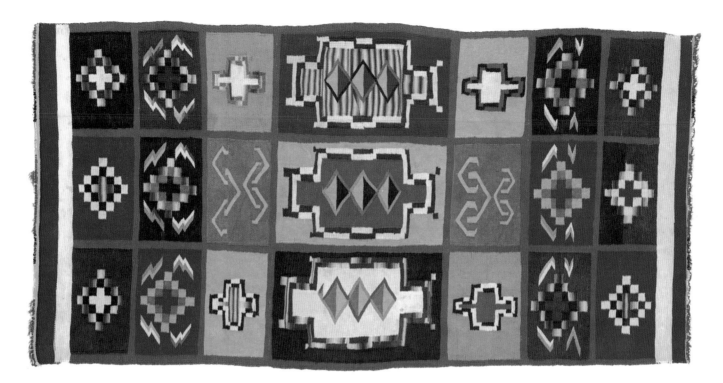

Figure 41

Navajo saddle blanket, 1880s

Double, tapestry weave; cotton warp, Germantown yarn

152.5 × 77.5 cm.

H. C. Yountz Collection; courtesy of John and Linda Comstock and the Abigail VanVleck Charitable Trust

and status on their owners. Thus, elegant horse trappings such as Navajo-made silver bridles, decorative woven cinches (Fig. 44), and fancy saddle blankets honor the horse and accentuate the owner's wealth. Several Navajo ceremonies, most particularly the Blessingway, include references to horses or to their owners. As one Navajo man observed, "The objects to be blessed were brought in: [saddle] blankets, bridles, saddles" (Oakes, Campbell, and King 1969:45).[6]

Germantown blankets and saddle blankets also appealed to Anglo-Americans. During the late nineteenth century, trains brought goods and tourists to Indian country, and the tourists brought dollars.[7] While traders and curio dealers took advantage of the tourist market, they also began to aggressively pursue commerce on the East Coast and in the Midwest. From about 1880 to 1920, sales of Native

American art were stimulated by a phenomenon known as the "Indian Room" (or den, or corner). Disenchantment with industrialized society and a concomitant desire to recreate a natural, traditional environment led some wealthy collectors to create a space decorated exclusively with Indian arts. This utopian ideal served as an exotic escape from mechanized modernity, "a quintessential equation with the 'pre-modern'" (Cahodas 1997:5). There seemed to be an assumption that "no well-appointed home was

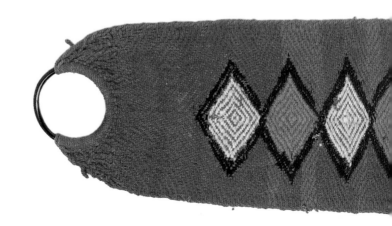

without its Indian den, or at least an Indian corner" (Alliot 1905:71). In particular, the romantic image of the Southwest—its compelling landscapes, quaint and picturesque peoples, and rich repertoire of Indian arts—served as an inspiration for creating the nostalgic, synthetic experience of the Indian Room.

Navajo Germantown textiles were featured prominently on the floors and walls of toney interiors as well as displayed in more modest settings. For a period of time, Germantown weavings, including saddle blankets, were among the most popular collectibles. For example, C. N. Cotton, who once was a partner of Lorenzo Hubbell and subsequently owned a Navajo rug and silver wholesale business in Gallup, New Mexico, issued a sales catalog in 1896 that featured "Fancy Saddle Blankets . . . about 33 x 50 inches. Made from fine Germantown yarn with scarlet ground with rich designs in contrasting colors . . . These are woven so closely there is practically no wear out to them . . . and it is a good three months task to begin and complete one. The material also is

Figure 42. C.N. Cotton catalog, 1896. Photograph b G. Warton James.

expensive; hence the prices are high . . . $5.00, $8.00, $10.00 and $12.00 each" (Williams 1989:67).

The trend of decorating homes with Indian art that began in the late nineteenth century has continued into the present time, particularly in locations such as Santa Fe, Phoenix, and Denver, where a strong patronage continues. Germantown textiles

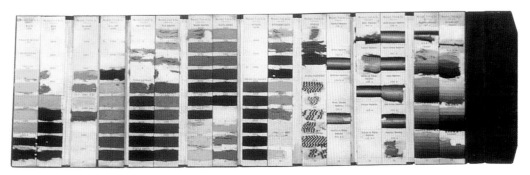

Figure 43. Germantown yarn sample card. Courtesy University of Pennsylvania Museum.

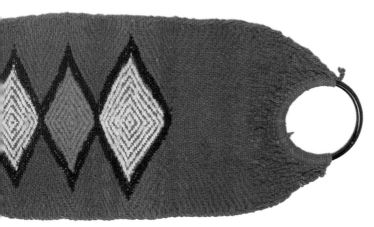

Figure 44. Navajo cinch, 1890–1913. Twill weave; handspun wool yarn. 70 x 18.5 cm.

Gift of J. G. McNary

were never numerous and today are even rarer. As a result, they have reached prices of staggering proportions. Even so, they are avidly sought by Navajo textile cognoscenti.

TWILL WEAVES AND PLAIN WEAVES

The Germantown yarn period was short-lived, lasting only about thirty years. It was superceded by the development of the regional-style Navajo rug when traders discovered that their clientele preferred muted dyes and/or the natural colors of sheep wool (see Rodee, this volume).[8] While these new-style rugs were for sale at most trading posts, and later at galleries and other shops featuring Indian art, some traders also continued to carry saddle blankets throughout the twentieth century. While the regional-rug period focused on markets outside Navajoland, saddle blankets were woven primarily for a Navajo market. Because they were needed by Navajo families that owned horses, saddle blankets produced during the twentieth century remained a salient example of Navajo textiles that continued to be woven for Navajo use (see Rodee). During the same time period as the Germantowns, some weavers produced saddle blankets using plain tapestry weave of handspun natural wool, incorporating simple designs (Figs. 7, 46, 47). Many of these blankets appealed to cowboys and other horseback riders. For example, the C. N. Cotton catalog advertised that "Common Navajo Saddle Blankets . . . folded, make fine saddle blankets, and in case of emergency can be used at night to sleep in . . . Regular Navajo Saddle Blankets . . . are pronounced by the cowboys all over the West to be the best blanket ever put under a saddle . . . They also make very pretty rugs and are often used for this purpose" (Williams 1989:65). Then too, the availability of synthetic dyes gave rise to bright, intricate patterns that

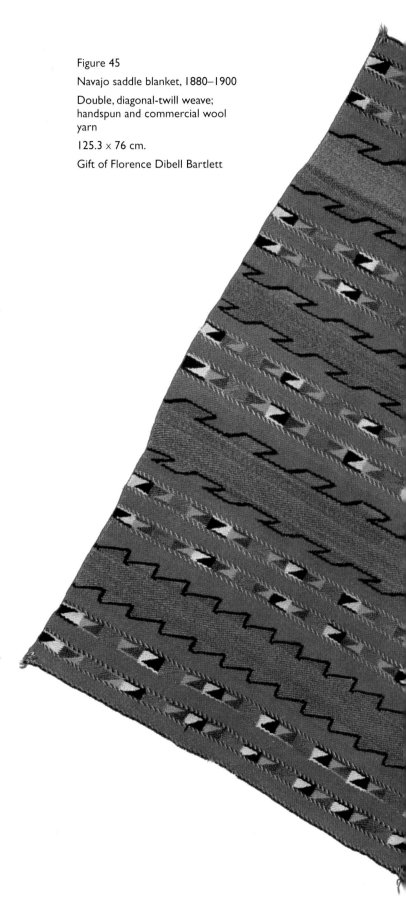

Figure 45

Navajo saddle blanket, 1880–1900

Double, diagonal-twill weave; handspun and commercial wool yarn

125.3 x 76 cm.

Gift of Florence Dibell Bartlett

Figure 46
Navajo saddle blanket, 1880–1900
Double, diagonal-twill weave; handspun wool yarn
119.5 × 74 cm.
Mrs. Phillip Stewart Collection

Figure 47

Navajo saddle blanket or rug,
1890–1900

Double, tapestry weave; cotton
warp and Germantown yarn

122 × 86.4 cm.

Gift of M. J. Golberg

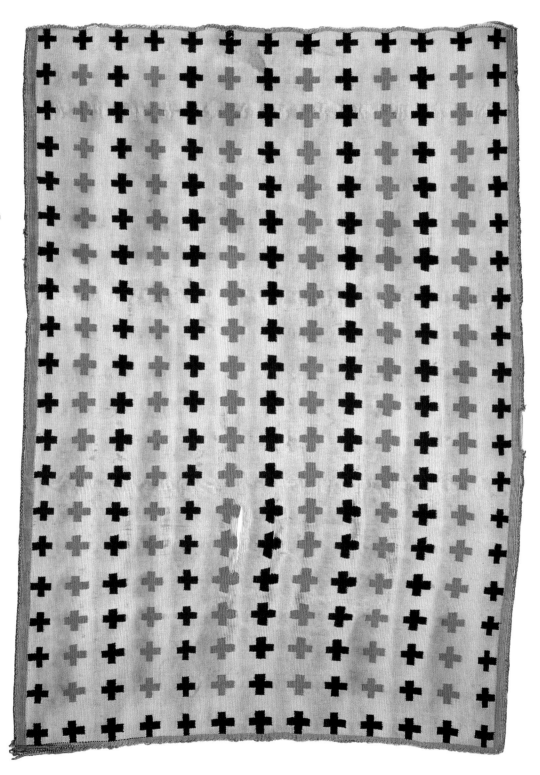

were reminiscent of the eye-dazzler period (Fig. 48). Some weavers simplified their task by leaving the center of the textile devoid of design, since it was the part that would fit under the saddle and therefore not be visible to either rider or viewer (Fig. 50).

Another unusual type of weaving seems to have made its appearance during the Transitional period: the two-faced textile, so-called because it features two entirely different designs on the two surfaces. Most examples are rug size, but a few saddle blankets also were woven in this style. Even though it is made with typical weft-faced tapestry weave, the process requires a complicated manipulation of four heddles. Since there is no precedent for this technique either in prehistoric or historic Pueblo weaving, as Kate Peck Kent observed, "The origin of the technique among the Navajos is something of a mystery However, it is familiar to Anglo-American weavers, and may have been taught to a Navajo woman by one of them" (Kent 1985:82). In any event, the first written account of these unique textiles was reported by Washington Matthews: "An important new invention has been made or introduced—a way of weaving blankets with different

Figure 48
Navajo saddle blanket, 1890–1910
Double, tapestry weave; cotton warp and handspun wool yarn
115 × 80.5 cm.
Gift of Florence Dibell Bartlett

Figure 49

Navajo saddle blanket,
1875–1885

Double, tapestry weave;
Germantown yarn

138 x 89 cm.

Gift of William C. Ilfeld

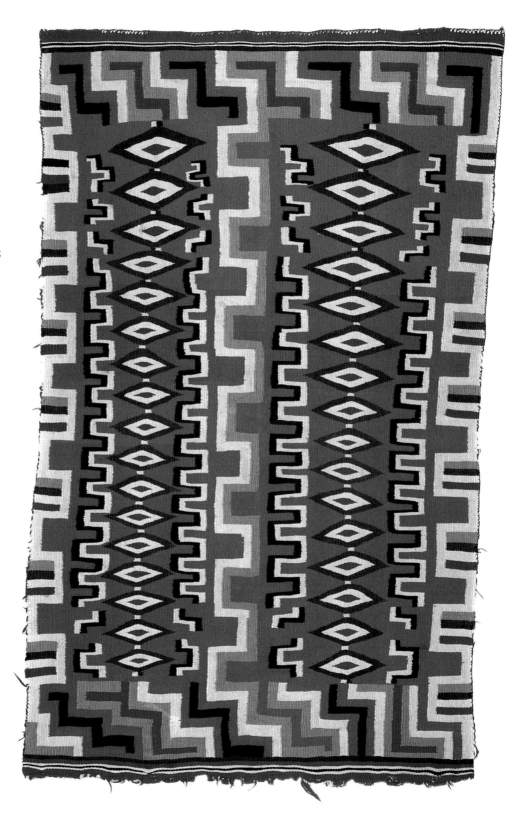

Figure 50

Navajo saddle blanket, 1910–1920

Double, tapestry weave; cotton warp and
handspun wool yarn

130.5 x 84 cm.

Gift of Albert B. Bartlett and
Dr. and Mrs. Lawrence K. Lunt

designs on both sides" (Matthews 1897).[9] Moreover, in a letter dated 27 January 1897, the trader Thomas V. Keam wrote the following response to his friend Matthews:

> As you supposed, it [has been] only about three years since I first saw this work . . . the double or reversible weaving I believe to be their own [Navajo] as I know of no other tribe who does such weaving" (Halpern 1985, Roll 1f: 467–468).

Archaeological textile fragments and written references in early Spanish chronicles indicate that at some point during the late seventeenth or early eighteenth century, the Navajos learned the technique of plain tapestry weave from the Pueblos and also the more complicated twill-weaving method (see Begay-Foss, this volume). It was during the Transitional period that twill weaving became increasingly common. The reasons for the proliferation of these pieces toward the end of the century are not entirely clear.

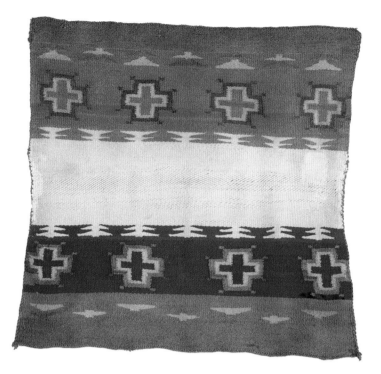

The incentive may have been partly due to a desire among some Navajo weavers to continue weaving textiles for Navajo use rather than for an outside market. It also seems possible that many weavers enjoyed the challenge of mastering this difficult technique. Then too, weavers must have been aware that twill-woven fabrics are thicker and sturdier than those made with plain weave and thus are eminently suited for rough wear and tear. Textiles woven between 1870 and 1890 sometimes have tapestry-woven designs on twill backgrounds (Kent 1985:80; see Fig. 51). All twill-weave textiles can be found on both single and double saddle blankets, with double saddles often featuring two different twilled patterns.

Twill-weave saddle blankets made at the turn of the century frequently incorporated beautiful patterns of nested diamonds executed in natural wool or with soft colors achieved by the judicious use of commercial dyes. Fringes can be found on several twill pieces in the Museum of Indian Arts and Culture collection. One fringed example features a

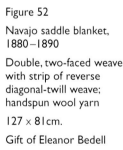

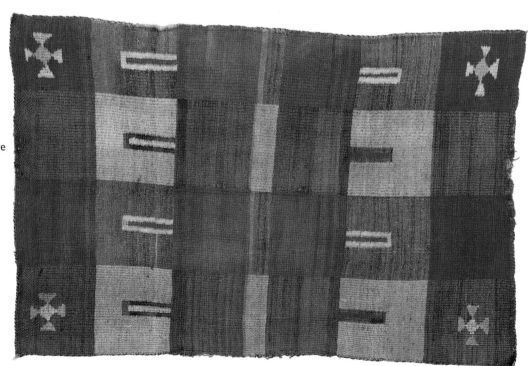

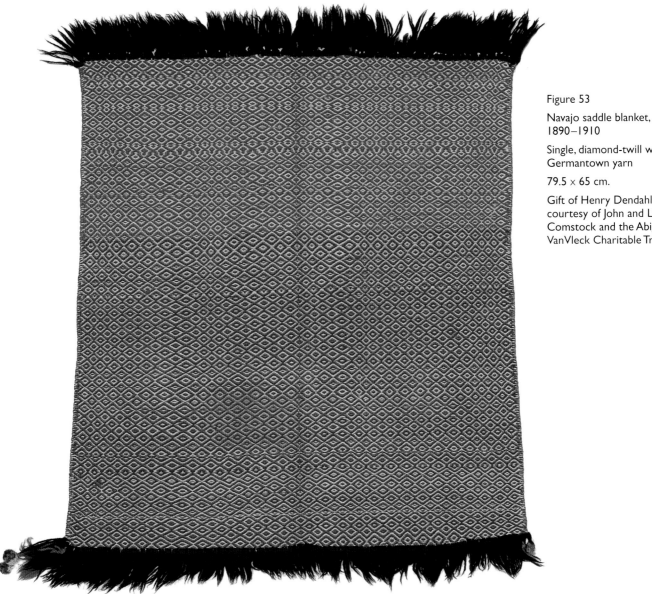

Figure 53

Navajo saddle blanket,
1890–1910

Single, diamond-twill weave;
Germantown yarn

79.5 × 65 cm.

Gift of Henry Dendahl;
courtesy of John and Linda
Comstock and the Abigail
VanVleck Charitable Trust

constellation of diamond-twill patterns that is particularly stunning (above). Perhaps these diamond twills with fringes were used as Sunday saddles like their Germantown counterparts. In any event, the textile vocabulary of diamond-twill weaves has many rich variations on the theme. It also seems that the more-fluent weavers were able to produce more-intricate designs.

Even though saddle blankets were made for Navajo use, they also had market appeal; this is clear from the C. N. Cotton example above (Williams 1985:65). Furthermore, as a well-known weaving authority, the late Kate Peck Kent, observed about twill weaves, "The thick twill-weave saddle blankets made excellent small rugs and they were purchased by Anglo-Americans for this purpose after 1900" (Kent 1985:80). Perhaps some of the attraction was the very fact that these textiles were among the very

few objects that were made by Navajos for Navajo use.[10] However, not all Anglo-Americans found diamond twills pleasing; in fact, the Franciscan fathers found them rather curious: "This weave has a very peculiar appearance: the whole blanket seems to consist of diamond shaped fields inside of which are diamond shaped figures . . . [it] too depends on the number of healds [sheds] used, and is mostly employed for making saddle blankets" (Franciscan Fathers 1910:243–244). Although the fathers clearly understood the technique, they seemed unimpressed with the aesthetic merits of diamond-twill weave.

Conclusion

We have seen the ways in which Transitional-period saddle blankets look backward: the techniques of plain tapestry weave and twill weave had been well established before Bosque Redondo. Navajo textiles began looking forward with the invention of the Germantown eye dazzler, even though some design characteristics found on Sunday saddles and throws derived from earlier serrate influences. Nonetheless, these singular weavings represented a visual configuration that was new and unique. Twill-weave saddle blankets made at the turn of the twentieth century predicted the persistence of these Navajo-made for Navajo-use textiles until the present time. While most Navajo weavings leave the Navajo Nation, saddle blankets continue to hold a special place within Navajo households. Navajo weavers have always integrated new ideas, styles, and designs into their textiles, translating them into a distinctive Navajo idiom. Unfortunately, throughout much of the history of Navajo weaving, the weavers have been anonymous, so for the most part, we will never know the names of those persons who made the textiles featured in this book.[11]

In 1881, Washington Matthews observed, "With no other native tribe in America . . . has the art of weaving been carried to a greater perfection than among the Navajos" (Matthews 1884:371). The best transitional saddle blankets, whether woven of handspun or Germantown yarns or with plain tapestry weave or twill weave, reflect this excellence in microcosm. Saddle blankets also speak volumes about Navajo culture: women's roles as keepers of sheep and weavers of their wool, men's roles as keepers of horses and users of saddle blankets.[12] This balance of male and female roles was established in the Navajo origin narrative and continues to shape Navajo values even today.

Notes

1. There have been numerous books and articles written about the Long Walk and Bosque Redondo for readers who wish to learn more.

2. With the exception of Hubbell's Trading Post in Ganado, Arizona, posts were not owned by the trader but rather were licensed from the U.S. government to provide goods and services to the Navajos.

3. Many museum curators in the Southwest have had the following experience: a person calls to request that the curator look at a "genuine" Navajo textile that he/she has just bought from a Navajo who was wearing it. Invariably, the piece turns out to be a Pendleton blanket.

4. Other goods sold at the trading post were bolts of velveteen and calico fabrics that were used to make the blouse and skirt considered to be the Navajo woman's traditional dress. However, the style is an adaptation of Victorian clothing worn by army wives at Bosque Redondo. Prior to this, the Navajo woman's dress was a two-piece woven garment, the *biil* (see Coulter).

5. The photograph of the Germantown sample card has been generously provided by the University of Pennsylvania Museum. The card was given to the university by Andrew Nagen, who rescued it from a

trash can at The Original Trading Post, a shop in Santa Fe.

6. The story of a Navajo man, Jeff King, as told to Maude Oakes, a scholar of Navajo ceremonialism, is part of the chronicle, *Where the Two Came to Their Father*.

7. Perhaps the single most influential business venture in the Southwest was the Fred Harvey Company, founded in 1876 to establish eating places and later, dining cars for the Santa Fe Railway. Beginning in 1900, displays and sales of Indian art were featured at railroad stations and Fred Harvey hotels throughout the route under the leadership of Herman Schweitzer, president of the Fred Harvey Company Indian Department. Schweitzer was so knowledgeable about Indian art that he became known as the "Harvey Anthropologist" (Howard 1996:87).

8. The exception to the use of colors found in natural sheep's wool was a red aniline dye provided by J. B. Moore at Crystal and Lorenzo Hubbell in Ganado. In fact, the proliferation of red designs in Hubbell rugs gave rise to the term *Ganado Red*.

9. Dr. Washington Matthews was an army surgeon posted at Fort Wingate (now in New Mexico) from 1880–1884 and again from 1890–1894. He was the first outsider to conduct intensive research among the Navajo, and his work remains a significant resource to all serious students of Navajo culture.

10. The other object that continues to be Navajo made for Navajo use is the ceremonial basket.

11. There were a few exceptions to this anonymity. One weaver, Ellie Ganado, demonstrated at the Grand Canyon and other Fred Harvey venues and for this reason became well known to tourists visiting the area. In his 1911 catalog, J. B. Moore referred to some weavers by name and included photographs of a few.

12. Some Navajo women also are excellent horseback riders; nonetheless, there are many more male than female riders.

REFERENCES

Adams, William Y. 1963. *Shonto: A Study of the Role of the Trader in a Modern Navaho Community*. Bureau of American Ethnology Bulletin 168. Washington, DC: Smithsonian Institution.

Alliot, Hector. 1905. "Primitive Art in California." *Los Angeles Examiner*, November 12.

Bailey, Garrick, and Roberta Glenn Bailey. 1986. *A History of the Navajos, The Reservation Years*. Santa Fe, NM: School of American Research Press.

Cahodas, Marvin. 1997. *Basket Weavers for the California Curio Trade*. Tucson: University of Arizona Press and the Southwest Museum, Los Angeles.

Dyk, Walter (recorder). 1966. *Son of Old Man Hat, A Navaho Autobiography*. Lincoln: University of Nebraska Press.

Franciscan Fathers. 1910. *An Ethnologic Dictionary of the Navajo Language*. St. Michaels, AZ.

Halpern, Katherine Spencer, ed. 1985. *Guide to the Microfilm Edition of the Washington Matthews Papers*. Albuquerque: University of New Mexico Press, in cooperation with the Wheelwright Museum of the American Indian, Santa Fe.

Hedlund, Ann Lane. 1996. "More Survival Than an Art: Comparing Late-Nineteenth and Late-Twentieth Century Lifeways and Weaving." In Eulalie H. Bonar, ed., *Woven By Grandmothers: Nineteenth-Century Navajo Textiles from the National Museum of the American Indian*. Washington, D.C.: Smithsonian Institution Press.

Howard, Kathleen L. 1996. "'A Most Remarkable Success': Herman Schweitzer and the Fred Harvey

Indian Department." In Marta Weigle and Barbara A. Babcock, eds., *The Great Southwest of the Fred Harvey Company and the Santa Fe Railway.* Phoenix, AZ: The Heard Museum.

Kent, Kate Peck. 1985. *Navajo Weaving: Three Centuries of Change.* Santa Fe, NM: School of American Research Press.

Matthews, Washington. 1897. "Navaho Legends." The American Folklore Society, Memoir 5. Boston, MA: Houghton Mifflin.

_____.1968 [1884]. "Navajo Weavers." Bureau of [American] Ethnology, Third Annual Report for 1881–1882. Washington, D.C.: Smithsonian Institution. Reprint, Palmer Lake, CO: Filter Press.

Moore, J. B. 1987. *United States Indian Trader, A Collection of Catalogs Published at Crystal Trading Post 1903–1911.* Albuquerque, NM: Avanyu Publishing, Inc.

Oakes, Maude, Joseph Campbell, and Jeff King. 1969 [1943]. *Where the Two Came to Their Father.* Bollingen Series 1. Princeton, NJ: Princeton University Press.

Powers, Willow Roberts. 2001. *Navajo Trading: The End of an Era.* Albuquerque, NM: University of New Mexico Press.

Roessel, Robert, Jr. 1983. "Navajo History, 1850–1923." In *Handbook of North American Indians,* Vol. 10: *Southwest,* ed. Alfonso Ortiz. Washington, D.C.: Smithsonian Institution.

Wheat, Joe Ben. 1977. "Patterns and Sources of Navajo Weaving." In *Patterns and Sources of Navajo Weaving,* ed. W. D. Harmsen. Denver, CO: Harmsen Publishing Company.

Williams, Lester L. 1989. *C. N. Cotton and His Navajo Blankets.* Albuquerque, NM: Avanyu Publishing, Inc.

4
Twentieth-Century Navajo Saddle Blankets

By Marian E. Rodee

THE PROCESS OF CULTURE CHANGE greatly accelerated with the railroad's arrival in the Southwest in 1880–1881, delivering larger quantities of goods from the East Coast. Traders marketed weaving as rugs for the home, and this coincided with an increased thickness and heaviness in textiles of the 1890s, the so-called pound blanket era. Families were unable to sell their raw wool at the posts because of a national depression that caused a collapse in the wool market. From the time they were settled on the reservation, the Navajo were subject to all the vagaries of the American economy. Each trading post drew customers from an area within easy travel by horse or wagon. As traders made suggestions to Navajo weavers about the style of rugs they preferred, those living in the region began to weave in those styles and colors; the name of the post was given to the weaving style of those who traded there. On maps it is helpful to see where mountain ranges interrupt travel and where valleys lie to fully understand the regional styles that emerged. The history of twentieth-century rug weaving is about the development of regional styles, through cooperation between traders and Navajo weavers, but saddle blankets have been largely left out of this documented history. While rugs were heavily influenced by and developed for an outside market, saddle blankets had a more local interest, both to the Navajo and other tribes and to western cowboys and ranchers. Saddle blankets are plain and utilitarian, made to look attractive under a saddle and, more important, to keep the saddle from rubbing the horse. They had many other uses too, but only occasionally does a blanket reflect one of the regional rug styles discussed here that represent the main trends in twentieth-century Navajo weaving.

Several early traders exerted their influence on Navajo weaving to produce more salable products for Anglo-Americans. One of these was J. B. Moore of Crystal, New Mexico, who settled at the top of Cottonwood Pass, an area with many Navajo families and good silversmiths; another was John Lorenzo Hubbell of Ganado, Arizona.

J. B. MOORE AND HIS CATALOG
Moore bought an already existing post in 1896 and

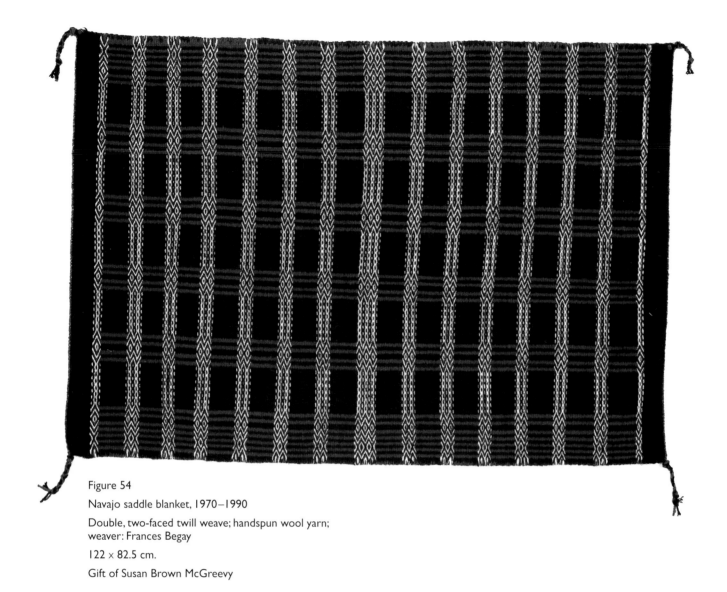

Figure 54

Navajo saddle blanket, 1970–1990

Double, two-faced twill weave; handspun wool yarn;
weaver: Frances Begay

122 x 82.5 cm.

Gift of Susan Brown McGreevy

set about to improve business. Since posts were founded at the request of the Navajo and not for the convenience of the trader, it was sometimes difficult to find markets for the materials the Navajo brought in. Crystal was rather remote from the railroad, and Gallup, New Mexico, was the closest Anglo town. Moore decided to try a marketing tool common in turn-of-the-century America, the mail-order catalog. In a series of single sheets and two catalogs (1903 and 1911), he illustrated and priced rugs that could be purchased and mailed to other parts of the United States. Apparently, the bright dyes and intricate patterns of the Germantown or "eye-dazzler" period were out of favor. Moore says that he and his wife personally supervised preparation of the wool,

including sending it to a scouring plant for cleaning (Moore 1911:54), and when it was returned, they supervised spinning the wool and dyeing it with superior dyes. He says in his 1903 catalog: "I have no purples, magentas, browns, etc. to send any one. Faulty colors make inferior blankets, and all second and first grades will be in good and perfect colors" (Moore 1903:23).

Although many other dealers put out catalogs to sell Navajo goods, his was the largest and most elaborate. Moore was also the first to actively sell the romance of the Southwest with photos of the landscape, hogans, and especially the weavers, giving their names and the patterns they had designed. It is these patterns that are most innovative, especially

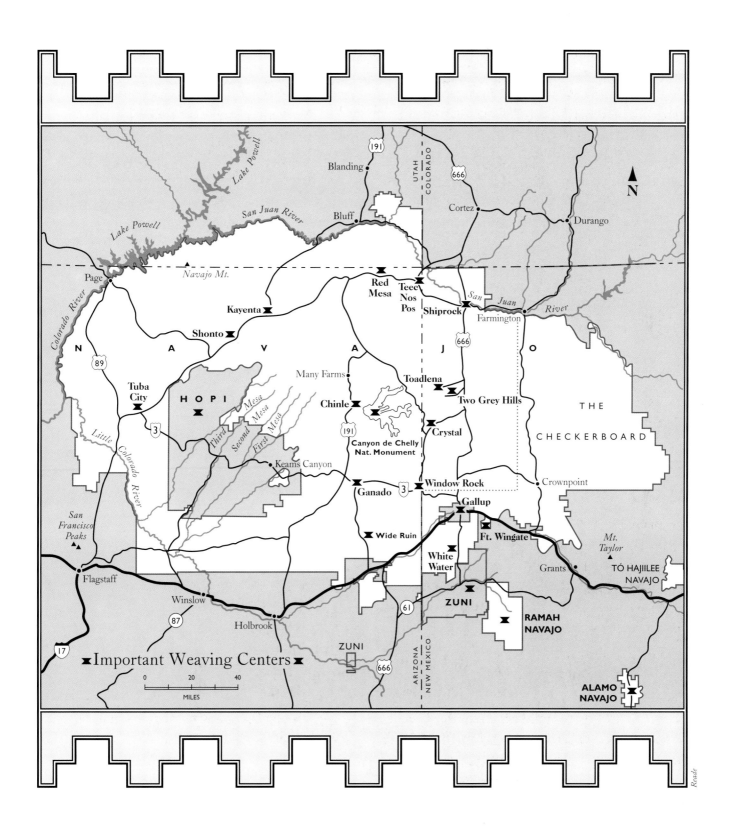

Important Weaving Centers

Blanding · 191

UTAH
COLORADO

Cortez · · Durango

666

Lake Powell

San Juan River

Bluff ·

Lake Powell

Page ·
Colorado River

Navajo Mt.

Red Mesa · Teec Nos Pos
Shiprock · *San Juan River*
Farmington

Kayenta

Shonto
89

N A V A J O

666

Tuba City
3

HOPI

Little Colorado River

Third Mesa
Second Mesa
First Mesa

Many Farms ·

Toadlena
Two Grey Hills

Chinle
191

Crystal

Canyon de Chelly Nat. Monument

THE
CHECKERBOARD

Keams Canyon ·

Ganado
3

Window Rock

Crownpoint ·

San Francisco Peaks ▲

Wide Ruin

Gallup
Ft. Wingate

Mt. Taylor ▲

Flagstaff ·

White Water

Grants ·

TÓ HAJIILEE
NAVAJO

Winslow ·
87

61

ZUNI

RAMAH
NAVAJO

17

Holbrook ·

ZUNI

666

ARIZONA
NEW MEXICO

ALAMO
NAVAJO

Important Weaving Centers

0 20 40
MILES

Reade

those in his 1911 catalog. Many have elaborate borders and large, centrally organized motifs with elaborate hooks and smaller designs in the four corners. This was in marked contrast to the banded or striped layout of older Navajo textiles. These patterns bear a definite relationship to oriental rugs, especially the kilims or flat weaves of tribal peoples in Turkey and Iran with whom they shared a similar type of loom. Oriental rugs had long been popular in American homes, and many machine-made copies were purchased by less well-off Americans.

The patterns in the catalog apparently became popular, for they were soon seen at Two Grey Hills, just north of Crystal but along the valley floor. Ed Davies and George Bloomfield of the neighboring posts of Toadlena and Two Grey Hills worked with their weavers to refine and improve the quality of their rugs, actually getting down on the floor of the post and going over flaws in the rugs. The weavers in this area had a natural dislike of red and other bright colors and preferred natural sheep colors of black, white, brown, beige, and gray. Pottery shards from ancient Pueblo sites scattered throughout the valley provided motifs for borders, while the oriental motifs promoted by Moore at Crystal formed the central patterns. Throughout the twentieth century, traders as well as outsiders made suggestions to weavers about what the world market would buy. Other areas such as the Four Corners region (where the states of Colorado, Utah, New Mexico, and Arizona meet) became known for rugs based on Navajo religious figures called *ye'iis*. The post of Tees Nos Pos in this area also specialized in eye-dazzler–style rugs with a multitude of colors and very complex designs. Monument Valley with its spectacular rock formations was a tourist attraction from the 1920s on, and weavers there produced pictorial souvenirs of the valley, with complex scenes of the landscape and clouds as well as the people living there.

Sheep became a problem as the century progressed. The Great Depression of the 1930s again meant low prices, if wool and rugs could be sold at all. This was the beginning of Navajo dependence on the federal government for welfare payments and wages related to public projects. At the same time, the new administration of Franklin Roosevelt exerted greater control over Navajo natural resources. The new commissioner of Indian Affairs, John Collier, attempted to stem the serious degradation of reservation land (which had been going on for years but only now was addressed by the federal government) by reducing the number of livestock. This reduction, while supposedly applied evenly to all stockowners, was disastrous to small herders. Sheep, goats, cattle, and horses were the basis of Navajo existence and social life; quite simply, the more sheep you had, the wealthier you were. Public works projects did provide a significant amount of wage work for Navajos. From 1933 to 1936, a voluntary reduction program was introduced but with little success, as families gave up their culls for sale and kept their good breeding stock (Bailey and Bailey 1986:185–193). From 1937 until 1941, the government forced the sale of livestock. There was little market for the animals, so they were purchased for very little and slaughtered, much to the distress of the Navajo. Wealth was represented by animals in ways that could not be understood by federal agents. They were used as currency and butchered in times of need and of celebration. The newly created Soil Conservation Service made a study of reservation lands and divided them into grazing districts; reduction quotas were greater in more severely damaged lands or districts. The Navajo remember this period of government intervention and their powerlessness to stop it with as much anger and resentment as they do the Long Walk and subsequent confinement at Bosque Redondo (Iverson 1983:643). Although the reduction ceased with World War II, the war and the availability of jobs around the reservation meant that less weaving was done during the 1940s too.

In the early twentieth century, many traders in

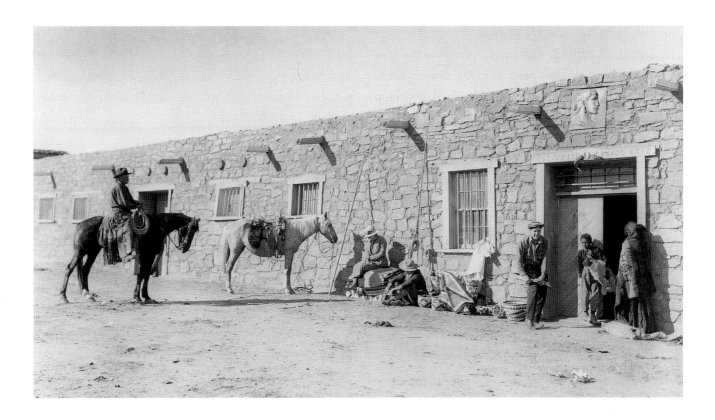

Figure 55. Hubbell Trading Post, Ganado, Arizona, ca. 1925. MNM 47913.

the Southwest other than Moore and Hubbell were trying to develop the market for Navajo textiles; these two, however, have received more attention than the others. The Ilfeld Company was the largest dealer in wool and a supplier of mercantile stores throughout New Mexico and Arizona. They bought blankets from C. N. Cotton, Manning, and Gallup Mercantile Company. Textiles, like raw wool, were shipped out in bales and priced by the pound (Ilfeld Papers). Customers went through the merchandise and returned what was not wanted. Saddle blankets went for $3 per pound around 1910, but Germantown textiles sold at a higher price and were listed individually.

In August 1911, F. H. Abbott, the deputy commissioner of Indian Affairs, sent a letter to all licensed traders asking for statistics on the value of merchandise sold and the condition of the arts in their region. Abbott wanted to know whether men or women produced the various crafts. No trader reported women making silver, but both men and women produced baskets. Weaving was primarily women's activity, although R. S. Baker, trader at

Shiprock, reported, "There are two men who make rugs on this reservation and they make the very best. There [sic] work is much better than the work of most of the women" (National Archives Document 74651). To the question of the kind of wool being used, Baker said they "now and then buy a saddle blanket with their native dye and find that it is not attractive like a rug made with artificial dye." He found the native dyes were "weak and did not have any life."

Olin C. Walker of Farmington commented, "Some few buy a wool warp ready spun which is alright and once in a while one will use cotton warp which is undesirable and I discourage it all I can, besides will not pay as much for them." Walker also said of saddle blankets:

If some means was used by which certain uniform sizes could be had, and patterns, and

especially in saddle sizes there is good demand for single and double saddle blankets, and most they make for that purpose are too small or too large. There is hardly a day I do not give out measures, but as stated before, as long as the traders will buy what they make, they will continue to make what they want too [*sic*]. And at present every trader and jober [*sic*] of blankets are over stocked with blankets. Yet if they were the right kind they would sell (National Archives Document 80885).

This seems to be a case of trying to fit a variable handmade product into the larger, American commercial need for standardization.

In an illustrated catalog (undated but sent to the assistant commissioner in 1911), the Hunter Mercantile Company of Farmington listed single saddle blankets (about 28 by 32 inches) and double ones (33 by 54 inches to 38 by 60 inches) at $6.50 to $7.50, which is more than small rugs (about 25 by 47 inches) at $5.00 to $6.50. One thing noted in the C. N. Cotton catalog is that sizes of saddle blankets did vary quite a bit, supporting the complaint of Olin Walker that there was no uniformity in sizes. John B. Moore was intent on promoting more expensive and distinctive rugs, stating, "I have no saddle blankets nor common ones to quote" (Moore 1911:58). Moore quoted prices by sizes and quality rather than by the pound, a practice that probably began in the 1890s during the national depression that drove down the price of raw wool. Women began weaving loose, coarse blankets then so that they could quickly get cash from their wool. The price of wool remained low until the beginning of World War I, when it went up again.

THE HUBBELL FAMILY AND GANADO

The other major trader who promoted Navajo weaving on a national scale was John Lorenzo Hubbell, who was centered at Ganado but had many posts throughout the central and western reservation from 1876 to 1930 (Blue 2000:xxiii). Upon his death in 1930, his trading empire went to his four children but was managed by Roman and Lorenzo.

In 1985, Elizabeth Bauer, curator of the Hubbell Trading Post National Historic Site, prepared a manuscript based on papers housed at the post; the following quotations are from this correspondence (Bauer 1987). In 1941, Lorenzo wrote, "We want blankets 30"×60" in saddles and 3'×5' and 4'×6' are good for floor rugs," but the "rug for all uses was 30× 30" (April 16, 1941). He sought to "encourage the making of saddle blankets 30"×30" and thicker as it is difficult to sell other sizes" (June 18, 1935). The traders gave each weaver a string thirty inches long with which to measure single saddle blankets and another sixty inches long for double ones (June 18, 1935). Apparently, standardization of sizes then was still an issue as it had been in 1910. In 1938 and 1940, saddle blankets were so popular that customers had to wait for delivery. Hubbell stated that "while the 30"×30" rugs will sell like hot cakes it takes a lot of wool to produce them and at present wool is very scarce" (November 10, 1941). The scarcity of wool was probably a result of the federal government's forced stock reduction program of the 1930s. During the 1940s, saddle blankets were the most popular textile sold at the post, although customers no longer wanted stripes but "designs and colorful center patterns" (April 2, 1946).

Lorenzo lamented the popularity of saddle blankets since they brought less money to the weaver than larger, more complex rugs; however, they continued to sell well throughout the 1940s, even though prices had not improved. As at the turn of the century, there were three grades of saddle blankets: regular, with a few stripes in plain solid colors, at 75¢ per pound; medium, at 85¢, with more stripes and

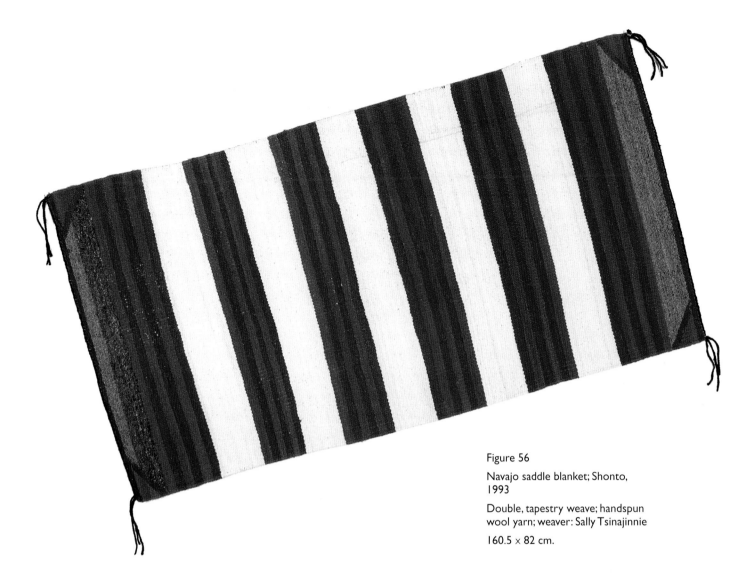

Figure 56

Navajo saddle blanket; Shonto, 1993

Double, tapestry weave; handspun wool yarn; weaver: Sally Tsinajinnie

160.5 x 82 cm.

brighter colors; and fancy, at 90¢ per pound—the latter had borders and/or designs in the corners. Cheaper saddle blankets were heavy and thick, and the more expensive ones had red and occasionally green in them (April 1, 1930). Stripes were the most typical designs, but "diamond and basket weave" were also sold (March 15, 1941); the latter were probably twills.

All-white mohair saddle blankets in single and double sizes were a specialty of the Hubbells' Na-ah Tee Trading Post (July 12, 1941). The silky angora goat hair creates a really soft pad, ideal for use under a saddle. Saddle blankets were in short supply during the 1940s; not only did stock reduction mean less wool, but women took on wage labor related to the war, meaning less weaving was done. Only five saddle blankets remain today in the Hubbell family collection at Ganado Trading Post National Monument: two have stripes, two are twills, and one is a vegetal-dyed example.

SHONTO

Shonto is a trading post known not for its fine rug weaving but for its natural beauty and the fact that it was the subject of several publications (above). One is anthropological, William Adams's *Shonto*, based on his doctoral dissertation; the second is the memoirs of Elizabeth Compton Hegemann, *Navaho Trading Days;* and the third historic, *Stokes Carson, Twentieth Century Trading on the Navajo Reservation*

by Willow Roberts. Both Elizabeth Hegemann and members of the Carson/Drolet families ran the post at Shonto, which is near the Anasazi ruin of Betatakin and not far from Monument Valley. In Adams's 1963 dissertation, based on his work as a clerk there during the 1950s, he reported that all but six women in the area were weavers, but 90 percent of their weaving was coarse and consisted of simple, banded saddle blankets (Adams 1963:83). Rugs were not much larger and were similar in pattern, but fine rugs were made by only five closely related women and one other. No vegetal dyes were used, only natural black, white, and gray wools with aniline red. About one hundred textiles were brought in each month, or one per family (Adams 1963:83). Based on his statistics, this translates as ninety saddle blankets per month, quite a large number for a small post and indicative of how quickly they could be woven. Occasionally, twill and two-faced saddle blankets were brought in. During the summer of 1955, there was an unexpected "proliferation" of double-faced saddle blankets, but none had appeared in the previous two years. Most weaving was done in summer, with each weaver finishing six to twelve per year. Single saddle blankets (again defined as 30" by 30") brought $4 and a double (30" by 60") $8. The highest price ever paid for a rug during the 1950s was $95 (Adams 1963:125). Income from rugs was supplemental, and the trader never paid cash for them but traded entirely for merchandise. Adams described rugs as a "nuisance" to Shonto traders, and the turnover was only 10 percent most months, sold mostly by mail order in lots of fifty to two hundred to dealers on both coasts. The saddle blankets at Shonto were fairly uniform, plain and coarse with stripes; a small one was so much and a large one a bit higher, and this carried over to rugs of higher quality. Forty-nine households received some income from rugs in 1955, but only two depended on it (Adams 1963:125, 172).

The situation at Shonto was quite different from that noted at Ganado in the central Navajo Reservation, where Lorenzo Hubbell complained that he could not get enough saddle blankets to fill his orders. Ganado, however, is very close to Gallup, and the railroad made marketing and shipping easier. The slow turnover in saddle blankets meant high markups of 10 to 20 percent, with 50 percent on larger rugs, presumably to make up for the loss on less desirable textiles. Adams believed that on the entire northwest Navajo Reservation no trading post credit was given against rugs. Traders paid for them entirely with merchandise, which is where they made their profit; however, some cash was given for a large rug (Adams 1963:200). The method used by the Shonto traders was to look over the rug or blanket in silence without touching or measuring it and then offer a figure in a firm voice and stick to it. Looking closely at the rug would weaken the trader's authority (Adams 1963:200). This is different from other posts where long bartering is the custom and a careful inspection by the trader is usual.

Ray and Melissa Drolet operated the Shonto post in the 1970s and 1980s, and Willow Roberts comments that "when times are hard, such as they were in 1981 and 1982, weaving is still an economic failsafe, and good traders will buy rugs, at least until they themselves are suffering" (Roberts 1987:191). At this time, the post was overstocked mainly with saddle blankets, and they had to stop buying until the inventory was decreased. Roberts remembers the blankets as thick, soft, and fluffy. Weavers used carding combs, which are more often used to prepare raw fleece for spinning, to make the blankets fluffy (see Figs. 57 and 58 for recent examples from Ganado). Regardless of size, if a more complex pattern was used, Roberts considered the textile to be a rug. Purple and turquoise were very popular at Shonto, along with other bright colors, while weavers at the nearby post of Navajo Mountain used more vegetal

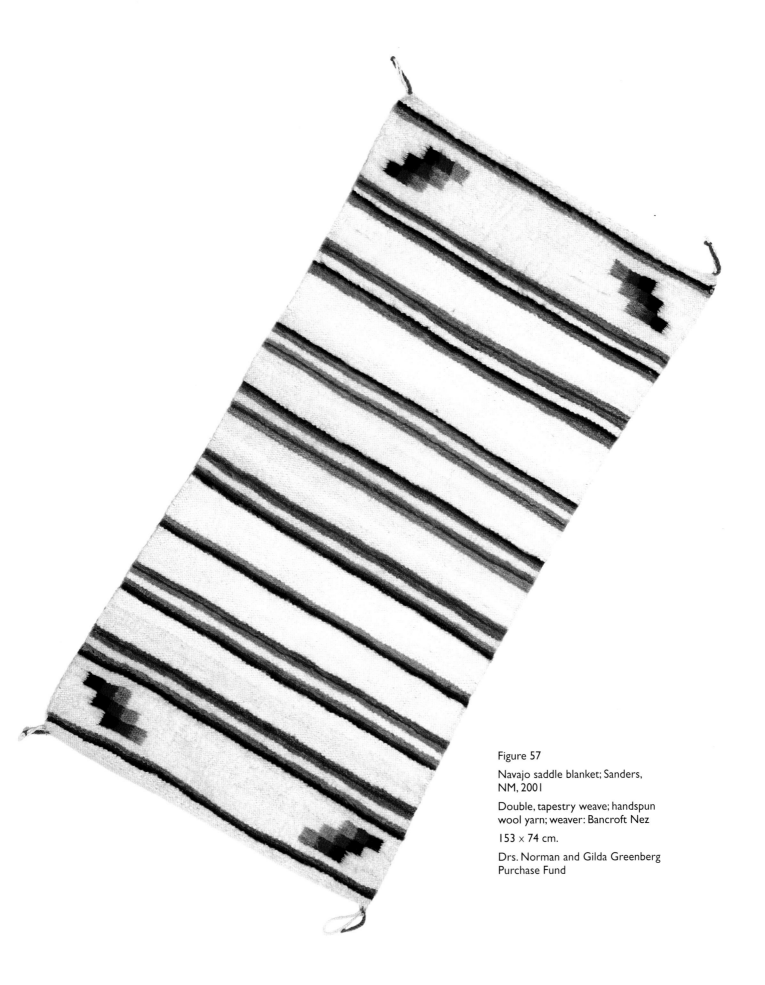

Figure 57

Navajo saddle blanket; Sanders, NM, 2001

Double, tapestry weave; handspun wool yarn; weaver: Bancroft Nez

153 × 74 cm.

Drs. Norman and Gilda Greenberg Purchase Fund

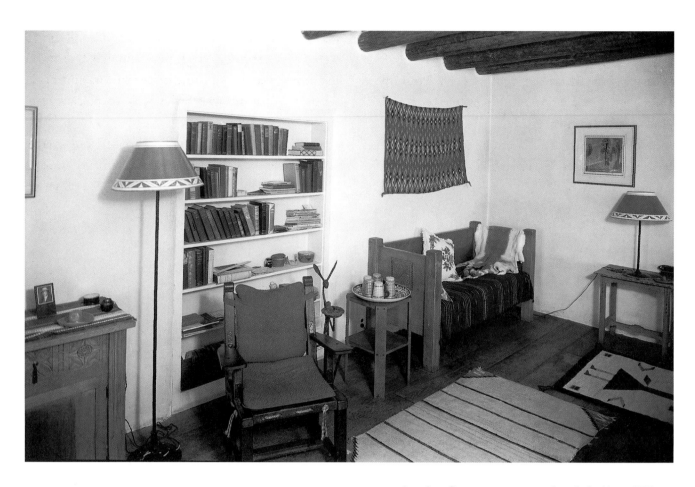

Figure 58. Interior of cabin at Ghost Ranch near Abiquiu, New Mexico, ca. 1935, showing a Germantown saddle blanket on the wall and a handspun saddle blanket on the floor. Photograph by T. Harmon Parkhurst. MNM 89617.

colors in their blankets. In a telephone conversation with the author (June 4, 2001), Ray Drolet remembered the weaving business in the 1980s as chiefly comprising saddle blankets made with some processed wool (Shiprock yarns) but mostly the weavers' own handspun. Larger saddle blankets were wholesaled to saddle makers in Montana and Wyoming. The double saddle blankets were a good tourist item that sold for $75 and made good floor rugs. According to Drolet, "If you hang them up you get moths, but not if you walk on them." The only patterns were stripes and stripes with corner designs. Very few twills were made, although he remembered from his boyhood that many excellent twills were woven in the Carson area south of Gallup. When asked about plain-center blankets bordered on all four sides, he said they could be from another region, but he never saw them at his post. As in the 1950s, Drolet said all the women knew how to make them, and they are still sold at the trading post at Inscription House.

WEAVING TODAY

Livestock controls are still in effect as the twenty-first century begins, but they are administered by the Navajo tribe itself, which issues grazing permits. Today, with increased employment and more children in day schools (hence not available for herding), little wool is produced commercially on the reservation. Wool is taken to warehouses, where it is processed (that is, scoured, spun, and dyed), then returned to the reservation and sold in prepackaged skeins for weaving. Traders carry a variety of pro-

cessed yarns sold in skeins in "Navajo" colors such as red, black, gray, and brown, or in plain white, which can be dyed by weavers and then woven. Most of the more expensive textiles are woven with commercial yarns that are frequently respun to make them finer. Handspun Navajo wool is often found in less finely woven products. The contemporary buying public does not seem willing to pay for the extra time involved to prepare the wool with the entire process of shearing to spinning and dyeing.

While the first part of the twentieth century saw the development of distinctive and identifiable Navajo rug styles, the last quarter of the century witnessed the breakdown of those styles; that is, a Ganado Red rug or a Two Grey Hills pattern no longer had to come from those trading posts. As the public learned more about Navajo textiles, they asked for certain styles. Furthermore, weavers became more sophisticated as improved roads led to greater travel. Weavers bought books and magazines and were able to experiment with patterns from areas of the reservation other than those where they were brought up. Now, unless the weaver's home is known, one can say that a rug is "in the style of" Ganado or Two Grey Hills. Saddle blankets are fairly rare items today, since weavers still are not well rewarded for them and the market seems to favor the finer and more artistic wall hangings. Also, commercial saddle pads are now used throughout the West instead of handmade Navajo products. Bill Malone, long-time trader at Ganado, states that today only a few saddle blankets are brought to the post each year, and those are by older weavers. He said, "Only grandmas weave saddle blankets" (June 2001).

Most of the common saddle blankets of the twentieth century are coarse, thick, fluffy, and mainly striped, with corner or edge patterns. Another basis for consideration is design or what looks best on the horse or rather, under the saddle. Phase III chief's blankets are designed to emphasize the wearer's spine, with the half and quarter diamonds that meet in front forming the same pattern front and back when worn. In this way, designs that emphasize corners and edges as well as allover patterns with no central focusing element are suitable as saddle blankets. A plain, unadorned textile of coarsely spun natural wool woven into a monochrome blanket, more like a commercial pad or sheepskin, is the simplest example. The closest to this style would be the plain white mohair blankets the Hubbells were getting from Na-ah Tee post; however, Navajo weavers have too great an artistic sense to do much of this type of weaving.

BANDS OF STRIPES DESIGNS

The examples seen in Figures 48 and 59 are typical saddle blankets of the Transitional period of the late nineteenth century, with the bright oranges, reds, and yellows of that period. The blankets are banded or zoned; that is, the stripes are arranged in three wide rows. The stripes in these two are made up of complex smaller elements—chevrons and rhomboids. The center of the textile is usually emphasized or set apart in some way. Twentieth-century striped blankets are just that—very straightforward rows with some elaboration in the form of wide stripes bordered by a small one in a contrasting color (Figs. 60). When a young girl begins to weave, her first piece is usually a small striped textile so that she can learn the mechanics of operating the loom: separating the sheds, placing her batten, and packing the weft down with the comb. Yet it is surprisingly difficult to weave even, straight lines. The tweedy effect seen in Figure 61 is produced by alternating weft picks and different colored yarns. This technique is common in rugs from the Crystal, New Mexico, region, which may be the origin of this blanket. The blanket in Figure 62 is a severely plain piece with seven bordered stripes and no attempt at orna-

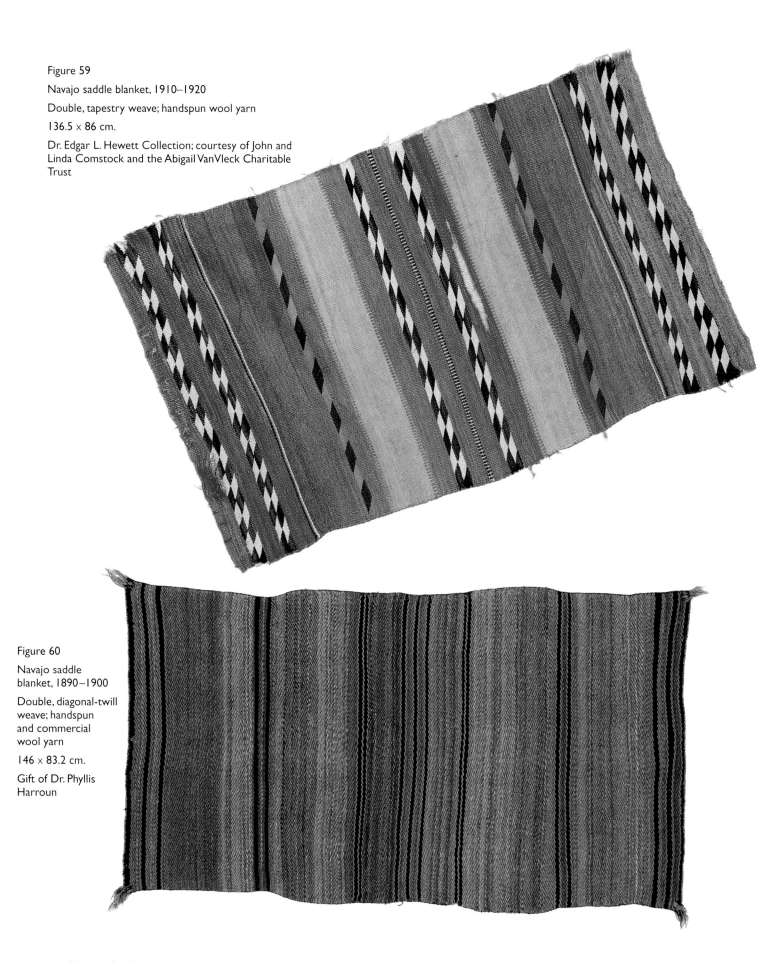

Figure 59

Navajo saddle blanket, 1910–1920

Double, tapestry weave; handspun wool yarn

136.5 × 86 cm.

Dr. Edgar L. Hewett Collection; courtesy of John and Linda Comstock and the Abigail VanVleck Charitable Trust

Figure 60

Navajo saddle blanket, 1890–1900

Double, diagonal-twill weave; handspun and commercial wool yarn

146 × 83.2 cm.

Gift of Dr. Phyllis Harroun

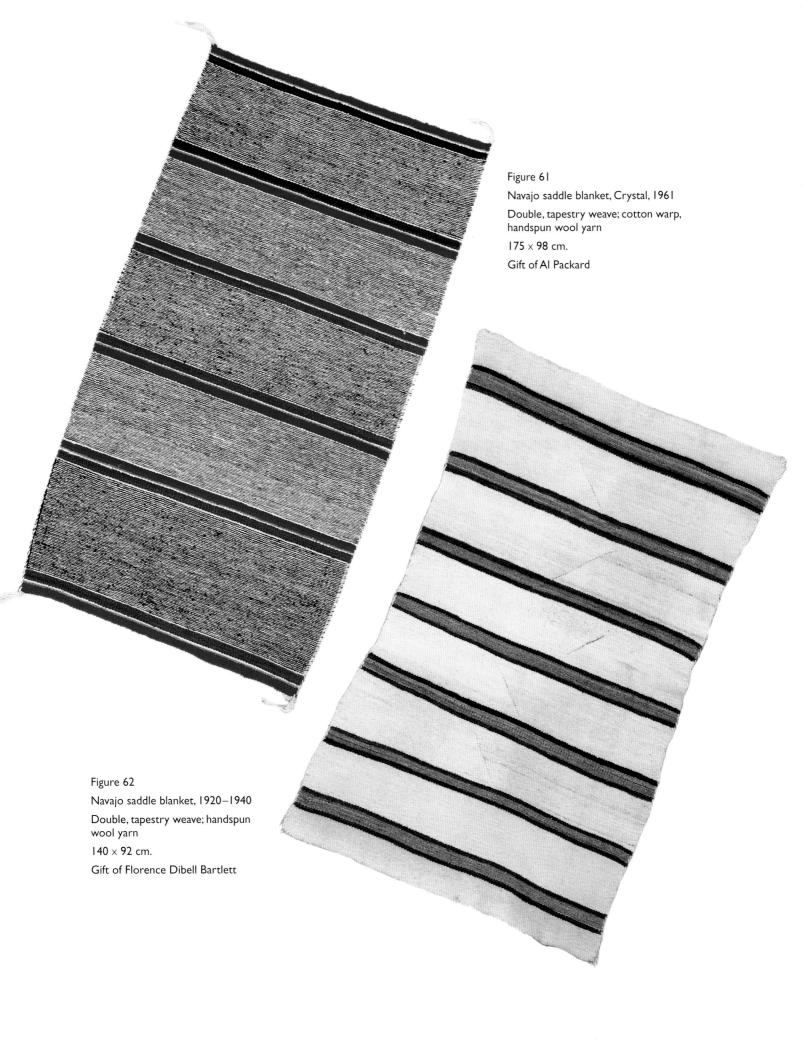

Figure 61
Navajo saddle blanket, Crystal, 1961
Double, tapestry weave; cotton warp,
handspun wool yarn
175 x 98 cm.
Gift of Al Packard

Figure 62
Navajo saddle blanket, 1920–1940
Double, tapestry weave; handspun
wool yarn
140 x 92 cm.
Gift of Florence Dibell Bartlett

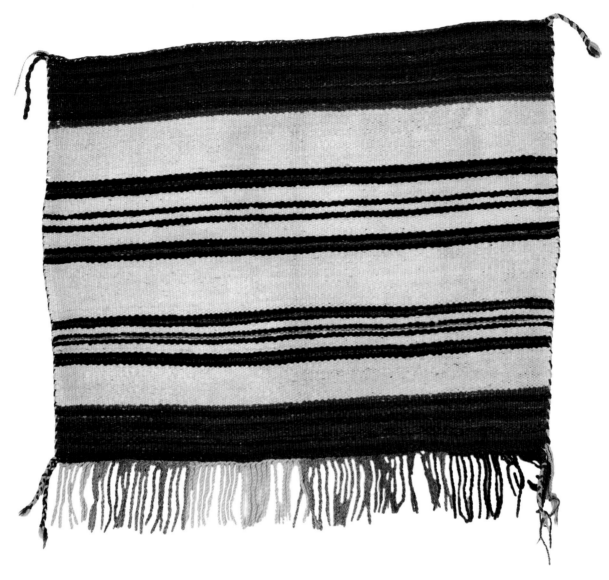

Figure 63
Hopi saddle blanket, 1900–1920
Single, tapestry weave; handspun wool yarn
88 × 82 cm.
Mrs. Phillip Stewart Collection

mentation or banding, that is, grouping the stripes into three or four distinct areas. An exceptional feature of this austere blanket is the tracing of the lazy lines with a strand of gray wool. On close examination, this was deliberately done and is not a stray fiber carded in accidentally. This is an extremely unusual technique and its purpose is unknown.

Another atypical saddle blanket, this time in an unusual single size, is Figure 63. The color combination of blue (probably indigo) with purple and gray is not typically Navajo. The fringe tied on along one edge is quite varied, with alternating sections of white, gray, brown, and black. Even more distinctive are the fancy braided tassels similar to those on Pueblo wedding mantas. All things considered, the blanket is probably Hopi and the only one in the collection. An absolutely stark-white textile with natural brown stripes is very plain but striking (Fig. 64); it is asymmetrical with plain stripes at one end and a wavy band at the other.

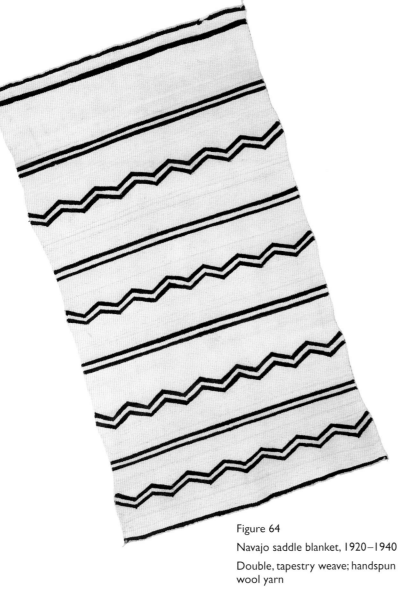

Figure 64

Navajo saddle blanket, 1920–1940

Double, tapestry weave; handspun wool yarn

140.5 x 79 cm.

Gift of Florence Dibell Bartlett

Figure 65

Navajo saddle blanket, 1920–1940

Double, tapestry weave; handspun wool yarn

168 x 96 cm.

Gift of Mrs. Kelvin H. Magill

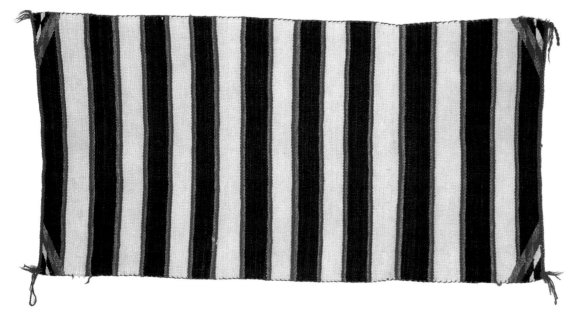

Figure 66

Navajo saddle blanket, 1920–1940

Double, tapestry weave; handspun wool yarn

167 x 94 cm.

Dr. Edgar L. Hewett Collection; courtesy of John and Linda Comstock and the Abigail VanVleck Charitable Trust

Three striped blankets (Figs. 56. 65, 66) have quarter diamonds in each corner. These are vestiges of the larger, more elaborate quarter diamonds in Late-Classic blankets (see Fig. 34). Stripes are treated in an entirely different manner in Figure 67, with color and outlining creating two opposing chevrons. This looks more like a Ganado Classic revival piece or banded design based on Classic blankets of pre-1880, the so-called Moki or Hopi style. It was made in 1934 by Nellie Cowboy for the Public Works of Art program.

Two recent acquisitions (Figs. 57, 68) were purchased in 2001 at the post at Ganado. Both are bands of stripes with small design elements in the four corners. The blanket in Figure 68 was woven by Nora Frank, age seventy, of Lupton, Arizona, and the one in Figure 57 by Bancroft Nez of Sanders, Arizona, age seventy-two. These are two of the "grandmas" who Bill Malone says are the only ones weaving saddle blankets today. Both these blankets have been finished with a carding comb to give them a thicker, brushed surface. A further variation on the four-corner design is found in Figure 70, with partial stripes and a black scroll in each corner. A textile from the 1920s or 1930s (Fig. 69) also has a design in each of the four corners—a large, orange water-bug motif against a gray square, but the striped center is reduced to one band.

Figure 67

Navajo saddle blanket, 1934

Double, tapestry weave; handspun wool; weaver: Nellie Cowboy

145 x 95.5 cm.

Public Works of Art Project

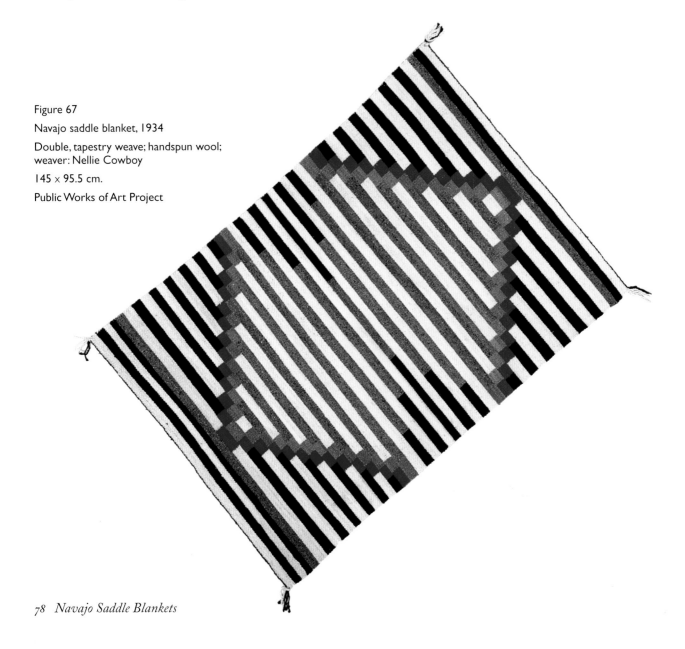

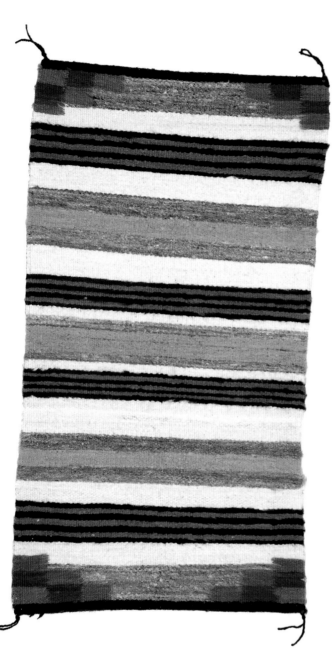

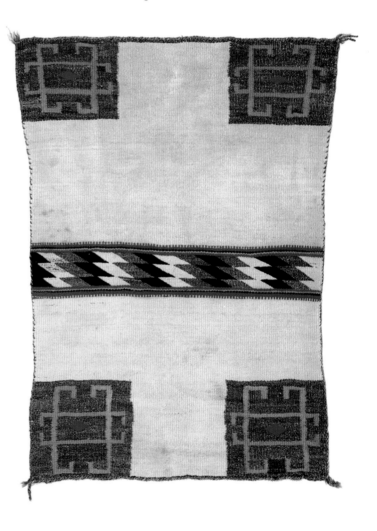

Figure 69

Navajo saddle blanket, 1900–1915

Double, tapestry weave; handspun wool yarn

125.5 × 86 cm.

Dr. Edgar L. Hewett Collection; courtesy of John and Linda Comstock and the Abigail VanVleck Charitable Trust

Figure 68

Navajo saddle blanket, Lupton, AZ, 2001

Double, tapestry weave; handspun wool yarn; weaver: Nora Frank

160 × 83 cm.

Drs. Norman and Gilda Greenberg Purchase Fund

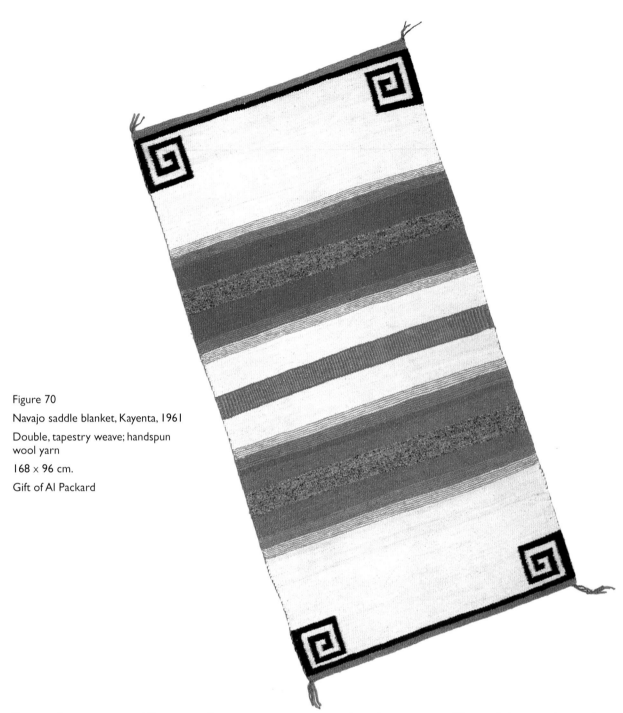

Figure 70

Navajo saddle blanket, Kayenta, 1961

Double, tapestry weave; handspun wool yarn

168 x 96 cm.

Gift of Al Packard

Plain Centers and Variants Designs

The ultimate in a four-cornered design saddle blanket is seen in Figure 71, with large, elongated quarter diamonds on a plain white ground. The entire blanket is framed by a black border usually seen in rugs. Plain-centered saddle blankets seem to begin around 1920, and they are in a way the ultimate reduction in design: a plain gray or white wool center that would be obscured by the saddle or rider, with ornamentation only on the visible part.

Another variant (Fig. 72) has a plain white center and a natural wool, camel-color serrated border.

The single saddle with swastikas or "whirling logs" (see Fig. 6) in each of the four corners was made before World War II, when the symbol's association with the Nazis made it repellent. The symbol, which is found in many other parts of the world, in this instance is derived from Navajo dry-painting imagery. This single saddle blanket shows years of hard use.

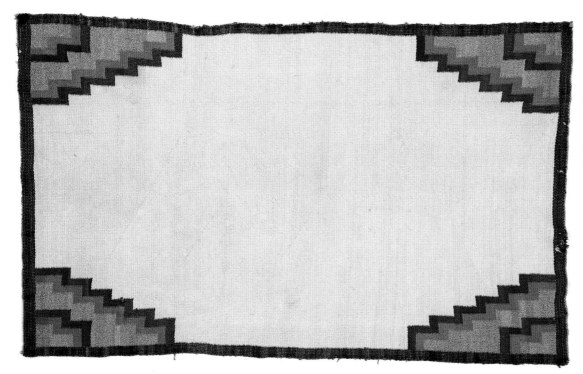

Figure 71

Navajo saddle blanket,
1920–1940

Double, tapestry weave;
handspun wool yarn

140 × 90 cm.

Gift of R. Fisher

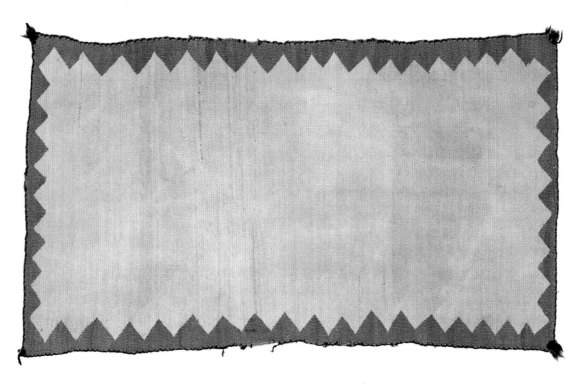

Figure 72

Navajo saddle blanket fragment, 1910–1920

Double, tapestry weave; handspun wool yarn

117.5 × 76 cm.

Gift of Dr. Phyllis Harroun

Perhaps the most perfect example of an open-center blanket is seen in Figure 73. Although there are expanses of natural brown wool with gradations (probably deliberate), the borders are different: the lengthwise ends have serrated black and white and the top and bottom ends a wave-like motif. The blanket's plainness is broken by duplicating the wavelike pattern across the center. Hung as a work of art, it is quite stunning. Doubled under the saddle on the horse, the border patterns would show on the rear and the front under the saddle. In Figure 74 one scarcely notices that the center is plain because the borders are so elaborate. Brilliant orange and red with touches of black and white are reminiscent of the Germantown eye-dazzler style and show it has not really died out on the reservation. The textile in Figure 76 is very similar and may be by the same weaver, while the meander in Figure 75 has taken over the textile rather than serving as a discrete border, as in most of the other saddle blankets.

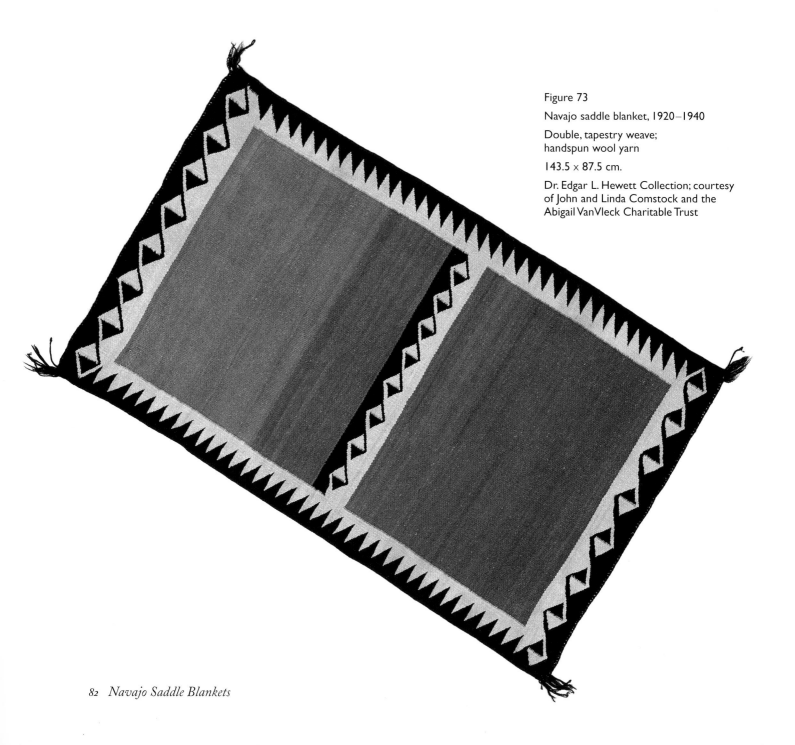

Figure 73

Navajo saddle blanket, 1920–1940

Double, tapestry weave; handspun wool yarn

143.5 x 87.5 cm.

Dr. Edgar L. Hewett Collection; courtesy of John and Linda Comstock and the Abigail VanVleck Charitable Trust

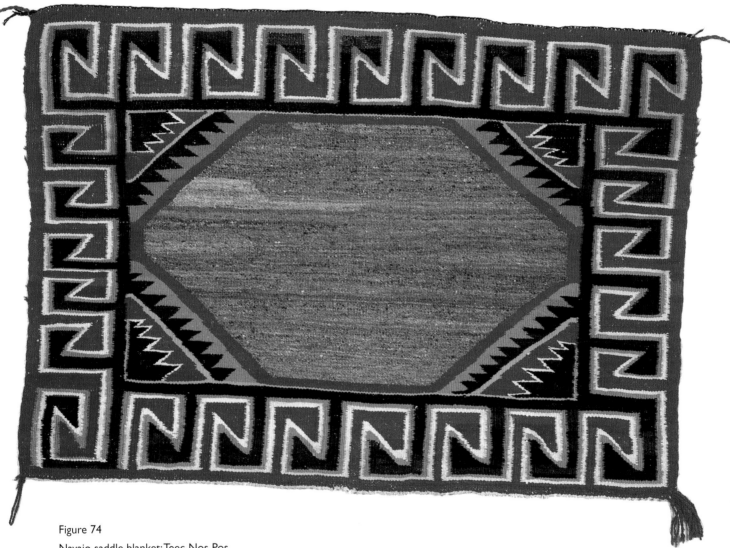

Figure 74

Navajo saddle blanket; Teec Nos Pos,
1910–1920

Single, tapestry weave; handspun wool yarn

99.5 × 69 cm.

Dr. Edgar L. Hewett Collection; courtesy of
John and Linda Comstock and the Abigail
VanVleck Charitable Trust

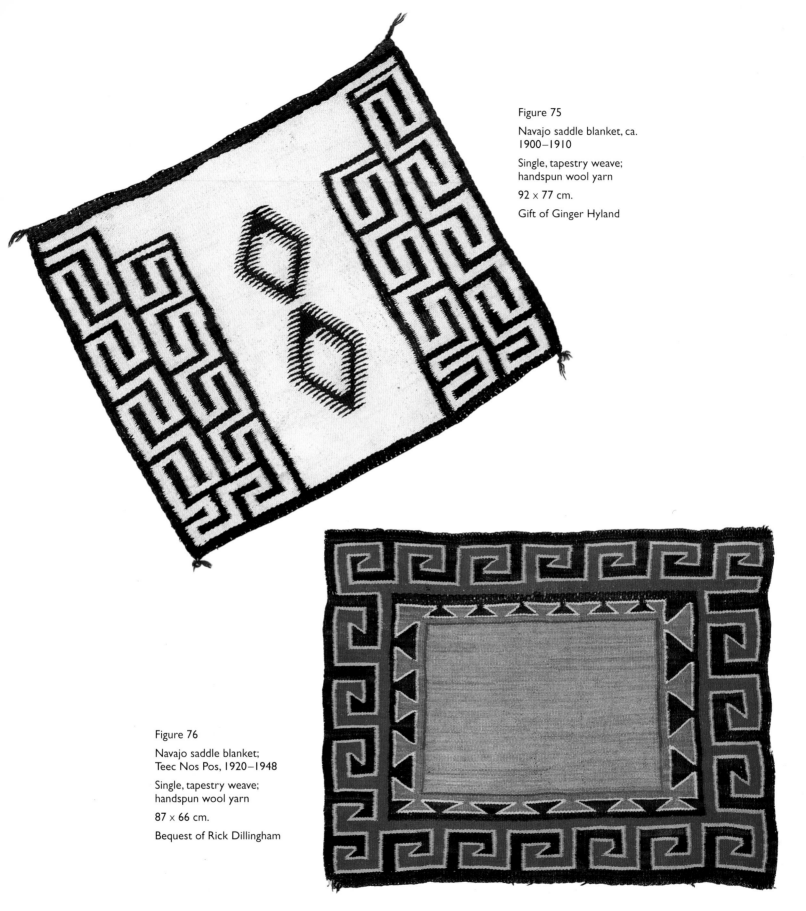

Figure 75

Navajo saddle blanket, ca. 1900–1910

Single, tapestry weave; handspun wool yarn

92 × 77 cm.

Gift of Ginger Hyland

Figure 76

Navajo saddle blanket; Teec Nos Pos, 1920–1948

Single, tapestry weave; handspun wool yarn

87 × 66 cm.

Bequest of Rick Dillingham

FANCY SADDLE BLANKETS

Perhaps these blankets are a continuation of what turn-of-the-century traders like C. N. Cotton called "fancy saddle blankets," pieces that are elaborately patterned and finely woven. Those here are almost all centrally patterned or designed. The blanket shown in Figure 7 is really a Germantown pattern that survived into the early twentieth century. It is made of handspun wool, and from the nature of the fibers it appears to date from 1900–1920. A typical Four Corners–area pattern, frequently called the Red Mesa Outline style, is seen in Figure 77. The post is close to that of Tees Nos Pos and shares some stylistic similarities, such as a multitude of colors and lots of diamonds outlined with contrasting colors. This outline style is also a reflection of the Germantown period of the late nineteenth century. A plain white, single saddle blanket of small size with interlocking diamonds in red and black (Fig. 78) could also be a saddle cover or throw, which would be placed over the saddle for the rider's comfort; the wear and bleeding of the red indicates hard use. Because Figure 79 very much resembles a tiled floor, it is

Figure 77
Navajo saddle blanket or throw; Red Mesa, 1970–1990
Single, tapestry weave; commercial wool and acrylic yarn
78 × 60.5 cm.
Gift of Ginger Hyland

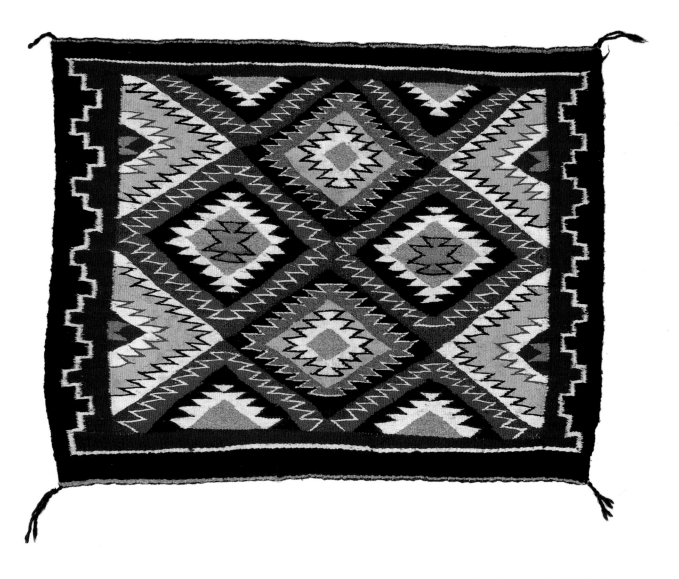

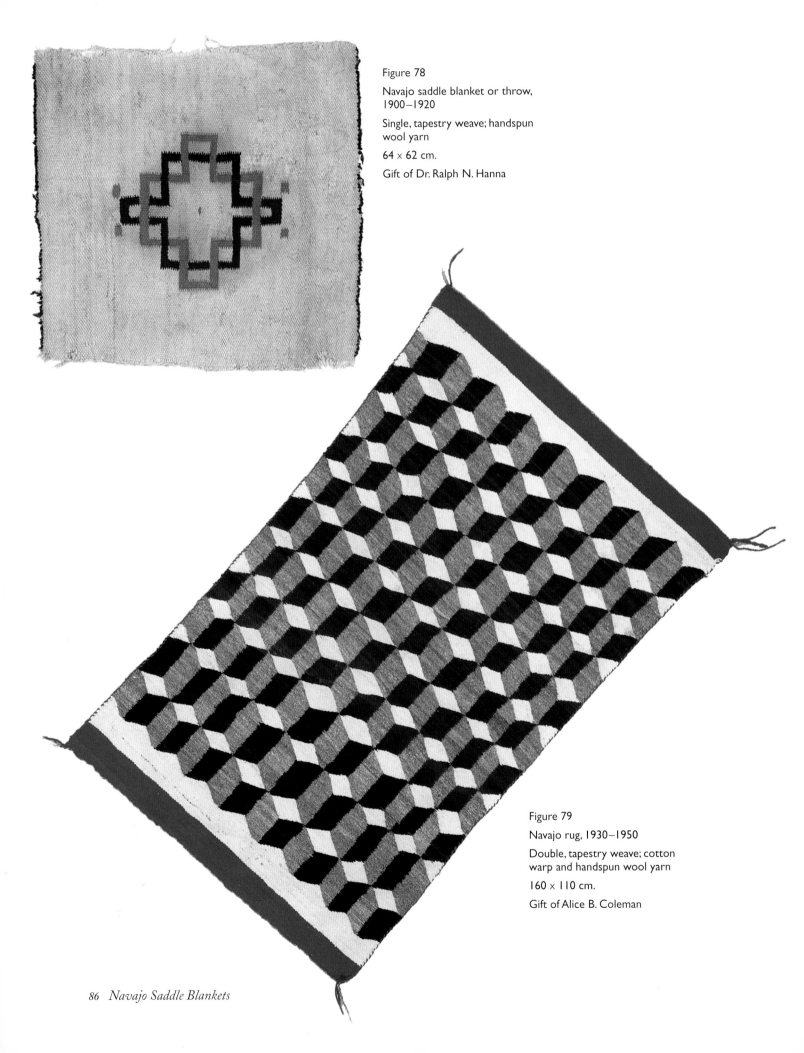

Figure 78

Navajo saddle blanket or throw, 1900–1920

Single, tapestry weave; handspun wool yarn

64 × 62 cm.

Gift of Dr. Ralph N. Hanna

Figure 79

Navajo rug, 1930–1950

Double, tapestry weave; cotton warp and handspun wool yarn

160 × 110 cm.

Gift of Alice B. Coleman

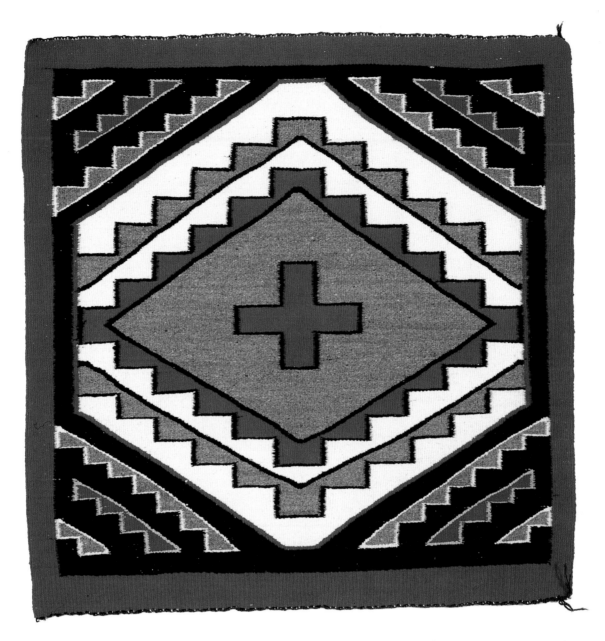

Figure 80
Navajo saddle blanket; Ganado, 1940–1960
Single, tapestry weave; handspun wool yarn
82 × 81 cm.
Gift of Ginger Hyland

probably not a saddle blanket but a floor rug; however, many people think the pattern is also appropriate for use under a saddle. The pattern first appeared around the 1960s, although no information is available about where on the reservation it was first made. Similar experiments were done around this time on Acoma polychrome pottery.

The saddle blanket in Figure 80 has many stylistic similarities with Ganado rugs from the 1940s onward (i.e., the use of red and a cross in the pattern) and is from that region. Virtually unique is the blanket in Figure 81, which is woven half in a checkerboard twill and half in a tapestry that displays a very eccentric pattern, with many strange filler motifs of

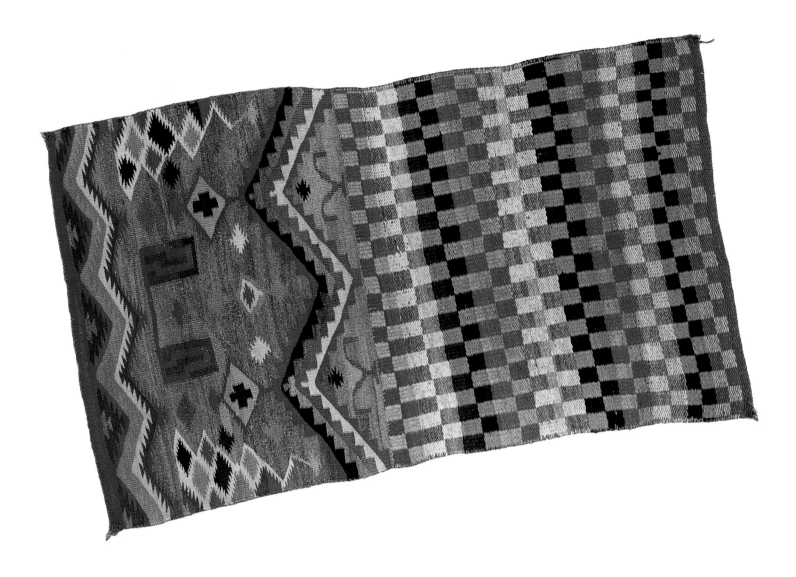

Figure 81

Navajo saddle blanket, 1900–1920

Double, twill and tapestry weaves; handspun and commercial wool yarn

147 × 87 cm.

Dr. Edgar L. Hewett Collection; courtesy of John and Linda Comstock and the Abigail Van Vleck Charitable Trust

hooks, conjoined diamonds, and crosses. This is truly reversible, with one plain half and one fancy. The region where the weave changes reveals a difference in the edges as a result of the difference in spacing and tension of the loom.

Tufted Blankets

Relatively uncommon, and represented in the MIAC collection by only two examples, are tufted blankets. One is a very plain and utilitarian striped example, while the other (Fig. 82) is a work of art woven by Elsie Nez in the 1990s. The tufts are pieces of angora goat hair that are knotted into the piece during weaving, much like the technique of oriental pile rugs. They are usually in single saddle size, have simple or no patterns, and most often are used as saddle throws or pads for weavers to sit on while working at the loom.

Saddle blankets have been ignored too long. They are perhaps the oldest form of Navajo weaving con-

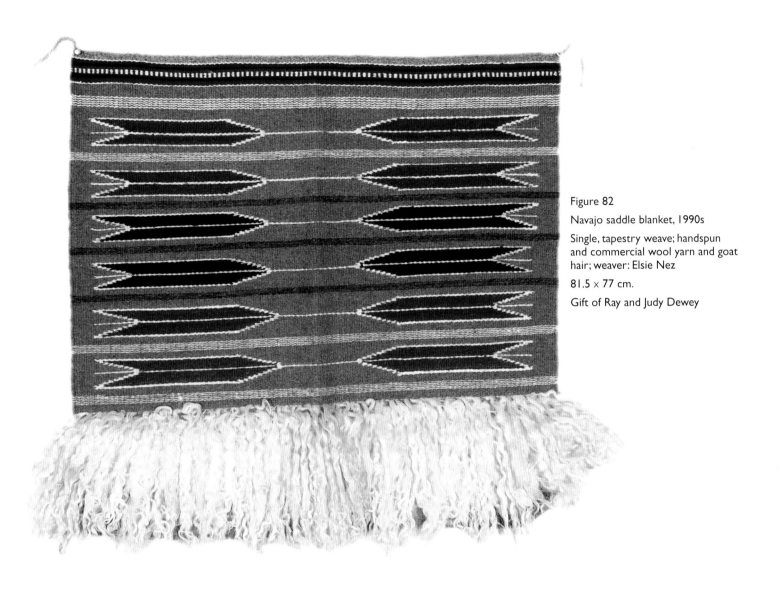

Figure 82

Navajo saddle blanket, 1990s

Single, tapestry weave; handspun and commercial wool yarn and goat hair; weaver: Elsie Nez

81.5 x 77 cm.

Gift of Ray and Judy Dewey

tinuously made for and used by Navajo people. Probably almost any textile can be used under a saddle, but certain specially woven designs and techniques are best for that purpose. Euro-Americans realized early on that Navajo textiles would make good saddle pads and floor rugs, and they probably were also thrown over chairs and hung on walls. The size of a double saddle blanket is very versatile, useful for a variety of purposes in both Anglo and Native American society. The Pueblo woman vendor under the portal at the Palace of the Governors in Santa Fe

(Fig. 83) has placed one on the ground to display and protect her pottery.

Because the saddle blanket has been neglected for so long, an attempt was made in this book to illustrate every piece in the museum's collection. Therefore, both worn and/or plain examples are provided next to pristine works of art. While the latter usually generate more attention, the utilitarian textiles, with their signs of daily use, provide an interest of their own.

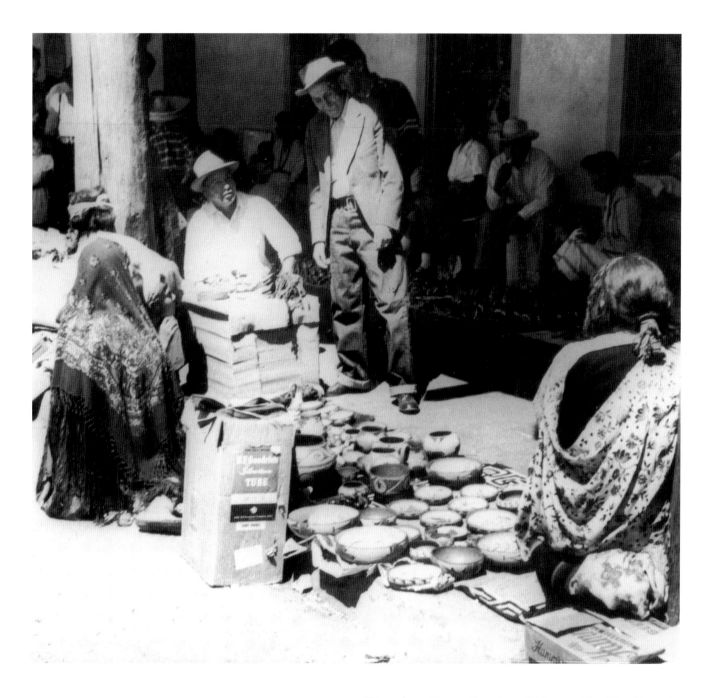

Figure 83. Indian Market vendors under the portal of the Palace of the Governors, Santa Fe, New Mexico, ca. 1952. The pottery is displayed on a double saddle blanket. MNM 183510.

REFERENCES

Adams, William, 1963. "Shonto." Smithsonian Institution Bulletin 188. Washington, D.C.

Amsden, Charles Avery. 1964 [1934]. *Navajo Weaving: Its Technic and Its History.* Santa Ana, CA: Fine Arts Press. Reprint, Chicago, IL: Rio Grande Press.

Bailey, Garrick, and Roberta G. Bailey. 1986. *A History of the Navajo: The Reservation Years.* Santa Fe, NM: School of American Research Press.

Bauer, Elizabeth. 1987. Catalog of the Navajo Textiles of the Hubbell Trading Post. Unpublished ms. on file at Hubbell National Historic Site.

Blue, Martha. 2000. *Indian Trader, The Life and Times of J.L. Hubbell.* Walnut, CA: Kiva Publishing, Inc.

Hunter Mercantile. n.d. Enterprise Printing. Farmington, N.M.

Ilfeld, Charles. Papers. Center for Southwest Research, University of New Mexico.

Iverson, Peter. 1983. "The Emerging Navajo Nation." In *Handbook of North American Indians.* Vol. 10, *Southwest*, ed. Alfonso Ortiz. Washington, D.C.: Smithsonian Institution.

Moore, J. B. 1987. *United States Indian Trader, A Collection of Catalogs Published at Crystal Trading Post 1903–1911.* Albuquerque, NM: Avanyu Publishing Inc.

National Archives. Office of Indian Affairs. Washington, D.C.

Roberts, Willow. 1987. *Stokes Carson: Twentieth Century Trading on the Navajo Reservation.* Albuquerque: University of New Mexico Press.

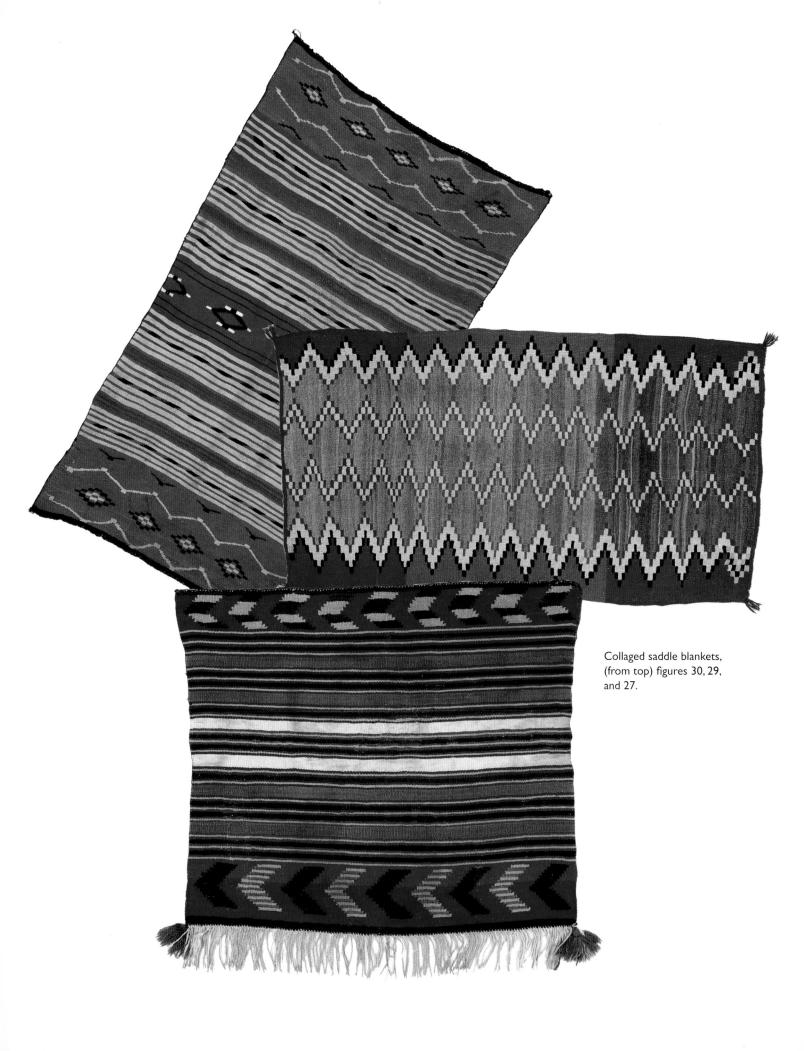

Collaged saddle blankets,
(from top) figures 30, 29,
and 27.

5
Saddle Blanket Analysis

By Casey Reed

T HE TECHNICAL ANALYSIS of Navajo saddle blankets examines the same materials, history, and designs or styles used in larger Navajo rugs and blankets. Forensic examination of the details that remain in woven artifacts offers evidence on which to build theories about the textiles, the history of the period, the complexity of new materials being introduced, and the dynamics of Navajo trading and culture.

Saddle blankets, like all Navajo textiles, show signs of how they were used. Sweat patterns from being under a saddle are evidenced by darkened, worn, and seemingly smaller yarns. The nap or surface fibers are worn off, making the yarn look smaller or tighter. The darker areas between the yarns are usually from well-packed dirt, stains, and sometimes mold. The stress from the saddle frequently wears the blanket characteristically in the middle, which appears as damaged or torn wefts and broken warps or selvages. Many saddle blankets were used as decorative art and do not exhibit sweat or use patterns. Heavy use of a thin, finely woven saddle blanket would wear it out quickly, so not many survived. For

this study, three textiles from the Museum of New Mexico's collection were selected for analysis of yarns, fibers, and dyes. These three pieces show no real use or wear patterns as saddle blankets.

Several different levels of observation and analysis of a textile are necessary to build a sufficient information base to ask meaningful questions and find evidence for constructing theories:

1. Art historical or stylistic analysis

2. 60x microscopic technical and yarn analysis

3. 200x microscopic fiber analysis

4. Qualitative and quantitative High Pressure Liquid Chromatography (HPLC) dye analysis

The first level of observation is based on the art-historical perspective that looks at observable technical qualities and yarns, as well as stylistic elements. Specific yarn characteristics influence pattern variations and color use. Correlations are made between materials and styles that are then used as evidence to determine the age and thus place the textile on an art-history time line. The Navajo textile time line has

three periods: the Classic, 1650 to 1868; the Transitional (Late Classic), 1868 to 1895; and the Rug, 1895 to the present. Most art historians engage a process involving the identification of yarn types and warp and weft counts. All subjective and objective insights about style, dyes (generally not tested), and evidence from observations are then used to place the textile within a period, while estimating the textile's age. Frequently, the examined textile is compared to others in the literature to cite precedence for materials and style, in respect to an art-history time line. Unfortunately, very few textiles with good provenances exist, and references to other textiles cited by authors with years of scholarly work and research are often based on intuition and comparison with other scholars' intuitive judgments.

The next level of investigation beyond the art historical uses a 60× microscope to examine technical qualities of the textile and identify yarn types, such as handspun, raveled, and commercial yarns. Navajo weavers formed yarns from woolen fabric, flannel, and cloths by a process called "raveling." The small yarns are raveled or stripped out of the fabric and retwisted together to form a new plied yarn the weaver uses to build the red weft yarns, which are the visible ones in a textile.

In the early 1800s, a type of red flannel was brought from Europe, most likely England, to the Southwest by the Spanish; they called this flannel *bayeta,* and its fine threads or yarns were raveled by the Navajos. In the second half of the 1800s, many different flannels were traded from the United States and Europe. Literally tons of flannel were brought into the United States from all over the world, some dyed here and some abroad.[1]

American flannel has been unfavorably compared to the Spanish trade flannel found in southwestern textiles. Technically, once imported into the United States, any imported flannel becomes American flannel. Terminology may well be a reflec-tion of the scholar's bias. Charles Avery Amsden was one of the first scholars to use the terms "bayeta" and "American flannel" to confer historical significance and to identify older, pre-1868 weavings with bayeta yarns as "better" when compared to newer ones using American flannel. This is an interesting distinction, as by Amsden's own research bayeta was sold up to 1920: "The two pioneers among Navaho traders, the late Lorenzo Hubbell and Mr. C. N. Cotton, could recall having sold bayeta Cotton told me he carried it as a regular trade item until about 1910, while Mr. Lorenzo Hubbell Jr. told Mr. Frederic H. Douglas that bayeta was made until about 1910, his father having disposed of his final bolt about 1920" (Amsden 1974:142). Ongoing research will shed additional light on the use of bayeta after 1868, and researching individual textiles is the best way to help clarify the evolving picture.

By microscopically examining bayeta and all raveled and commercially plied yarns, the direction of the twist and spin of the yarns can be noted. To understand the twist and spin of raveled and commercial yarns in Navajo textiles, let us consider a rope as a model. The twist and spin in a large rope is technically the same as that in a small, commercial wool yarn. If we take a one-inch-diameter rope and untwist the individual cords from the body of the rope, we can count the plies (Fig. 84). If we look at the side of the rope and determine the direction of the twist, or a spiral from the side perspective, we can superimpose the letter S on the surface, and the middle section of the S will parallel the direction of the plies on an S twist. If the plies are perpendicular to the S, it is called a Z twist and the middle of the letter Z parallels the twist. The same process is repeated for each ply within the body of the rope, and to give the rope stability, the spin of each of the plies twisted together is always in the opposite direction of the twist in commercially twisted and spun yarns. So, if we have an S twist, then the individual plies are Z

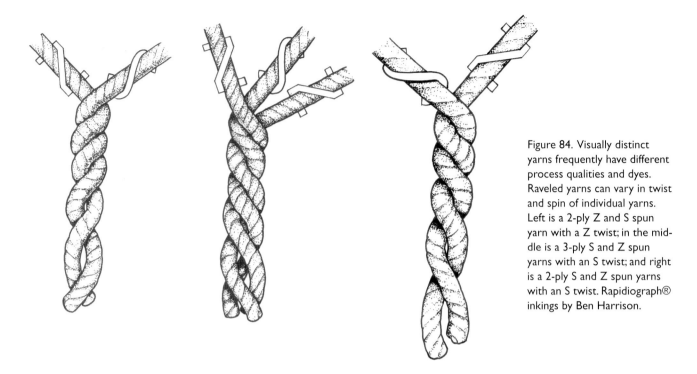

Figure 84. Visually distinct yarns frequently have different process qualities and dyes. Raveled yarns can vary in twist and spin of individual yarns. Left is a 2-ply Z and S spun yarn with a Z twist; in the middle is a 3-ply S and Z spun yarns with an S twist; and right is a 2-ply S and Z spun yarns with an S twist. Rapidiograph® inkings by Ben Harrison.

spun. Occasionally, the Navajos have varied this by making raveled, retwisted yarns with an S twist on the main yarn with plies that have two Z-spun yarns twisted together with one S-spun yarn. There can be many other combinations of twist and spin of yarns. When we find these twist-and-spin variations in a yarn, they indicate that different raveled commercial or flannel yarns were used. Dye analysis frequently confirms that separate yarn sources were raveled together in the same textile.

Once different yarns are identified, we move to yarn sampling to identify distinct fibers at 200X. Worsted and non-heat-processed yarns are noted. This level of observation is most useful when there is a question about identifying an individual fiber from distinct yarns. Churro sheep fibers can be microscopically identified as different from merino, and the difference between handspun and worsted or machine-processed and damaged fibers is also observable. Kemp fibers are larger wool fibers found on the backs of sheep; they can be identified along with the smaller fibers as evidence for the type of

wool or sheep. Warp yarns act as the skeleton of the textile under the weft yarns and can be identified and microscopically compared to weft yarns. Differences and similarities noted between weft and warp yarns help identify trade materials, Navajo-produced materials, and technical weaving qualities and also provide better understanding of the textile's complexity.

After yarn and fiber identification is noted for each sample, molecular examination or quantitative and qualitative chemical analysis of the dyes is done using High Pressure Liquid Chromatography (HPLC)—the fourth level of investigation to gather evidence for our working theories. HPLC is a well-established process for testing the purity of pharmaceuticals and water and for testing biomedical materials. HPLC technology works best when used with a computerized Photodiode Array Detector (PDA) that helps identify the different dyes and dye components. The process allows us to examine light absorption qualities from each peak on a chromatograph. Separations of dyes are displayed on a

chromatograph as separate peaks, and each peak can be identified by the spectral information or light frequencies detected. Spectral libraries of known dye standards have been established to compare with unknown samples of dyes extracted from yarn samples.

These dye standards include sixty-five pre-1900 synthetic dyes that when found can be associated with patent dates in the Color Index (CI). An extensive collection of natural dyes and dye components all having CI numbers is also used to extend the analysis beyond basic, natural red dyes, such as lac and the well-used variety of cochineal from Mexico and South America,[2] to being able to identify Armenian cochineal from the Middle East, as well as dozens of yellows and browns, greens, blues, and nat-

ural shellfish purple dye. There is also a collection of fifty natural dyes and dyed yarns assembled with the help of Navajo weavers and dyers to identify native Navajo natural dyes (courtesy of Isabell Meyers Deschinny). All of the dyes except the native Navajo ones, including the sixty-five pre-1900 synthetic dyes, have been certified as accurate by Dr. Helmut Schweppe (below), a well-published career dye analyst for BASF (Badische Anilin and Soda-Fabrik), the first European synthetic dye mill. Only two laboratories in the United States have this collection of

Figure 85. A collection of dye standards certified as accurate by Dr. Helmut Schweppe. These standards are used along with dyes extracted from wool dyed with these same standards to develop the computerized dye standard libraries that are used to identify spectral information from unknown dye samples from textiles.

certified dye standards—the J. Paul Getty Museum in Los Angeles and the Smithsonian Institution in Washington, D.C.

Technical analysis sheds some light on dating the Classic period in Navajo textiles. Most art historians end the period in 1868—the time when most Navajos were released from incarceration at Fort Sumner in eastern New Mexico (1864–1868). After Bosque Redondo, using Classic-period skills and the same materials or even new yarns, dyes, and styles, weavers produced textiles technically equivalent to or in some examples superior to those woven before the incarceration. If we consider the evidence that the same weavers were working both before and after 1868, then the reputed end of the Classic period in the literature today may be based not so much on the weavings or weavers but on an easily established historical event.

The Navajos employed traditional designs as well as innovative new styles after 1868, and using an extended palette of predyed commercial yarns and synthetic dyes, they blossomed aesthetically. This is best exemplified beginning about 1880 by Germantown textiles made with machine-spun, predyed yarns. Many stylistic elements and the characteristic use of materials remained unchanged in the textiles examined, but if we look closely we may find evidence in the yarns and dyes for changes from or consistencies with the period before Bosque Redondo.

Changes in materials and styles become more evident in weavings as they get closer to the 1900s. Many textiles are called transitional weavings because of stylistic and technical qualities such as stylized borders and the trend toward heavier, totally handspun rugs. The period of weaving after 1900 is called the Rug period. Early in the Transitional period, materials changed from raveled red, commercial, and handspun yarns all appearing in one textile, which typifies Classic-period weaving, to exclusive use of synthetically dyed and naturally colored hand-spun yarns. We will use dates from synthetic dyes and other criteria, including technical and forensic information, to help determine if the selected saddle blankets were produced by Classic-period weavers, rather than placing them in the art historical time line that closes the Classic period between 1865 and 1868. Such criteria are helpful in initial observations but frequently arbitrary in interpreting evidence from textiles made before 1900. Synthetic-dyed raveled yarns from the 1880s have been found in technically Classic-period weavings with worsted, lac-dyed raveled yarns, but the use of lac-dyed raveled yarns were supposedly displaced by cochineal-dyed yarns after 1865. Based on these and other conflicts, we will determine Classic-period weaver qualities and assign that designation to the weavings examined.

In the first textile (page 92, center), some repairs, using several kinds of yarns, are apparent along the edges and in the body of the piece. No sweat or wear patterns exist, and the white bands in the middle are not compressed or worn at all; thus the repairs are not from use as a saddle blanket. The red bands are raveled from flannel or commercial yarns and re-spun into yarn for the textile; this pre-Bosque skill helps tie the weaving to the Classic period. Small rectangles arranged to form diamonds are the dominant stylistic elements, leaving triangles along the sides. Early weavings of the Classic period used stepped rectangles corner-to-corner to form diagonal design elements. True diagonal design lines do not seem to occur in any textile with a provenance before the mid 1870s (Hedlund and Stiver 1991). This historical observation must not be overgeneralized to mean that stepped-rectangle design elements indicate that weavings containing them are always older than the mid 1870s. This design element has been revived and reused even today. The weaver used two raveled yarns twisted together to produce a small,

two-ply yarn, and she also used a single-ply yarn of the same red hue in other areas, which appeared to be handspun. This would indicate she was carding and respinning commercial or flannel yarns into a new, larger yarn.

Three-ply, commercially produced yarns were used to weave yellow, rectangular design elements, and at some places in the textile these were doubled to six plies. Commercial yarns are spun, twisted, and dyed so they are ready to use in a weaving. Commercially plied yarns dyed with natural dyes are called Saxony yarns, and synthetic-dyed ones are called Germantown, even though the dye masters on the East Coast and in Germantown, Pennsylvania, used natural dyes before the introduction of synthetic dyes. With more research we may be able to identify more qualities in these yarns and be more precise as to their origins. (A microscope reveals where the weaver used this two-ply red yarn and may have re-carded it to a one-ply yarn in some places.) The dye analysis found a difference between the red raveled two-ply and one-ply yarns from narrow bands in the middle, indicating restoration or use of two different flannel sources.

The dyes found in the double saddle blanket are:

1. Red, one-ply loosely spun or twisted yarn: cochineal.

2. Yellow, three-ply commercial yarn: natural yellow dye.

3. Red, two-ply raveled **S** twist, **Z** spun: cochineal and a synthetic dye (not well matched).

4. Selvage yellow yarn: synthetic yellow, not the same as weft.

5. Top band of red one ply or two plies in different locations: cochineal and natural yellow dye.

All the yellow dyes mixed with cochineal were the same natural dye. Technically, the one-ply yarn is considered handspun and could be evidence that the Navajo used cochineal for red dye. Examination of the two-ply raveled red yarn showed cochineal and a synthetic dye. The restoration along the edges is fairly extensive in the blanket, and we may have extracted samples of overdyed or restored yarns. This assumption is supported by the Spectral Report information that does not match well the dye standards from the pre-1900 group of standards, so the dye may have come from a later time, post 1900, when the piece was restored. Retesting each of the two-ply red yarn's plies separately would give more information because we found the same natural yellow and not a synthetic in the other red yarns tested; thus we would expect the synthetically dyed yarn to not be consistent or used originally. The yellow, three-ply yarn had a yellow dye different from that used with one of the two-ply red yarns, indicating the flannel and commercial yarns have different origins. The synthetic dye found on the selvage yarn indicates it was added after the textile was made. Based on the idea that the weaver would have used the same yellow yarn in the selvage as in the weft, this is evidence that the selvage was repaired with a synthetically dyed yarn. All of this evidence indicates that several sources of yarns and dyes were used for both the original weaving and restoration of this textile.

The presence of all natural dyes except for the synthetic ones employed in the restoration suggests that the textile predates 1880, the date when synthetic dyes became commonly used by dye mills as well as the Navajo. Further, if no synthetic dyes are present consistently or in originally fabricated, non-restored areas and there are no diagonal design lines, then the saddle blanket could have been made in the 1870s or earlier.

The next textile examined (page 92, bottom) is a single saddle blanket with warp ends that were looped and used to tie down and hold tension on the warps. When the weaving was finished and removed

from the loom, this technique left looped tassels at one end. This is an unusual technique because the traditional Navajo warp is integrated with selvages at the top and bottom, making a complete textile or "web" before the colored weft yarns are added to make a blanket. In this example, the warp did not have the integrated selvage yarns at one end, which left the exposed warps as looped tassels. The weaver also used a three-ply white yarn, just as the blue, yellow, dark red, and red yarns are all plied, and this suggests that the three-plied yarns had a common source. Because they vary in the number of plies, we must consider two different commercial yarn sources for the four-ply yellow and red yarns and the three-ply blue, white, and red commercial ones. In the dye analysis, we found the same flavonoids in the yellow and red plied yarns but only a trace amount (which is likely a contamination) in the one-ply red, handspun yarn, indicating it is from a different source. The chromatographic information indicates the handspun yarn was not dyed with the same dye batch as the commercial and raveled red yarns. The dye analysis thus supports the idea that this textile is an example of the Navajo use of cochineal-dyed, handspun yarn. Another noticeable feature is the asymmetric use of bands in the chevrons at the nontasseled end. Varied band widths, color used to form stripes of light and dark areas in the same design element, and irregularly placed design elements are all characteristics of a Classic weaver.

The dyes and yarns from the blanket provided the following evidence:

1. Dark red, four-ply Z spun, S twist: cochineal mixed with natural yellow.

2. Red handspun or one-ply from ¼-inch-wide stripes in the middle: cochineal (trace of natural yellow found).

3. Blue, three-ply commercial yarn: synthetic blue, patent date 1858.

4. Yellow, four-ply Z spun, S twist: natural yellow

dyes (not the same yellow mixed with the red raveled yarns above).

We can theorize that this textile was not made after 1880, for a synthetic dye with a patent date of 1858 is present. Allowing time for the weaver to obtain the yarn and weave the textile, we can add a conservative four years; thus the earliest possible date it could have been woven is ca. 1862. This gives an eighteen-year period when the textile likely was made, but the evidence indicates it was almost certainly woven during the Classic period.

The last textile examined (page 92, top) is somewhat larger than a typical saddle blanket and has many aesthetic and technical qualities of a Classic-period weaving. The basic banded design, similar to the previous example, is accented with diamonds at each end constructed from rectangles arranged in diagonal design steps that contact each other corner-to-corner. Lines at each end form triangular-shaped cells around the dark indigo diamonds, but none of these design elements were made with woven diagonal lines. In the middle are indigo diamonds with unique white accents to bring the center design element into harmony with the ends and to pull all three areas into recessed visual fields; these fields are created by using yarns that contrast with the blue, red, and white bands in the middle. Such design elements are part of Classic-period aesthetics.

The technical qualities are also consistent with the skills of a Classic weaver. Raveled red yarns vary from a one ply to very loosely spun two to five plies of fine flannel threads spun into one yarn. The red one-ply yarn is also considered a handspun yarn, making this an example of the Navajo use of cochineal red dye (Fig. 86). This is supported by the dye analysis, which did not reveal the same natural yellow dye on the one-ply yarn but found it on the other two commercial and raveled yarns. Reinforcing the idea of two sources of yarn for the red color, the three-ply commercial and five- to two-ply raveled

Figure 86. Microphotograph of three different yarns in Figure 30 (page 92, top). The right is a commercial 3-ply yarn worsted yarn. In the middle is a raveled 2 to 5-ply worsted yarn. At the right is a bright red 1 or 2-ply hand spun yarn. All yarns are dyed with cochineal.

red yarns seemed to be worsted yarns, and the one-ply and two-ply (handspun) bands, which have different dye analysis characteristics, were not worsted. There are handspun white, dark blue, and light blue, Navajo-dyed weft yarns that also were not worsted, and a handspun white wool warp.

The yarn and fiber analysis of the textile is:

1. Commercial, three-ply red yarn: cochineal and natural yellow dyes.

2. Five- to two-ply lighter red than above: cochineal and natural yellow dyes.

3. One-ply or two loosely spun red: cochineal and a trace amount of natural yellow dyes.

4. Light blue, handspun: indigo and natural yellow.

To think of these textiles as a point on an art-history time line or as belonging to this or that period is difficult, but scientific observations of the yarns and dyes, combined with the art history, provide evidence that Classic-style textiles were indeed woven after that period. These technical observations can be used to make stylistic judgments from an art historical perspective more accurate. Although we cannot be accurate about the age of these textiles until we have the objective information, cumulatively, this research can support or help change the criteria that determine art-history time lines or periods.

Navajo weaving produced in the late nineteenth century changed more than it had in the previous two hundred years. The U.S. war with Mexico forced trade in the Southwest to shift from Mexico to the United States by 1850. When the Spanish were no longer in control of Mexico, they could not regulate trade with the Navajo or control their territories, which became the southwestern United States. The railroad reached New Mexico in 1880, and this brought tremendous amounts of supplies, including yarns, bolts of flannel, and dyes, into the region. Navajo textiles reflect these changes even when they were woven by the same weavers operating before the new materials arrived.

Dye mills in Europe and the United States made their own transitions from natural to synthetic dyes from about 1880 to 1890, when both were used side by side (Adrosko:1982). This is interesting because the history of the dye industry itself is not in step with the art history perspective that ties the end of the Classic period to the end of Bosque Redondo. Instead, we have evidence both from the textile industry and Navajo weaving that the greatest period of transition was from the mid to late 1870s to 1900.

During that time, the Navajos, like much of the world around them, sought to maintain their traditions, religion, and other cultural qualities in the midst of rapid changes and conflicts. Evidence from textile research has revealed transitions, as new materials and design elements were tried concurrently with older materials and traditional styles, but we have not found evidence for an abrupt change in Navajo textiles occurring in the 1860s. There seems to be a hiatus of sorts, with fewer textiles made from 1865 to 1875 (or there may be fewer surviving examples), but Classic-period weavers continued weaving after 1868 using their pre-1868 skills. We are also finding a relatively high frequency of handspun yarns dyed with cochineal that do not have the yarn or fiber characteristics of worsted commercial or raveled flannel yarns, although gaps in the literature regarding the Navajos' historical use of cochineal have been explained by stating that they did not use the dye.

All this in a saddle blanket. It would seem to be much more than just a textile used under a saddle, but after so much time and history, these blankets are a rich art form with a wealth of forensic details. All pre-1900 Navajo textiles contain information that can give insight into this complex textile art, materials and trade practices, Navajo aesthetics, ethnology, and weaving techniques, as well as the history of the period. Historians do scholarly research but by necessity must be intuitive and creative when it comes to interpreting the past and making sense of the gaps we know little about, based on available information. Although several art historians thought these three saddle blankets were not from the Classic period, research provided evidence that they surely are. The past is gone, and accurate records of most of the history of Navajo weaving are too. A good starting point is to ask what the textile can tell us from an objective, reproducible, scientific point of view to better organize and clarify what little we do know from a poorly documented, historically complex, and rapidly changing past, the period from 1850 to 1900.

NOTES

1. For a discussion of the wool trade, see Worthington C. Ford's 1894 study, *Wool*.

2. Dyes used in the 1800s shifted from Old World natural dyes produced from plants and insects to synthetic dyes; until then, much of the New World had used the insect *Dactylopius coccus* to make cochineal for red dye, as well as the *Kerria lacca* insect from India, which was used primarily by English mills to make lac.

REFERENCES

Adrosko, Rita J. 1982. *Natural Dyes in the United States.* U.S. National Museum Bulletin 281. Washington, D.C.: Smithsonian Institution.

American Association of Textile Chemists and Colorists. 1993. *The Color Index.* NC: Research Triangle Park.

Amsden, Charles Avery. 1974 [1934]. *Navajo Weaving: Its Technic and Its History.* Santa Ana, CA: Fine Arts Press, in cooperation with the Southwest Museum. Reprint, Glorieta, NM: Rio Grande Press.

Ballard, Mary W. 1989. *Important Early Synthetic Dyes: Chemistry, Constitution, Date, Properties.* Washington, D.C.: Conservation Analytical Laboratory, Smithsonian Institution.

Ford, Worthington C. 1894. Treasury Department. *Wool and Manufactures of Wool.* Washington, DC: Government Printing Office.

Hedland, Ann Lane. 1990. *Beyond the Loom.* Boulder, CO: Johnson Books.

Hedland, Ann Lane, and Louis I. Stiver. 1991. "Wedge Weave Textiles of the Navajo." *American Indian Art Magazine* 16, 3 (Summer):54–65.

Hollister, Uriah S. 1972. *The Navajo and His Blanket.* Glorieta, NM: Rio Grande Press, Inc.

James, George Wharton. 1920. *Indian Blankets and Their Makers.* Chicago, IL: A. C. McClurg and Co.

King, Rosalie Rosso. 1985. *Textile Identification, Conservation, and Preservation.* Park Ridge, NJ: Noyes Publications.

Leene, Jentina E. 1972. *Textile Conservation.* Washington, D.C.: Smithsonian Institution.

Mauersberger, Herbert R. 1947. *Matthews' Textile Fibers: Their Physical, Microscopical, and Chemical Properties.* New York: John Wiley & Sons, Inc.

Mera, H. P. 1995. *Pueblo Indian Embroidery.* Mineola, NY: Dover Publications, Inc.

Ramsey, Albert R. J., and Claude H. Weston. 1917. *Artificial Dye-Stuffs, Their Nature, Manufacture, and Uses.* New York: E. P. Dutton and Co.

Reichard, Gladys A. 1928. *Social Life of the Navajo Indians.* Columbia University Contributions to Anthropology, vol. 7. New York: Columbia University Press.

_____. 1974 *Weaving a Navajo Blanket.* Reprint, New York: Dover Publications, Inc.

Robinson, Stuart. 1969. *A History of Dyed Textiles.* Cambridge, MA: M.I.T. Press.

Rodee, Marian. 1987. *Weaving of the Southwest.* West Chester, PA: Schiffer Publishing, Ltd.

Schweppe, Helmut. 1993. *Handbuch der Naturfarbstoffe,* Vorkommen, Verwendug, Nachweis. Landsberg/Lech, Germany: Ecomed.

Wouters, Jan. 1990/1991. *A Norm for HPLC Analysis of Natural Dyes: A Necessary Tool for the Analyst and the Textile Curator.* Brussels, Belgium: Institut Royal du Patrimoine Artistique.

Wouters, Jan, and Noemi Rosario-Chrinos. 1992. Dye Analysis of Pre-Columbian Peruvian Textiles with High-Performance Liquid Chromatography and Diode-Array Detection. *Journal of the American Institute for Conservation* 31, 2:237–255.

Wouters, Jan, and Andre Verhecken. 1989. The Scale Insect Dyes *(Homoptera: Coccoidea).* Species Recognition by HPLC and Diode-Array Analysis of the Dyestuffs. *Annales de la Societe Entomologique de France* 25, 4:393-410.

_____. 1991. High-performance Liquid Chromatography of Blue and Purple Indigoid Natural Dyes. *Journal of the Society of Dyers and Colourists* 107:266–269. Bradford, UK.

The Cowboy Market for Navajo Saddle Blankets

By B. Byron Price

No GROUP OF HORSEMEN more eagerly embraced Navajo saddle blankets than did the cowboys of the American West. Because their livelihoods were dependent upon reliable horseflesh and they were expected to provide their own saddles and saddle blankets, these colorful riders took particular interest in the health of their mounts and the quality of their tack.

Top hands lavished much of their meager wages on quality gear that could, in cowboy parlance, "stand the gaff." Saddle blankets were no exception. Texas cowboy Carl P. Benedict recalled that a good cowhand "generally paid more for the blanket than for any other part of his rig, except the saddle" (Benedict 1943:6–7). Charles Siringo, the famous cowboy-detective, remembered that cowboys in the 1870s and 1880s paid $5 for common blankets, but some procured fancy ones costing ten times that amount (Siringo 1914:51–52).

Whatever the price, quality saddle blankets were of such value that they were sometimes the targets of cow-camp thieves. "The great majority of cowboys are strictly honest and have hearts in them like red

steers," wrote a correspondent of the *Texas Livestock Journal* in 1882, "but there is a small class of them who, when outfits are driving up, prowl around and steal quirts, misplaced spurs they have a fancy for, and inadvertently exchange their old saddle blankets for better ones" (Slade 1882:8).

Western horsemen protected the backs of their mounts with a variety of saddlecloths or pads, including old quilts. Before Navajo saddle blankets began to appear in quantity in the 1880s, factory-made saddle blankets of wool or wool-cotton blend dominated the western market. Many cowpunchers favored gray and indigo-colored, government-issue blankets that weighed a little over three pounds. Measuring 75 inches long by 67 inches wide, such covers could be used for bedding as well as saddle padding. Anecdotal evidence suggests that at least some cowpunchers acquired government blankets through gambling or by trading liquor to Indians and soldiers (Kellner 1938; Rickey 1976:117; Ingerton 1937:15, 18–19; Walker et al. 1937:36; Dorsey and McPheeters 1999:352).

Coarse wool saddle blankets made in California

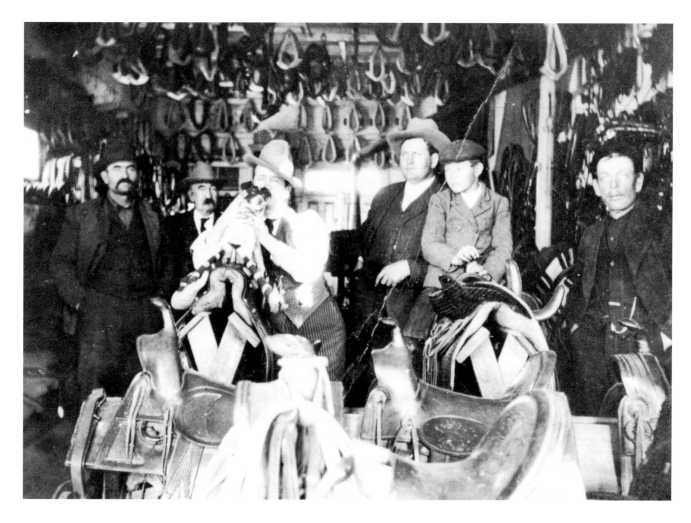

Figure 87. Unidentified Gainesville, Texas, saddlery, ca. 1909.
Courtesy Panhandle Plains Historical Museum Collection.

were also popular among many western riders, as
were colorful woolen *sudaderos* produced on treadle
looms on both sides of the Mexican-American bor-
der (Walker et al. 1937:36; Rickey 1976:117). "In the
Southwest," wrote one observer in 1894, "he [the
cowboy] is apt to sport a variegated saddle-cloth
with fringed edge, such as the Mexicans parade"
(Dodge 1894:101). Hispanic weavers on the King
Ranch in South Texas produced a distinctive style of
saddle blanket adorned with the ranch brand, the
Running W (Graham 1991:93).

At least a few cowboys and a larger number of
urban horsemen secured heavy felt saddle blankets or
fancy saddle pads known as *coronas*. More expensive
than most blankets, coronas were often custom-
made of fine Brussels carpet, lined with sheepskin,
trimmed with leather, and cut to conform to the
shape and dimension of the saddle skirts. Felt blan-
kets, however, rarely possessed the durability
required of a cowboy's rig (Hermann H. Heiser
Saddlery Co. [1915]:212, 214; Rollins 1936:125;
Lindmier and Mount 1996:127, 129).

In areas where manufactured goods were scarce
and expensive, cowboys emulated Plains Indian
horsemen by making their own saddle blankets from
animal hides. According to rancher and frontiersman
Charles Goodnight, many Colorado cowboys in the
late 1860s and early 1870s used antelope hides as sad-
dle blankets. Others chose the tanned hides of buf-
falo calves (Mace 1998:67; Goodnight 1928:25;
Adams 1968:7).

The extent of padding necessary to maintain a sound back depended in large measure on the type of riding required, the size and weight of the saddle, and the conformation and condition of the horse. Traversing rough terrain, cutting and stopping at full speed, and roping heavy steers inevitably taxed the backs and withers of even the strongest horses. Many developed sores or galls that, aggravated or unattended, eventually disabled the animals (Jaques 1989:86). An ex-cowboy told one interviewer, "I have seen them old horses' backs just as sore and them flies just following it around just like they was after a dead brute" (Roberts 1937:21).

Clean, well-maintained saddle blankets of adequate size mitigated these conditions. Most mass-produced saddle blankets had to be folded two to four times or used in pairs to achieve a desirable thickness. Even then, their presence did not always ensure adequate ventilation of the horse's back. In such cases, an absorbent sweat cloth or pad was often placed next to the skin to help prevent scalding or chafing. Following a practice widespread in the West before the Civil War, many cowboys used a gunnysack or some other piece of loose-fibered burlap to keep the backs of their horses dry and cool (Lowe 1965:61–62; Stillman 1990:26; Dodge 1894:101).

Lightweight sweat blankets and pads woven of or stuffed with porous horsehair, mohair, deer hair, and even Spanish moss produced the same beneficial results as burlap. These wonderfully absorbent covers were quick to dry and molded easily to the contours of a horse's back. Although many were homemade, during the late nineteenth and early twentieth centuries the Sanitary Hair Pad Company of Chicago and several other manufacturers produced countless gall-retardant hair blankets and pads weighing as little as two pounds each. The market for horsehair blankets suffered, however, when they were blamed for transmitting anthrax (Kniffen 1953:179; Sentinel Butte Saddle Co. [ca.1916]:71; Hamley & Co.

1924:87; N. Porter [1936]:116; Garcia Saddlery Co. [1929]:129; Lindmier and Mount 1996:130).

Saddle blankets caked with salt and sweat or continually ridden wet during the summer heat were sure to cause saddle sores and tender-backed horses. Yet finding time and water to wash blankets on the range was sometimes difficult. Horsemen with more than one blanket rotated and refolded them daily to ensure a clean, dry, smooth fit (Coe 1968:151; Rollinson 1948:37).

Even the finest saddlecloths tended to slip, crawl, or wrinkle if improperly folded or misplaced on the horse's back. Although sheepskin-lined saddle skirts, available beginning in the early 1880s, helped hold saddle blankets more securely in place, many factory-made blankets and pads were simply too light and ill-woven to withstand the unrelenting demands of ranch work (Rice 1881; Beatie 1981:67; Clevenger 1972:84).

It is little wonder then that heavy, thick, sturdy, and absorbent Navajo-made saddle blankets were so rapidly adopted by the cowboys of the West when they began to appear in commercial quantities in the early 1880s. Ironically, a shift in Navajo weaving was already underway thanks to competition from machine-made textiles, which curtailed the production of wearing blankets and accelerated the output of floor rugs and saddle blankets. By this time, too, the availability of commercial dyes and yarn had enabled Navajo weavers to dramatically increase their output of these goods (Zimmer 1998:81).

At least a few cowboys and ranchers operating near the Navajo Reservation had acquired Indian-made saddle blankets by the late 1870s. The quality and durability of these coarsely woven woolen blankets soon attracted adherents in Mexico as well, where traders sold large numbers to vaqueros annually (Howard 1952:9).

The extension of the railroad to the Four Corners area and the trading center at Gallup, New

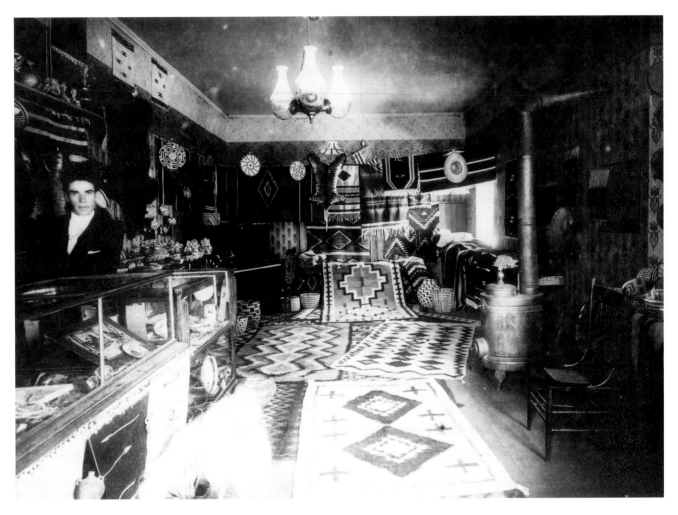

Figure 88. Interior of the Jack Collins Curio Store, Santa Fe, New Mexico, ca. 1910. MNM 10718.

Mexico, and the development of a network of Indian traders and trading posts by the early 1880s facilitated the spread of Navajo saddle blankets beyond their home region. Drifting cowboys and the growing use of trade catalogs by saddleries and western outfitters introduced "Naveejos," as some denizens of the range called them, to an ever-larger market throughout the decade. In 1937, former Texas cowboy Charlie Walker told historian J. Evetts Haley that he did not begin to encounter Navajo blankets on the West Texas range until after 1884. Walker recalled that cattle drovers accompanying herds from the Big Bend to Colorado by way of the Pecos returned with

Navajo-made saddle blankets, and by the spring of 1889 they were widely used (Kellner 1938; Walker et al. 1937:36; Liles and Howell 1937:18). Harry Ingerton, another of Haley's informants, remembered seeing Navajo saddle blankets for sale in Las Vegas, New Mexico, in 1883, and that soon they had "appeared in quantity in Roswell and soon after in Amarillo" (Ingerton 1937:15, 18).

Although Indian-made saddle blankets did not appear in the 1883 trade catalog issued by the Denver Manufacturing Company, a prominent Colorado outfitter (Denver Manufacturing Co. 1883:164), by the mid 1880s Cheyenne, Wyoming, saddle maker J. S. Collins and Company stocked "a large line of genuine Navajo Indian Saddle Blankets ranging in price from $1.50 to $6.00 and $7.00 each, according to sizes and qualities." Collins also offered "regular

Folding Saddle Blankets—prices, from $1.50 to $4.00 per pair; and a full assortment of Ladies' and Gents' Saddle Cloths, from $1.25 to $3.50 each" (J. S. Collins & Co. [ca. 1886]:61), as well as several grades of Brussels carpet and buffalo-hair saddle pads at prices from $1.75 to $4 each. By the 1890s, many other saddleries from Texas to Montana and the Dakotas had begun to stock Navajo saddle blankets to meet their customers' growing demand (Knight 1983:28–29).

The presence of saddle blankets in the inventories of major western saddle houses, however, was still far from universal. L. Frank, a premier San Antonio, Texas, saddle manufacturer, for example, did not include them among the cloth, carpet, and felt saddle housings advertised in its first catalog, published in 1890. And judging from the contents of surviving trade literature, few major Pacific Coast saddleries carried Navajo saddle blankets until well into the twentieth century. This was certainly the case with such leading San Francisco makers as L. D. Stone and Company and Main and Winchester. The latter firm had issued comprehensive trade catalogs at least since the late 1870s (L. Frank 1890; L. D. Stone & Co. [c.1894]:191-194; Main & Winchester [No. 10]:51–52; Main & Winchester [1878]).

Navajo saddle blankets entered the marketplace at the zenith of eastern and foreign investment in the western range cattle industry. Corporate-owned ranches predominated and with them corporate attitudes about labor, cattle, and horses. On most ranches cowboys were not allowed to own their own mounts. Instead, they were issued a string of six to ten horses and were expected to maintain them in first-rate condition. "The cowboy is careful of his ponies," wrote one knowledgeable spectator, "not only from a horseman's motives, but because he is held to account for them" (Dodge 1894:100–101). Cowpunchers whose horses consistently turned up with sore backs were soon looking for another job.

According to Bob Beverly, a longtime cowboy and drover, few wagon bosses "would keep a man if his saddle hurt a horse's back" (Beverly 1938).

The appearance of Navajo double saddle blankets in commercial quantities in the early 1880s also coincided with the introduction of a new generation of stock saddles, much heavier and with larger skirts than their predecessors. Most of these new models averaged forty to fifty pounds in weight, with a few reaching sixty pounds. Although subsequent designs produced lighter models with smaller, rounded skirts, the size, weight, and use of stock saddles continued to demand substantial padding (Vernam 1964:327; Smith 1977:92).

Thicker and more absorbent than most of their competitors and with an open weave that allowed for the freer circulation of air over the horse's back, Navajo saddle blankets possessed a competitive advantage over most of the mass-produced saddle blankets and pads in the marketplace. In his 1894 book, *Riders of Many Lands*, Theodore A. Dodge, a former army officer, paid homage to the Navajo blankets then used on the cattle ranges of the Southwest: "These wonderful bits of handwork, of bright, agreeable colors, are worth from fifty dollars upwards, never seem to wear out, are cool and pleasant to the pony's skin, do not gall, and are by long odds the best thing under a saddle which exists" (Dodge 1894:101).

Whereas cheaply made blankets were subject to fraying, fading, and shrinkage, Navajo saddle blankets were the model of durability. "A Navajo blanket," said one latter-day writer, "will survive many years of rough use and show no signs of wear, except perhaps that it becomes a little softer" (Howard 1952:8). Many saddle makers no doubt concurred with their distinguished colleague S. D. Myres of El Paso, Texas, who declared: "There is no blanket that equals a 'Navajo' for wearing value" (S. D. Myres Saddle Co., n.d.:59). According to the 1924 Hamley

Company catalog, Navajo blankets "wear so long that they are really the cheapest to buy—to say nothing of the more satisfactory service they give" (Hamley & Co. 1924:87). Wear leathers, sewn on each side of a saddle blanket to retard fraying where it contacted the rigging straps, extended the life of the covering and were well worth a dollar or two additional cost (Mora 1946:108; Price 2001).

The finest Navajo saddle blankets owed their strength and absorbency to a relatively loose twill weave that produced a thick, soft padding. The heft of the blanket also curbed wrinkling, which was another common cause of sore-backed horses. Although most saddleries stocked Navajo saddle blankets in both single and double sizes, the 30-inch-square single blanket did not sufficiently support the weighty stock saddles used in ranch work. Instead, most cowboys favored the double Navajo made in the same or a slightly larger width and twice as long, which, when folded in half, provided a thicker cushion (Marquess 1977:25, 31; Clark 1963:245; Hamley & Co. 1924:87; Mora 1946:108).

Riders placed their saddle blankets, regardless of size and type, well up on the withers of the horse and folded them so that they extended down equally on both sides. The arrangement of the blanket, however, was sometimes a function of regional preference. Cowboys on the Great Plains, for example, tended to array their blankets with generous edges extending below the saddle skirts, while their Pacific Coast counterparts folded them more compactly to hang even with the edges of the skirts (Mora 1946:108; Vernam 1964:308).

Apart from practical considerations, the design and color of Navajo saddle blankets appealed to fashion-conscious cowpunchers. "The old cowboys loved color," wrote Glenn Vernam, "anything to relieve the drabness of backcountry workaday life. . . . Beautiful Navajo blankets formed a bright background for the finest in saddlemaking art. No two were quite alike.

Each set the rider apart individually. Collectively, they presented a kaleidoscope of scintillating color that was romance on parade" (Vernam 1964:400–401).

Woven in traditional designs, most Navajo saddle blankets sported stripes or simple geometric patterns in their corners or along their edges. To relieve the monotony, weavers sometimes produced a different design on each half of a blanket, which allowed riders to change the pattern on view by simply refolding the blanket. Such motifs were usually rendered in natural wool colors of gray, brown, or black, sometimes with colorful accents of red, orange, yellow, or other hues. Savvy saddle makers usually charged more for the fancier types, which could be sold as floor rugs (Howard 1952:9; Marquess 1977:25; Zimmer 1998:82-83; for examples of pricing based on design, see Keyston Bros. 1939:46; Stockman-Farmer Supply Co. 1929:40).

By 1910, Navajo goods dominated the saddle blanket market in the Southwest and on the Great Plains, a trend that would continue for more than a half century (Vernam 1964:364). In its 1916 catalog, the Sentinel Butte Saddle Company of North Dakota boasted: "The Navajo saddle blankets are too well known among riders for us to comment upon their merits, their long use throughout the West having established their supremacy among various kinds of blankets now used" (Sentinel Butte Saddle Co. [ca.1916]:72). Yet on the eve of World War I, Navajo-made saddle blankets were still not part of the inventories of such prestigious western outfitters as the Los Angeles Saddlery and Findings Company; Stock Yards Harness Company, Kansas City, Missouri; and Hamley and Company, Pendleton, Oregon (Los Angeles Saddlery & Findings Co. 1912:347–349; Stock Yards Harness Co. [ca. 1910]):52–53; Hamley & Co., n.d.:39–40).

Indian traders in New Mexico and Arizona are said to have garnered a higher profit margin on saddle blankets than on any other trade goods. Double

Figure 89. Postcard advertising Mexican, Chimayó, and Navajo Saddle Blankets, Kirk Trading Co., Gallup, NM, ca. 1955. Collection of Don Jenkins.

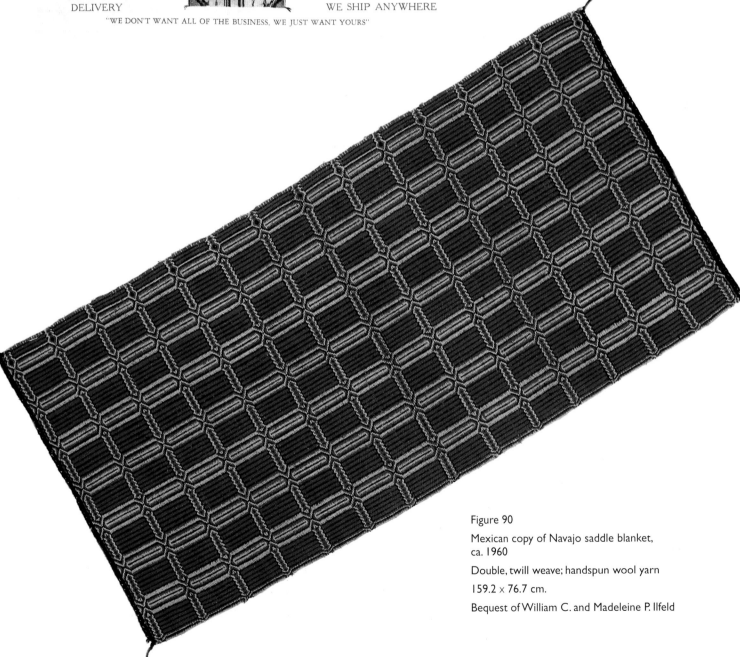

Figure 90

Mexican copy of Navajo saddle blanket, ca. 1960

Double, twill weave; handspun wool yarn

159.2 × 76.7 cm.

Bequest of William C. and Madeleine P. Ilfeld

blankets that sold to western outfitters for $.75 to a $1 per pound wholesale at the turn of the century brought $3 to $6 in the retail market depending upon the quality and pattern (Zimmer 1998:83). In outfitters' trade literature, Navajo weavings appeared alongside a variety of mass-produced saddle blankets and pads. In contrast to the bland text that accompanied most goods, some of the captions advertising the Navajo-made products attempted to evoke the colorful mystique associated with the natives of the American Southwest. An S. D. Myres Saddle Company catalog from the 1930s, for example, suggested that the decorative motif present in a Navajo blanket was "expressive in Indian language of some ideal" and that the blanket's "rich and natural color," usually achieved with commercial dyes, was the weaver's "secret" (S. D. Myres Saddle Co., n.d.:59).

A duotone illustration depicting an individual blanket or perhaps an array of blankets and rugs usually accompanied these descriptive and occasionally florid captions. One of the most elaborate such advertisements appeared in catalogs issued by Charles P. Shipley Saddlery and Mercantile Company, Kansas City, Missouri, between about 1916 and the 1930s. Shipley's full-page presentations included four Navajo saddle blankets and seven rugs. A few years earlier, R. T. Frazier's Saddlery of Pueblo, Colorado, which issued some of the most extensive and elaborate trade literature in the West, had enhanced its own full-page presentation of reservation-made saddle blankets and rugs with four line drawings. One featured a Navajo weaver at her loom and another, a family of Navajo blanket weavers. The other two decorative cuts of Indian life bore no relationship to Navajo culture. Shipley's and Frazier's pleasing arrangements notwithstanding, many of the illustrations of Navajo saddle blankets appear crude compared to the more numerous and carefully

prepared cuts representing other saddle blanket makers (Charles P. Shipley Saddlery and Mercantile Co. [ca. 1916]:67, and 1935:42; R. T. Frazier's Saddlery, n.d.:83). In its 1916 catalog, the Sentinel Butte Saddle Company used the same illustration of a Navajo weaver at work that Frazier had several years earlier (see Sentinel Butte Saddle Co. [ca. 1916]:72).

Despite their popularity among western riders, Navajo saddle blankets faced formidable competition from the products of such northern and eastern manufacturers as the Louisville Girth and Blanket Mills of Kentucky, the American Pad and Textile Company in Ohio, and the Northern Ohio Blanket Mills with headquarters at Cleveland (Louisville Girth and Blanket Mills 1898:57; R. T. Frazier's Saddlery, n.d.:83; [Northern Ohio Blanket Mills] 1900:66). In response to the popularity of Navajo saddle blankets, several of these companies began to offer colorful, machine-woven wool and wool-blend saddle blankets complete with tribal names and what some advertisers termed "genuine Indian designs" (Hermann H. Heiser Saddlery Co. [1915]:213). Sentinel Butte Saddle Company, for example, offered a 4½-pound, "imitation Navajo" blanket called the "Rough Rider," priced at $5.50 (Sentinel Butte Saddle Co. [ca. 1916]:71). Fred M. Stern, a San Jose, California, western outfitter, described his $3.50 "Stern Special" saddle blanket as looking "like a genuine Navajo" (Fred M. Stern, n.d. [No. 29]:26), and Hamley and Company of Pendleton, Oregon, featured a heavy, blue wool blanket it termed the "next thing to a Navajo" (Hamley & Co. 1924:88). Made in a variety of sizes and ranging in thickness from single to four ply, some of these pretenders made suitable floor rugs, convalescent blankets, and couch covers as well as saddle blankets (Hermann H. Heiser Saddlery Co. [1915]:213).

In the late 1920s and early 1930s, mohair saddle

blankets, some of them made in Del Rio, Texas, by the Keller Company and others in Mexico, challenged the domination of Navajo varieties in at least some parts of the Southwest. Competitively priced, single mohair saddle blankets cost from $3 to $4.50 and double blankets $7 to $8.50, sums equal to or slightly below the lowest grade of Navajo saddle blanket in the saddle maker's inventory (E. T. Amonett [1930]:57; R. J. Andrew & Son [ca. 1931]:54, 56).

R. J. Andrew and Son, a saddlery in San Angelo, Texas, stocked Keller blankets "made of pure virgin mohair with just enough horsehair to prevent crawling." Andrew advised his customers to "ride a Keller blanket and patronize home industry" (R. J. Andrew & Son [ca. 1931]: 54). In 1931, California saddler Fred Stern touted a "new style" Navajo saddle blanket made 28-inches square and an inch thick, "the right size for a single but having the double thickness" (Fred M. Stern, n.d. [No. 31]:11). According to Stern's catalog, the extra thickness kept the $5 blanket, which was finished with mohair, from wrinkling or "rolling" (Fred M. Stern, n.d. [No. 31]:11).

Because of a lack of uniformity in the design, color, size, and weight of Navajo saddle blankets, retailers avoided quoting exact prices and descriptions. Instead, both wholesalers and retailers priced them by weight according to the thickness, quality of wool and weaving, and attractiveness of design (see Table). "It is a well-known fact," the 1915 catalog of the Heiser Saddlery Company explained, "that the genuine Navajo Indian-make all-wool Blankets are made in a large variety of designs, according to the temperament and ideas of the Indian at the time of its manufacture and that, consequently, it is very seldom that any two Blankets are exactly alike in design, color or size" (Hermann H. Heiser Saddlery Co. [1915]:213). Like most outfitters, Heiser claimed to have purchased his inventory of Navajo saddle blankets "direct from the Indian traders at the Reservation" (Hermann H. Heiser Saddlery Co. [1915]:213), and he therefore was in a position to supply any size and design of blanket or rug. New Mexico saddle maker E. T. Amonett made similar claims but felt compelled to assure his customers that his Navajo saddle blankets came "in correct saddle blanket sizes" (E. T. Amonett [1931]:83).

A casual survey of trade-catalog descriptions, however, indicates some variation in size among Navajo saddle blankets reaching commercial outlets. In both 1916 and 1924, for example, the Charles P. Shipley Saddlery listed the measurements of its single Navajo saddle blankets at 28 inches by 33 inches and double blankets at 64 inches by 34 inches. Shipley's 1935 catalog, however, cites single blankets at 28 inches square and doubles, when folded, at 30 inches square. Navajo trader Tony Richardson recalled that most single saddle blankets of the 1930s measured approximately 31 inches square (Charles P. Shipley Saddlery and Mercantile Co. [ca. 1923]:58, and 1935:42; Richardson 1986:177). John Sinclair's memoir of New Mexico ranch life, *Cowboy Riding Country*, states that in the 1930s, E. T. Amonett's Roswell saddlery offered four grades of Navajo saddle blankets, "the singles averaging two to three pounds, thirty by thirty inches square. The doubles weighed four to seven pounds and measured thirty-four by fifty-six inches" (Sinclair 1982:24). The 1942 Hamley catalog listed singles at 30 by 30 inches and doubles at 34 by 56 to 68 inches (Hamley & Co. 1942:67). In bunkhouses and ranch houses, fancy saddle blankets sometimes doubled as floor rugs, and some cowhands also used them for bed covers or as ground cover for their bedrolls.

Many western retailers stocked a variety of Navajo textiles. In 1916, for example, the Sentinel Butte Saddle Company, which called itself "the largest dealer in Navajo woolen goods in the Northwest" (Sentinel Butte Saddle Co. [ca. 1916]:72)

Retail Saddle Blanket Prices 1886–1960					
Source	Date	Weight	Weight Single	Weight Double	Price
J. S. Collins Cheyenne, WY (trade catalog)	ca. 1886				$1.50–$6 & $7 each, depending on quality
R. T. Frazier Pueblo, CO (trade catalog)	ca. 1905ca.				$1.50–$3 single $3–$6 double
John Quitman Stevens, Jr., South Texas (memoir)	ca.1907–1913				$5 each
G. S. Garcia, Elko, NV (trade catalog)	1910	2–8 lbs.			$1.50 per lb.
J. H. Wilson, Denver, CO (trade catalog)	ca. 1915				$1.70–$2.50 per lb. single $1.80–$3 per lb. double
Hermann H. Heiser, Denver, CO (trade catalog)	1915				$3.50–$7.50 single $5–$12 double ($1–$2.50 per lb.)
G. S. Garcia, Elko, NV (trade catalog)	1916	2–8 lbs			$2.50–$3 per lb.
Sentinel Butte Saddle Co., ND (trade catalog)	1916				$4–$6 single $6–$12 double
Charles P. Shipley Kansas City, MO (trade catalog)	1916			4–8 lbs. 5–9 lbs.	$5–$10 each $7–$9 each (medium fancy)
T. Flynn Pueblo, CO (trade catalog)	1922				$8, $9, $10 each (double only)
Charles P. Shipley, Kansas City, MO (trade catalog)	ca. 1923			4–9 lbs. 5–9 lbs.	$2–$3 per lb. (plain and medium fancy)
Hamley & Company, Pendleton, OR (trade catalog)	1924		$2\frac{1}{2}$–$3\frac{3}{4}$ lbs.	4–7lbs.	No.1 $2.25 per lb. No.2 $1.65 per lb. No.3 $1.40 per lb.
Herman H. Heiser, Denver, CO (trade catalog)	1926		$2\frac{1}{2}$–4 lbs.	5–8 lb	$2.50 per lb. single or double $3 per lb. extra fancy
Stockman–Farmer Supply Co., Denver, CO (trade catalog)	1929		$2\frac{1}{2}$–4 lbs.	$4\frac{1}{2}$–7 lbs.	$1.45 per lb. (plain colors) $2.25 per lb. (bright colors, fine weaves)

Source	Date	Weight	Weight Single	Weight Double	Price
G. S. Garcia, Elko, NV (trade catalog)	1929	2–8 lbs,			$3 per lb. (best quality)
Zimmer (article)	1930s				$1.25–$2.50 lb. (thickness and fineness of weave)
E. T. Amonett, El Paso, TX & Roswell, NM (trade catalog)	1930				$1.85 per lb. $7.50–$12.50 each
E. T. Amonett, El Paso, TX & Roswell, NM (trade catalog)	1931				$1.50 per lb.
R. J. Andrew, San Angelo, TX (trade catalog)	1931		3–5 lbs.	6–8 lbs.	$1.50–$2.25 per lb. $4.50–$11.25 single $9–$18 double
Charles P. Shipley, Kansas City, MO (trade catalog)	1935				$4–6 single $7–12 double
N. Porter, Phoenix, AZ (trade catalog)	1936		3 lbs.(ave.)	6 lbs.(ave.)	$1.25 (plain)–$1.50 lb. (fancy) $3.75–$4.50 single $7.50–$9 double
Western Saddle Mfg. Co., Denver, CO (trade catalog)	1937	4½ to 7 lbs.			$1.40 per lb.
S. D. Myres, El Paso, TX (trade catalog)	1930s				$7.50–$10 single $10–15 double
Fred M. Stern, San Jose, CA (trade catalog)	1930s		2–3 lbs.	5–6 lbs.	$1.75 lb. $3.50–$5.25 single $8.75–$10.50 double
Gipson (memoir)	1930s				$10 ea.
Hamley & Co., Pendleton, OR (trade catalog)	1942	6 lbs. (choice)	2–3½ lbs.	4–7 lbs.	No. 1A $2.25 per lb. (choice) No. 1 $1.90 per lb. No. 2 $1.60 per lb. No. 3 $1.35 per lb.
Richardson (memoir)	Late 1940s				$7.50 single $15.00 double
E. T. Amonett, Roswell, NM (trade catalog)	1948				$6–$9 single $16–22.50 double
Howard (article)	1952				$10 single $20 double
Bill Price, Lubbock, TX (interview)	1960				$12 wholesale $19.95 retail

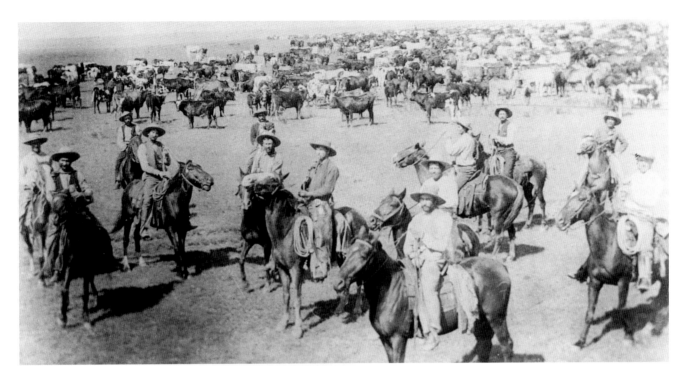

Figure 91. "The Day Herd," New Mexico cowboys, ca. 1890.
MNM 104688.

offered fancy rugs for $8 to $10 each and woven pillow tops at $1.75. A picturesque array of Navajo floor rugs filled two full pages of the 1922 catalog of T. Flynn's Pueblo saddlery (T. Flynn Saddlery Co. [ca. 1922]:54–55). In the 1930s, Sheridan, Wyoming, saddle maker and prominent dude ranch outfitter Otto Ernst carried an assortment of Navajo weavings, priced from $1.00 to $1.50 per square foot, as well as "Chimayo Indian Blankets & Silk Zarapes" (Otto F. Ernst, Inc., n.d.:54). Ernst's catalog also offered "Genuine Indian Bead Work, Relics and Curios" that included war clubs, tomahawks, wampum, war bonnets, bows and arrows, bone breast plates, belts, moccasins, dresses, and vests, acquired from Indian reservations on the Great Plains.

Although Ernst and his contemporaries in the dude ranch trade introduced an increasing number of recreational horsemen from outside the West to the virtues of Navajo saddle blankets, the Great Depression, coupled with the steady decline of horsepower in the face of the automotive revolution,

severely curtailed the saddle blanket market. Already skimpy, cowboy wages declined even further in the face of prolonged drought and falling cattle prices. Neither federal intervention in the cattle business nor discounted merchandise offered by some saddle makers during the hard times reversed the trend (Gipson 1977:142; E. T. Amonett [1931]:inside front cover, 2). By 1941, the saddle blanket market had reached its nadir. According to an Indian trader at Inscription House in Arizona, locally made saddle blankets "could hardly be given away" and "brought the trader even less money than the wool alone would have if sold in the fleece" (Richardson 1986:176). Despite low prices, wholesale buyers and retail customers were scarce until a new, more colorful style, "attractive enough to use as a floor piece" (Richardson 1986:177), helped revive the market on the eve of World War II.

The war and its aftermath brought even more dramatic changes to the Navajo saddle blanket trade. The sheep that produced the thick, "fuzzy" wool used in some of the best Navajo blankets gave way to breeds better adapted to desert conditions but with shorter wool. Of even greater significance, many

weavers abandoned their looms and turned to other, more lucrative trades (Richardson 1986:176–177, 179–181). "The problem of the traders," noted one observer in 1952, "is not in getting orders, but in persuading the Indians to weave enough saddle blankets to meet the demand" (Howard 1952:8).

As the supply of saddle blankets shrank and demand from recreational horsemen escalated, prices began to rise. By the mid 1940s, average Navajo saddle blankets retailed for $7.50 and $15 in the Southwest and higher elsewhere. Within a decade, double saddle blankets of middling quality cost retailers $12 each and sold in saddleries and western stores for $20, plus $2 more for wear leathers sewn on each side. A boom in Navajo arts and crafts in the 1960s brought still higher prices for all types of weavings, and by the early 1970s, an average, reservation-made saddle blanket retailed for $125 (Price 2001).

Recreational horsemen sustained the demand for Navajo saddle blankets in the post–World War II era. The cowboy market for tack, however, declined steadily in the face of low ranch wages and higher-priced gear. In the 1970s, with Navajo saddle blankets virtually cost prohibitive to all but wealthy horsemen, outfitters turned increasingly to cheaper, treadle-loomed blankets made in Mexico to meet the needs of their cowboy customers. Woven from a combination of wool and cotton and available in a wider range of colors than Navajo types, many of the blankets from south of the border mimicked Indian designs (Price 2001; Howard 1952:9).

By the 1990s, prices for coveted Navajo double saddle blankets in twill or diamond-twill weaves had reached $300. For horseback work their use was now confined largely to the show ring. The development of broad-shouldered, thick-barreled quarter horses now required "oversize" saddle blankets 31 inches by 62 inches or larger, some of them fitted for competition with tooled-leather trim, conchas with horsehair tassels, and silver cornerplate accents to match those of the saddle (Zimmer 1998:84; Denison and Nudo 1996:68).

As early as 1920, saddle maker S. D. Myres recognized the tenuous nature of the Navajo saddle blanket trade. His trade catalog that year noted: "The supply of Navajos [saddle blankets] is very limited, and each year marks a decrease in the number produced for commercial purposes. It is only a question of time when this will be an extinct art" (S. D. Myres Saddle Co. 1920:90). Yet Navajo saddle blankets, like the cowboys who used them, proved remarkably resilient in the face of rapid changes over the past century. That these diverse, handmade products, produced in remote locales, competed effectively for so long against mass-produced saddle blankets and pads with far more marketing muscle is indeed remarkable. Although Navajo saddle blankets are virtually extinct as horse gear, at the dawn of the new millennium they still flourish as an art form and will forever be connected in spirit with the cowboys of the West.

REFERENCES

Adams, Ramon F. 1968. *Western Words: A Dictionary of the American West.* Revised edition. Norman: University of Oklahoma Press.

Amonett, E. T. [1930.] *E. T. Amonett Illustrated and Descriptive Catalogue and Price List. Silver Anniversary Number.* Roswell, NM: Hall-Poorbaugh Press.

———. [1931.] *E. T. Amonett Illustrated and Descriptive Catalogue and Price List 27.* El Paso, TX: Ellis Bros. Printing Co.

———. [1948.] *No. 49 Catalog Supplement.* N.p.

Andrew, R. J. & Son. [ca. 1931.] *Catalogue. Manufacturers and Dealers in Saddles and Harness and a Full Line of Bits, Spurs, Bridles, Chaps, Cuffs, Quirts, Boots,*

Etc. and Everything Carried in Stock by a Live, Up-to-date Saddle House. San Angelo, TX: Holcombe Blanton Printery.

Beatie, Russel H. 1981. *Saddles.* Norman: University of Oklahoma Press.

Benedict, Carl P. 1943. *A Tenderfoot Kid on Gyp Water.* Austin: Texas Folklore Society.

Beverly, Bob. Letter to J. Evetts Haley, Lovington, NM, January 22, 1938, Saddles File, Nita Stewart Haley Memorial Library, Midland, TX.

Clark, Laverne Harrell. 1963. "Early Horse Trappings of the Navajo and Apache Indians." *Arizona and the West* 5 (Autumn).

Clevenger, Barbara. 1972. "Harlan Webb, Saddle Maker." *Quarter Horse Journal* 24 (September).

Coe, Wilbur. 1968. *Ranch on the Ruidoso.* New York: Alfred A. Knopf.

Collins, J. S., & Co. [ca. 1886.] *J. S. Collins & Co. Wholesale and Retail Saddlers Commercial Block.* Cheyenne, WY: the company.

Denison, Jennifer J., and Marilee B. Nudo. 1996. "Saddle Roundup." *Horse & Rider* 35 (October).

Denver Manufacturing Company. 1883. *Illustrated Catalogue of the Denver Manufacturing Company, Tanners, Manufacturers and Wholesale Dealers in Leather, Leather Goods, Whips, Lashes and Saddlery Hardware.* Denver, CO: Daily Times, Spring Printing House.

Dodge, Theodore A. 1894. *Riders of Many Lands.* New York: Harper & Brothers.

Dorsey, Stephen and Kenneth L. McPheeters. 1999. *The American Military Saddle, 1776–1945.* Eugene, OR: Collector's Library.

Otto F. Ernst, Inc. N.d. *Makers of Fine Saddles, Catalog No. 13.* Sheridan, WY: Mills Company.

T. Flynn Saddlery Co. [ca. 1922.] *Illustrated Catalog and Price List No. 18.* Pueblo, CO: O'Brien Printing Co.

Frank, L. 1890. *Catalogue No.1. Manufacturer of Saddlery, Harness, and Jobber of Saddlery Hardware.* San Antonio, TX: Guessaz & Ferlet.

R. T. Frazier's Saddlery. N.d. *Saddlery Catalog No 8.* Pueblo, CO: the company.

Garcia, G. S. 1910. *Everything for the Vaquero. Illustrated Catalogue Number 12.* Elko, NV: Elko Free Press.

_____. 1916. *Everything for the Vaquero. Illustrated Catalogue Number 17.* Elko, NV.

Garcia Saddlery Co. [1929.] *Catalog No. 27.* Elko, NV.

Gipson, Fred. 1977. *Cowhand.* College Station: Texas A&M University Press.

Goodnight, Charles. Interview by J. Evetts Haley, Clarendon, TX, August 2, 1928, Goodnight Interview File, Panhandle Plains Historical Museum, Canyon, TX.

Graham, Joe S. 1991. "Vaquero Folk Arts and Crafts in South Texas." In Joe S. Graham, ed., *Hecho en Tejas: Texas-Mexican Folk Arts and Crafts.* Denton: University of North Texas Press.

Hamley & Company. N.d. *Catalog Number Two, Hamley Saddles.* Pendleton, OR.

_____. 1924. *Catalog Number 25, Hamley Saddles for Men Who Care.* Pendleton, OR.

_____. 1942. *Hamley's Cowboy Catalog No. 41.* Pendleton, OR.

[Hastings, Frank S.] [1919]. *The Story of the SMS Ranch.* N.p.: Stamford, TX: SMS Ranch.

Hermann H. Heiser Manufacturing & Selling Company. [1926.] *Illustrated Catalogue No. 21.*

Harness, Riding Saddles, Bridles, Harness Parts. Denver, CO.

_____. 1926. *Price List No. 2 Applying to Catalogue No. 21, March 1st, 1926.* Denver, CO.

Hermann H. Heiser Saddlery Co. [1915.] *Catalog Number 15.* Denver, CO: Press of Smith-Brooks.

Howard, Virginia. 1952. "The Navajo Saddle Blanket." *Western Horseman* 17 (August).

Ingerton, Harry. Interview by J. Evetts Haley, Amarillo, TX, June 19, 1937, Nita Stewart Haley Memorial Library, Midland, TX.

Jaques, Mary J. 1989 [1894]. *Texan Ranch Life: With Three Months Through Mexico in a "Prairie Schooner."* Reprint, College Station: Texas A&M University Press.

Kellner, C. J. E. Interview by J. Evetts Haley, January 18, 1938, Saddles File, Nita Stewart Haley Memorial Library, Midland, TX.

Keyston Bros. 1939. *Catalog No. 75.* San Francisco, CA.

Kniffen, Fred. 1953. "The Western Cattle Complex: Notes on Differentiation and Diffusion." *Western Folklore* 12.

Knight, Oliver. 1983. "Western Saddlemakers, 1865-1920." *Montana: The Magazine of Western History* 33 (Spring).

Liles, M. L. "Mike," and Mrs. Dave Howell. Interview with J. Evetts Haley, Kenna, NM, August 4, 1937, Nita Stewart Haley Memorial Library, Midland, TX.

Lindmier, Tom, and Steve Mount. 1996. *I See By Your Outfit.* Glendo, WY: High Plains Press.

Los Angeles Saddlery & Findings Co. 1912. *Catalog No. 14, August 1912.* Los Angeles, CA: Press of A. H. Gaarder.

Louisville [KY] Girth and Blanket Mills. 1898. "Talk About 'Good Things,' Here's a Cinch" (advertisement). *Harness Gazette* 17 (June).

Lowe, Percival G. 1965 [1905]. *Five Years a Dragoon and Other Adventures on the Great Plains.* Reprint. Norman: University of Oklahoma Press.

Mace, Mariana. 1998. "Native American Saddle Blankets: A Study of Shape and Tribal Attribution." *American Indian Art Magazine* 24 (Winter).

Main & Winchester. N.d. *Illustrated Catalog No. 10.* San Francisco, CA: Freygang Leary Co.

_____. [1878.] *Main & Winchester's Catalogue.* San Francisco, CA: Harrison.

Marquess, Joyce. 1977. "The Navajo Saddleblanket." *Shuttle, Spindle and Dyepot* 8 (Summer).

McCauley, James E. 1943. *A Stove-up Cowboy's Story.* Dallas: Texas Folklore Society.

Mora, Joe. 1946. *Trail Dust and Saddle Leather.* New York: Charles Scribner's Sons.

S. D. Myres Saddle Co. 1920. *S. D. Myres Saddle Co. 1897–1920.* El Paso, TX.

_____. N.d. *S. D. Myres Saddle Co., Manufacturers of the World's Finest Saddles: Cowboys' Wants a Specialty.* El Paso, TX.

[Northern Ohio Blanket Mills, Cleveland, OH]. 1900. Untitled article. *Harness Gazette* 19.

N. Porter. [1936.] *Catalog Number 26 for Summer 1936 and Winter of 1936–'37.* Phoenix, AZ.

Price, Bill B. Interview by B. Byron Price, Lubbock, TX, June 25, 2001. Notes in possession of author.

Rice, R. E. Letter to Robert Cator, May 23, 1881, James H. Cator Papers. Panhandle Plains Historical Museum, Canyon, TX.

Richardson, Gladwell. 1986. *Navajo Trader.* Tucson: University of Arizona Press.

Rickey, Don. 1976. *$10 Horse, $40 Saddle: Cowboy Clothing, Arms, Tools and Horse Gear of the 1880's*. Fort Collins, CO: Old Army Press.

Roberts, Jim W. Interview by J. Evetts Haley, June 24, 1937, Nita Stewart Haley Memorial Library, Midland, TX.

Rollins, Philip Ashton. 1936. *The Cowboy*. Revised edition. New York: Charles Scribner's Sons.

Rollinson, John K. 1948. *Wyoming Cattle Trails*. Caldwell, ID: Caxton Printers, Ltd.

Sentinel Butte Saddlery Co. [ca. 1916.] *Illustrated Catalog No. 11*. Sentinel Butte, ND: the company.

Charles P. Shipley Saddlery and Mercantile Co. [ca. 1916.] *Catalog No. 15*. Kansas City, MO: the company.

_____. [ca. 1923.] *Catalog No. 19*. Kansas City, MO: Chas. E. Brown Printing Co.

_____. 1935. *Catalog No. 28*. Kansas City, MO: the company.

Sinclair, John L. 1982. *Cowboy Riding Country*. Albuquerque: University of New Mexico Press.

Siringo, Charles. 1914. *A Texas Cow Boy*. New York: J. S. Ogilive Co.

Slade [pseud.]. 1882. "The Cowboy by Slade." *Texas Livestock Journal*, October 21.

Smith, Lewis. 1977. "The Famous Pueblo Saddles." *Quarter Horse Journal* 29 (September).

Fred M. Stern, Ltd. N.d. *Catalog No. 29 of Fred M. Stern*. San Jose, CA: the company.

_____. N.d. *Catalog No. 31, Western & English Riding Equipment*. San Jose, CA: the company.

Stevens, John Quitman, Jr. 1972. "Autobiographical Episode: A Boyhood on the South Texas Range Prague Ranch, 1907-1913." *Texana* 10 (No. 2).

Stillman, J. B. D. 1990. *Wanderings in the Southwest, 1855*. Edited by Ron Tyler. Spokane, WA: Arthur H. Clark.

Stockman-Farmer Supply Co. 1929. *Catalog No. 34, Spring 1929*. Denver, CO: the company.

Stock Yards Harness Company. [ca. 1910.] *Illustrated and Descriptive Catalogue No. 8*. Kansas City, MO: Franklin Hudson Publishing Co.

L. D. Stone & Co. [ca. 1894.] *Illustrated Catalogue No. 11 of L. D. Stone & Co. Wholesale and Retail Manufacturers of Harness, Saddles, Saddlery Hardware, Etc*. San Francisco, CA: Hoyle & Co., Printers.

Vernam, Glen R. 1964. *Man on Horseback*. New York: Harper and Row.

Walker, C. W. (Charlie), W. W. (Walter) Walker, and W. D. (Bill) Walker. Interview by J. Evetts Haley, Dunlap NM, August 5, 1937, Nita Stewart Haley Memorial Library, Midland, TX.

Western Saddle Manufacturing Co. 1937. *Price List No. 53*. Denver, CO: the company.

J. H. Wilson Saddlery Co. N.d. *Pocket Edition Illustrated Saddle Catalog No. 16 with Description and Prices of Riding Goods Only*. Denver, CO.

Zimmer, Stephen. 1998. "Navajo Saddle Blankets: Traders Developed the Market for These Handmade Beauties." *Western Horseman* (July).

7
\mathcal{W}eaving Processes and Techniques

By Joyce Begay-Foss

FOR HUNDREDS OF YEARS, weaving has supported the lives of the Navajo people. For most traditional Navajos, it is a part of everyday life on the vast, remote Navajo Reservation, which is about 26,000 square miles in area and is located in parts of Arizona, New Mexico, and Utah. From generation to generation, the weaving tools and cultural knowledge of weaving have been passed on. For some weaving families, it has brought them consistent cultural status and wealth. It has enabled many Navajo people to continue their simple, semi-nomadic way of life, through trading their blankets, wool, and sheep. The finely woven blankets and rugs are still sought after as trade items from regional Southwest tribes and trading post managers. Weaving is a constant matrix of cycles continuing to evolve with respect to the sheep, horses, land, and the natural elements. Weaving is not considered an art form based on western culture but a true connection to the Navajos' relationship to harmony and balance based on ceremonial lifeways. There is also structure and order related to ceremonies, songs, and taboos associated with Navajo weaving.

It is said through Navajo oral traditional stories that Spider Man built the first loom for the Navajo people and that Spider Woman taught the Navajo people how to weave.

The Navajo loom's upper wooden post is symbolic of the sky, and the lower wooden post representative of the earth. The warp sticks are made of sun rays, and the upper rope strings connecting the warp to the upper post is of lightning, the lower strings are of sun halo, the stick shed is of rock crystal and the pull shed of sheet lightning. The pull stick shed is secured to warp strings by rain-ray cords.

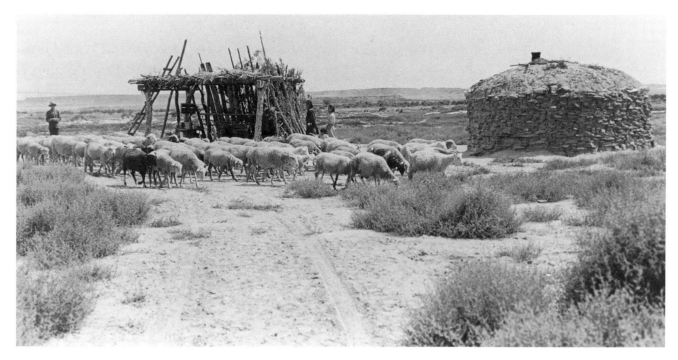

Figure 92. Flock of Navajo sheep in front of a hogan and summer brush arbor, ca. 1920. MNM 44177.

For the longest time, it has been generally thought that women were the only weavers in Navajo society. The idea is stated in written text and documented in journals of military men from the previous century. From the Navajo perspective, male weavers have always been part of traditional Navajo history and culture. Male weavers are mentioned in our creation stories in the underworld but this is not mentioned in the English versions of our Navajo stories.

Today, a handful of young boys and men continue to weave as our male ancestors did in the past. We are continuing the stories of our histories through weaving.

—Wesley Thomas, Navajo weaver, from
Weaving in the Margins:
Navajo Men as Weavers

Saddle blankets are usually worn on the horses on the first night of a Navajo Squaw dance, which is during the summer. People still use them for riding and while herding sheep or cattle.

—Clarina Begay, Navajo weaver
Lukachukai, Arizona

Nowadays, most of the Navajos that use saddle blankets are the riders at the rodeos.

—Sarah Natani, Navajo weaver
Table Mesa, New Mexico

I remember my grandmother weaving saddle blankets for my grandfather and how my grandfather cherished them. He had one woven with a twill pattern, which he used on a daily basis, and a very intricate Parade saddle blanket that was reserved for special trips, like to the fair, Squaw Dances, and other ceremonies. That saddle blanket was very colorful and had fringes on the back and tassles on the backside.

I've always wanted that piece because it was so beautiful, but nobody knows whatever happened to that piece. Some of the twill saddle blankets are still around the house, used as area rugs or coverings for couches and chairs. We don't own any horses now, so they are rarely reproduced anymore. I occasionally weave one, but it's rarely two.

—Roy Kady, Navajo Weaver
Teec Nos Pos, Arizona

Early saddle blankets were utilitarian and were in constant use by the Navajo people. Navajo weavers sometimes wove protection designs into the blanket to protect the rider from harm, either from the natural elements or accidents. Horseback riding is still a necessary form of transportation to herd sheep and for travel to remote parts of the reservation. Designs could be very simple, as in banded patterns, and also very complex, as in the various twill, double-pattern, and two-faced weaves. Twill weaves are the most traditional design used almost exclusively for saddle blankets. This is due to the thickness and durability of the technique.

In earlier times, saddle blankets were considered like protective shields. For additional protection, small pieces of horsehair and pieces of money were woven in the saddle blanket. Used everyday when riding, and also the men used them as sleeping bedrolls. Today, they are mostly regarded for appearance and design.

—Bonnie Benally Yazzie, Navajo weaver
Crownpoint, New Mexico

Saddle blankets were as common as the early wearing blankets. They had to be very wearable and durable.

—Jaymes Henio, Navajo weaver
Ramah, New Mexico

WEAVING A NAVAJO SADDLE BLANKET

The weaver first builds the traditional vertical loom in a suitable place for her to weave. Proper lighting is always a concern for most weavers, and natural sunlight is preferred. The Navajo loom has no permanent framework, and only the supporting poles and the weaving tools can be used again and again.

It is constructed with two upright posts and a lower and upper crossbeam to create a square, sturdy, freestanding frame. Although the loom generally is made out of wood, such as piñon or cedar, most weavers today will use a frame made out of standard lumber. Looms are constructed large enough so that a weaver is not limited to a certain size of woven textile. Some weavers would maintain various loom frames at their hogans, outside under a shade house, or at their summer sheep camp in the mountains.

Stick/Pull Shed Heddles

The heddles are made out of slender hardwood twigs of mountain mahogany, willow, greasewood, or cedar. The stick shed is inserted between a certain group of warp strings to mark a shed. The pull-shed heddle is attached to warp strings with twisted loops of strings so that when pulled will bring the back warp strings forward.

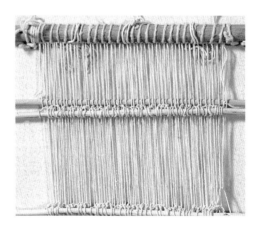

Figure 93. One-pull and one-stick shed setup. Courtesy of Joyce Begay-Foss

Basic plain weave consists of over and under weaving, thus having two sheds (pull and stick shed). Four-shed weaving, which applies to twills and double weaves, has three pull sheds and one stick shed.

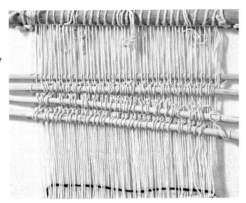

Figure 94. Three-pull and one-stick shed setup. Courtesy of Joyce Begay-Foss

WEAVING TOOLS

Traditionally the Navajo men make the weaving tools, and today most weavers can buy them at trading posts and at other markets on the reservation. Weavers usually do not share their tools with one another and take great care in where they are placed. It is an honor when a weaver gives a person her weaving tools, usually handed down to a family member.

Batten

A long, flat stick made of a hardwood such as cedar, oak. or greasewood. It is inserted between warp sheds to hold warp strings in place so that the weaver can lay in the weft yarn. Various sizes in length and width are used at different stages in weaving.

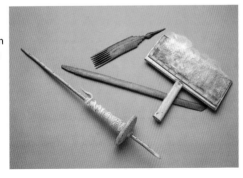

Figure 95. Weaving tools, Clockwise from bottom to top: spindle, batten, comb, wool card.

Comb

A wooden-tined weaving fork made out of hardwood such as cedar, oak,. or greasewood. The weaving fork, made in various sizes, is used to pack down the weft yarns.

The next step for the weaver is preparation of warp and weft, which requires shearing, cleaning, carding, spinning, and dyeing the wool fibers.

Warp and Weft Characteristics

Wool is used for both warp and weft in Navajo saddle blankets. The breeds of sheep raised vary among Navajo weavers and include churro, rambouillet, Lincoln, corriedale, and merino. Mohair fibers from goats are also occasionally used for weft yarns and sometimes are carded with wool to create unique mixed-fiber combinations.

The quality of the warp for a saddle blanket has to be very strong and durable. Germantown saddle blankets made between 1880 and 1910 have been known to have cotton warps, which are not as durable as wool. Early Germantown weft yarns came in an array of brilliant, commercially dyed colors, and today, trading posts on the reservation are introducing weavers to a new, single-ply Germantown yarn.

A warp is a continuous length of spun string that is wound over and under two dowels, with plied cordage at the edges, thus creating a foundation on which the weft is woven. After the warping process is finished, the sheds are marked and the pull or stick sheds are inserted and attached. Most weavers spin their own warp yarn strings in various weights and colors of white, gray, and brown.

Softer yarns are used so as not to irritate the horses, and warp is spun thicker with wool and mohair mix.
—Ron Garnanez, Navajo weaver
Waterflow, New Mexico

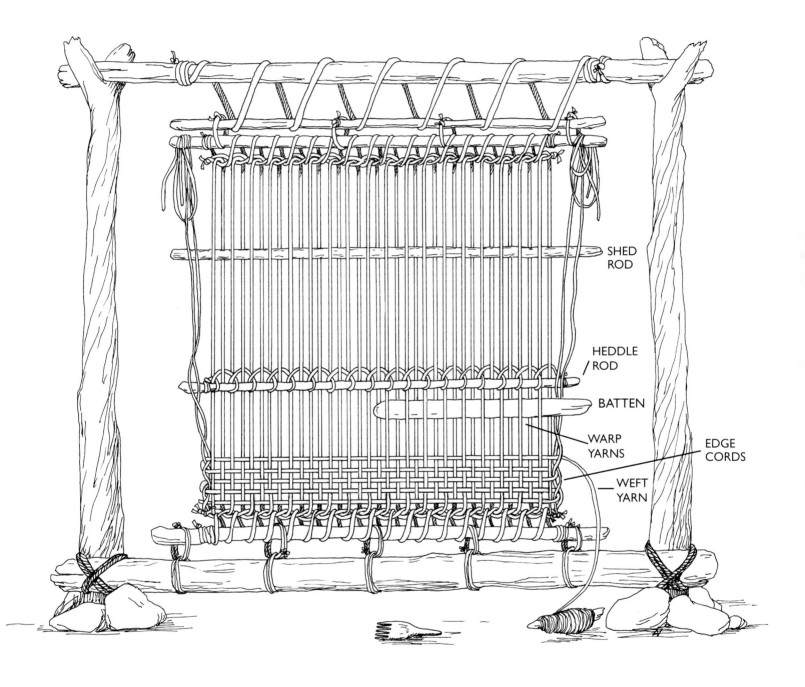

SHED
ROD

HEDDLE
/ ROD

BATTEN

WARP
YARNS

EDGE
CORDS

WEFT
YARN

Figure 96. Traditional Navajo loom.

The warp is secured at both ends to a round dowel, which then is secured to the upper and lower crossbeams. Tension is very important, so the upper warp dowel and crossbeam is where the rope can be adjusted to tighten the warp. Side selvage cords are tied onto the warp dowels parallel to the warp and are woven along with the weft. Occasionally, some weavers eliminate the side selvage cords on their saddle blankets.

PREPARING THE YARN

Sorting and Washing Wool

After it has been shorn from the sheep, the wool is sorted by fiber length, and then debris such as burrs or other vegetal matter is picked off.

Now the wool is ready to be washed. It is immersed in cool water with yucca root soap and soaked overnight. Water is then drained and the wool is spread out in the sun to dry. If the wool is extremely dirty the process is repeated. When washing or wetting the wool, care must be taken not to agitate it too much, or it will felt the wool. When dry, the wool is ready to be carded.

Carding

A small handful of clean, dry wool is placed on the wool carders and brushed so that the wool fibers lie parallel to each other. The carding will also remove additional vegetal debris from the wool. Each carded handful of wool is then rolled up and set aside, ready to be spun into yarn.

Spinning

Spinning is done by using a spindle whorl. The spindle whorl has a small, circular disc base (no more than five inches in diameter) with a spindle shaft running through the center, usually about twenty-two inches long. The spindle base is made out of hardwood or pine lumber and the shaft out of wild currant, mountain mahogany, cedar, or willow. Commercial dowels are also used.

Spinning begins by taking a rolled, carded piece of wool and pulling and twisting it in a certain direction over the tip of the spindle whorl. Spinning for warp and weft is defined as having a Z or S twist, which is in relation to the direction that the fiber is spun as clockwise or counterclockwise. Most Navajo weavers spin the weft as a single-ply yarn. If they are using the weft for end and side selvages, they would have to double- or triple-ply their yarn.

Colors and Dyeing

Traditionally, diamond-twill saddle blankets were woven in natural handspun colors of black, brown, gray, and white. The wool in finer, tapestry-woven blankets was dyed either with vegetal or aniline dyes. Colors obtained from vegetal dyes reflect the landscape and are mostly natural pastel hues. Brighter and consistent colors were obtained with aniline dyes, which were purchased in small dye packets at the trading posts. In the late 1800s, the traders supplied weavers with yarns commercially spun and dyed, such as Germantown and Saxony yarns. These types of yarns are distinguished by their bright colors and also by being three-plied or four-plied.

In the 1940s, weavers would weave in brighter colors such as oranges and reds. I remember there were these white horses that when the riders would take off the saddle and saddle blanket, there would be an orange or red stain on the horses back. Due to the scarcity of water, they didn't rinse out the dyes.
—Sarah Natani, Navajo weaver
Table Mesa, New Mexico

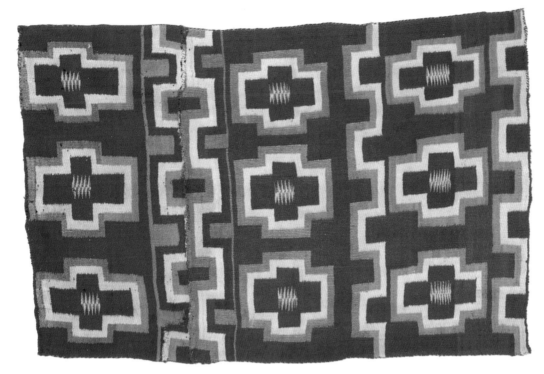

Figure 97

Navajo saddle blanket fragment, 1880–1900

Double, tapestry weave; handspun wool yarn

117.5 × 76 cm.

Gift of Dr. Phyllis Harroun

Types of Design and Weaves

Navajo weavers do not mark the design on the warp strings. Traditional weavers have their own way of measuring and counting in regard to design placement. Saddle blankets are not often identified by regional styles, for example Two Grey Hills or Chinle, but mostly by the pattern or style of weave.

Using the two-shed tapestry weave, banded patterns and pictorial blankets were woven as saddle blankets. A four-shed setup creates the twill weaves, such as the diagonal twill, diamond twill, herringbone twill, and plain twill. Four-shed weaving also created double-pattern weave and two-faced weaving. The complexity of four-shed weaving has always been overlooked in descriptions of Navajo textiles. The process of setting up each individual shed is very time-consuming, and the weaver has to be very experienced in her warp counts to accomplish the twill or double-weave patterns. Warp and weft counts vary according to the size of the textile and fineness of the weave.

I have seen elaborate bordered designs and empty design centers; Whirling logs designs, livestock brands, and regional names like Lukachukai and Shiprock woven on each corner of the saddle blanket.
—Clarina Begay, Navajo weaver
Lukachukai, Arizona

Twill weaves are the most common and also eye-dazzler borders with plain centers.
—Ron Garnanez, Navajo weaver
Waterflow, New Mexico

Older weavers would measure five hand lengths for half a saddle blanket. Double weave blankets are always woven as a single saddle blanket. If the saddle blanket is too thick, the saddle will not be stable.
—Ron Garnanez, Navajo weaver
Waterflow, New Mexico

Weaving Processes and Techniques 125

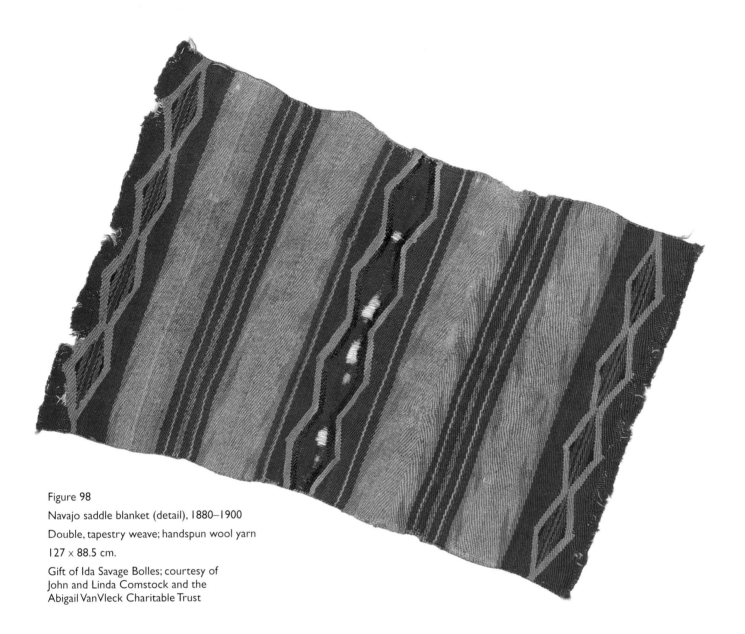

Figure 98

Navajo saddle blanket (detail), 1880–1900

Double, tapestry weave; handspun wool yarn

127 × 88.5 cm.

Gift of Ida Savage Bolles; courtesy of
John and Linda Comstock and the
Abigail VanVleck Charitable Trust

Twill Weaves (Four-shed)

Diagonal twill is produced by tying up the heddles in twos, then skipping two, but from one heddle to the next there is an overlap of one warp string. Diamond twill has many variations of draft setups. Pattern and design are based on color combinations and heddle arrangements.

> *Twill weaves are the most common and
> are usually sold or traded to local community
> members. Natural colors are preferred.
> Traders prefer Ganado red twills.*
> —*Clarina Begay, Navajo weaver*
> *Lukachukai, Arizona*

> *Natural wool colors for twill weaves are black,
> brown, white, and gray. I weave diamond,
> herringbone, diagonal twill, and pictorial
> saddle blankets, but mostly upon request
> from my brothers, relatives, and members
> of the Ramah community.*
> —*Jaymes Henio, Navajo weaver*
> *Ramah, New Mexico*

> *Weaving a saddle blanket is a lot of work,
> especially the twill weaves, and even the
> Navajo people do not want to pay
> very much for one.*
> —*Sarah Natani, Navajo weaver*
> *Table Mesa, New Mexico*

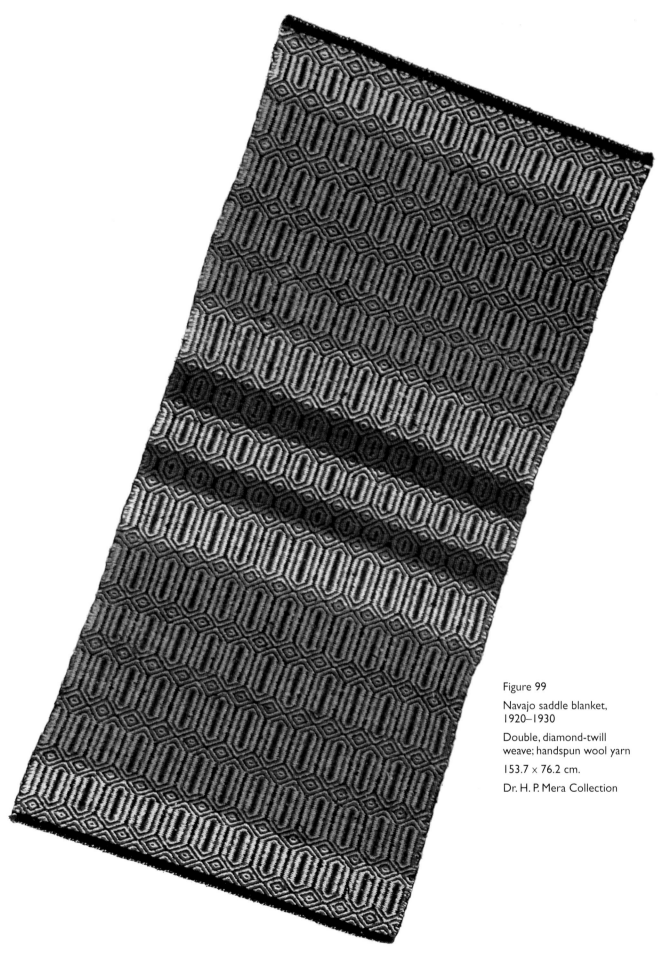

Figure 99

Navajo saddle blanket,
1920–1930

Double, diamond-twill
weave; handspun wool yarn

153.7 × 76.2 cm.

Dr. H. P. Mera Collection

Figure 100
Navajo saddle blanket,
1910–1930

Single, diamond-twill weave;
handspun wool yarn

82 × 71 cm.

Mrs. Phillip Stewart Collection

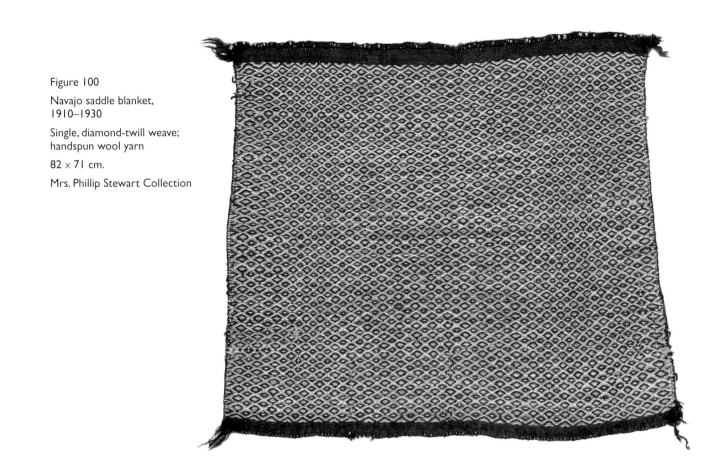

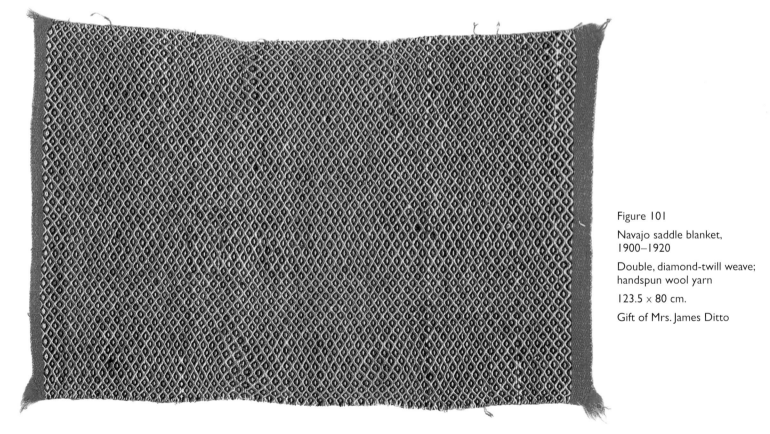

Figure 101
Navajo saddle blanket,
1900–1920

Double, diamond-twill weave;
handspun wool yarn

123.5 × 80 cm.

Gift of Mrs. James Ditto

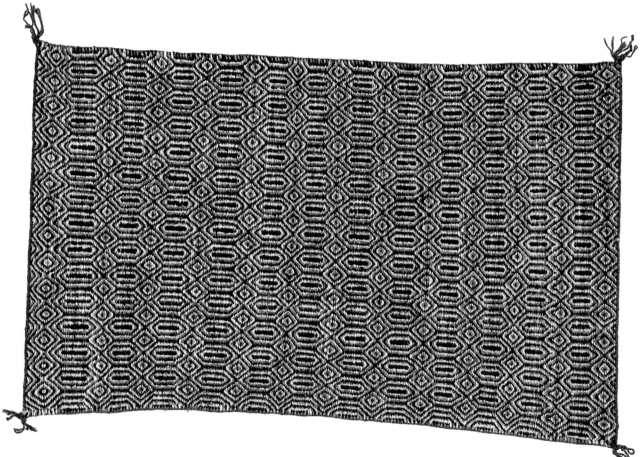

Figure 102

Navajo saddle blanket;
Fort Wingate, 1935–1965

Double, diamond-twill weave;
handspun wool yarn

128.8 × 80 cm.

Gift of William C. Ilfeld

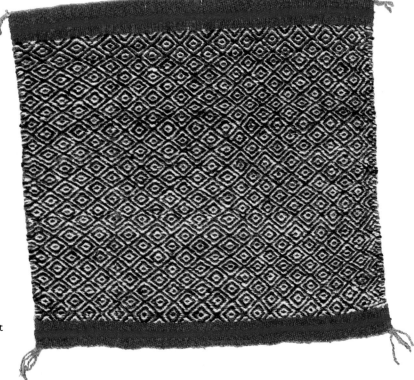

Figure 103

Navajo saddle blanket; Ramah, 1999

Single, diamond-twill weave;
churro and handspun wool yarn;
weaver: Zonnie Henio

76.5 × 74.5 cm.

Purchased by the Friends of Indian Art

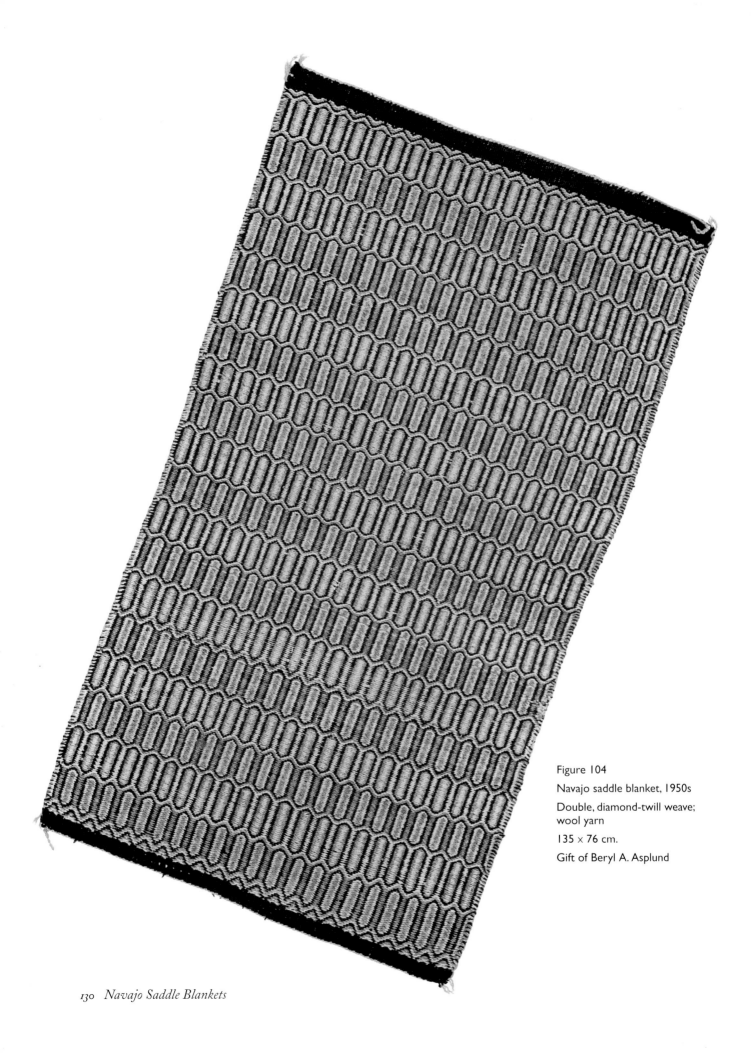

Figure 104
Navajo saddle blanket, 1950s
Double, diamond-twill weave;
wool yarn
135 × 76 cm.
Gift of Beryl A. Asplund

Two-Faced Weave (four-shed)

The rare two-faced design is woven using a four-shed setup to create two completely different designs, one on the front and a different one on the back of the blanket.

Double Weave (four-shed)

Double weave is woven by using a four-shed setup in which a design is woven in reverse groups of colors.

Tufted Weaves

Tufted weft is woven with tufts of mohair or wool inserted behind two warps with one-warp spacing. Alternating rows of tufts are woven to create a pelt like textile. Plain weave on natural yarns was woven between the tufts. This style could be used on top of the saddle and was commonly used by women (see Fig. 82).

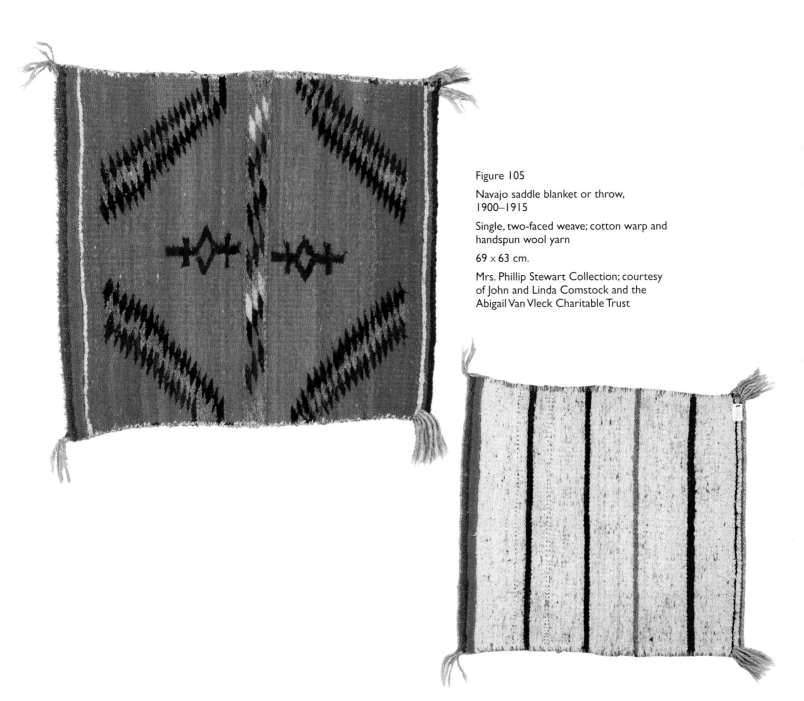

Figure 105

Navajo saddle blanket or throw, 1900–1915

Single, two-faced weave; cotton warp and handspun wool yarn

69 × 63 cm.

Mrs. Phillip Stewart Collection; courtesy of John and Linda Comstock and the Abigail Van Vleck Charitable Trust

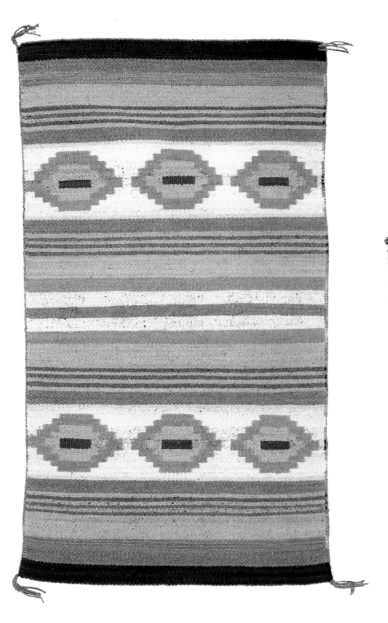

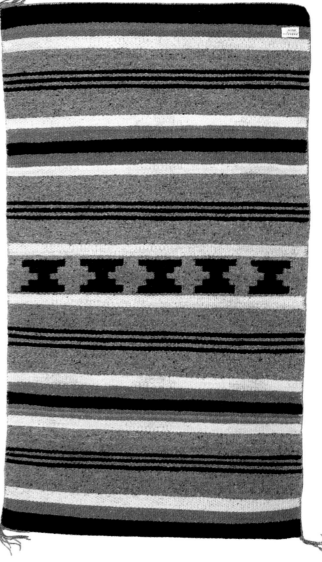

Figure 106

Navajo saddle blanket, 1954

Double, two-faced weave; handspun wool yarn; weaver: Florence Roanhorse

150 × 98 cm.

Gift of M. L. Woodard

Figure 107

Navajo saddle blanket,
1940–1960

Double, twill weave;
handspun wool yarn

126 × 69 cm.

Gift of Dewey Galleries, Ltd.

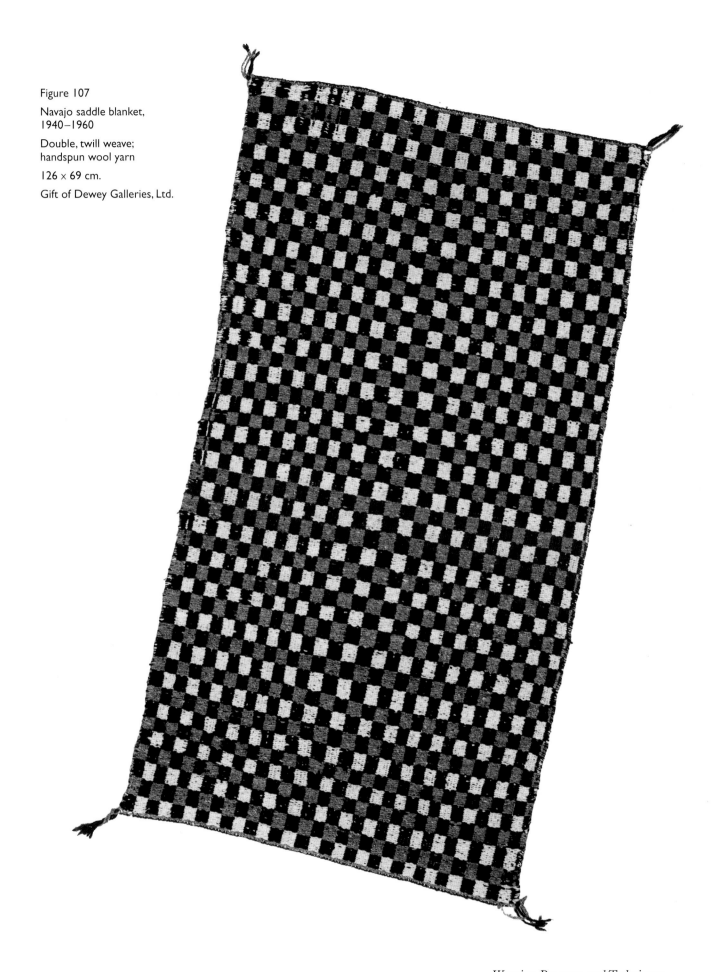

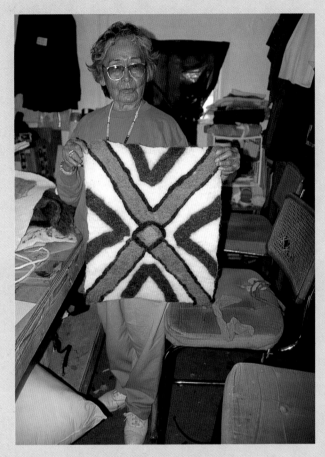

Betty Yazzie with her hand-felted rug, August
2002. Photo courtesy Maggie Tchir.

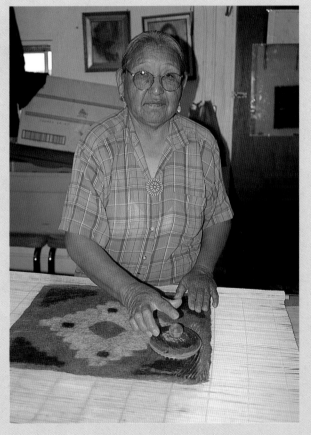

Workshop participant works on felting a small rug.
Photo courtesy Maggie Tchir.

FELTED SADDLE BLANKETS

Navajo are naturally "people of wool." In 1998, Mongolian/Inner Asian woolen felt-making techniques were introduced at the annual Navajo conference and workshop event, "Sheep Is Life," and, subsequently, into Navajo homes and sheep camps. Through an ongoing exchange, a new genre of textiles has begun to emerge in the Navajos' daily work with wool.

In the summer of 2000, a felt-making project based on Asian traditions was organized through the non-profit organization, Diné bé' íína' and the Navajo Churro Sheep Association. It brought together a core group of elders at the Jeddito Sewing Center, nearby Keams Canyon, Arizona.

This project initially sprang out of a meeting between Canadian felt and fiber artist Maggie Tchir and Lena Benally, a Navajo weaver and shepherd. As these two women began to share the ancient art of felt making with other Navajos, the circle of enthusiastic felters grew, much as it might in Mongolia, where in felt-making tradition there is the concept of a mother lineage: Out of the old "mother felt" the new "daughter felt" is fashioned. Each felt maker creates her own language, pattern, and form through this time-honored art, transforming it into a new "daughter " in the felt-making lineage. In this manner, the living lineage of Mongolian/Inner Asian felting tradition is being passed on to Navajo weavers and shepherds.

Felting is a non-woven textile tradition that is generally considered to have originated in Central Asia and is probably the earliest woolen textile technique. Felt is made from many animals, predominant sheep. The transformation from wool into felt is made possible by wool's two unique properties: elasticity and the ability to "creep." By applying moisture, heat, and pressure, the fibers open up and "creep "together. Prolonged kneading makes the fibers tangle and firmly interlock, creating a thick and durable mass.

Navajo elders appreciate the felt-making process because it is less physically demanding than weaving. Many elders are afflicted with arthritis and have great difficulty weaving. Although making a felt rug or saddle blanket is a arduous activity, it is a communal one in which many people help in its preparation, from carding the wool, laying out the surface designs, wetting it down with warm water, and finally taking turns in energetically rolling and kneading of the rug. Navajos enjoy the communal, social aspects of the felting process as well as the new and intriguing way of approaching their time-honored relationship with wool.

—Maggie Tchir

*E*pilogue
By Lane Coulter

A T THE TURN of a new century, changes are afoot for Navajo saddle blankets. Aside from the introduction of the new felting techniques, contemporary Navajo weavers are making brand new Germantown saddle blankets from commercial yarns and weaving hand-spun "eye dazzlers" based on the patterns and colors of the blankets of the 1880s and 1890s. Other weavers are challenging themselves to learn the difficult four-harness techniques that create the complex and beautiful herringbone and diamond twill weaves. A number of textile workshops are being held to encourage Navajo weavers to develop their skills and produce finer textiles for today's collector market.

Santa Fe gallery owners Ray Dewey and Joshua Baer have recently mounted pioneering exhibitions of older Navajo saddle blankets focused on the aesthetic qualities of these textiles. The expanding audience for these textiles has responded especially to the wonderful scale, contemplative subtleties, and intriguing graphics of the older blankets.

In researching the collections of Navajo weavingsat the Museum of Indian Arts and Culture, I believe there are exciting opportunities for future expansion: examples of pictorial weaving including ranch brands and such symbols as images of the horse and blankets commissioned as rodeo prizes (e.g. "Champion Saddle Bronc Rider") would add to the variety of the collection. Additional examples of Pueblo woven saddle blankets and blankets woven by Classic Period weavers would add immeasurably to the existing core collection.

We hope that this book will encourage other museums and private collectors with Navajo weaving collections to exhibit and publish their saddle blankets. We can trust that this book is just the beginning of a greater appreciation of this remarkable yet utilitarian art form.

*I*ndex

Note: Page numbers followed by *f*, *n*, or *t* refer to figures, notes, or tables respectively.